Penn State University

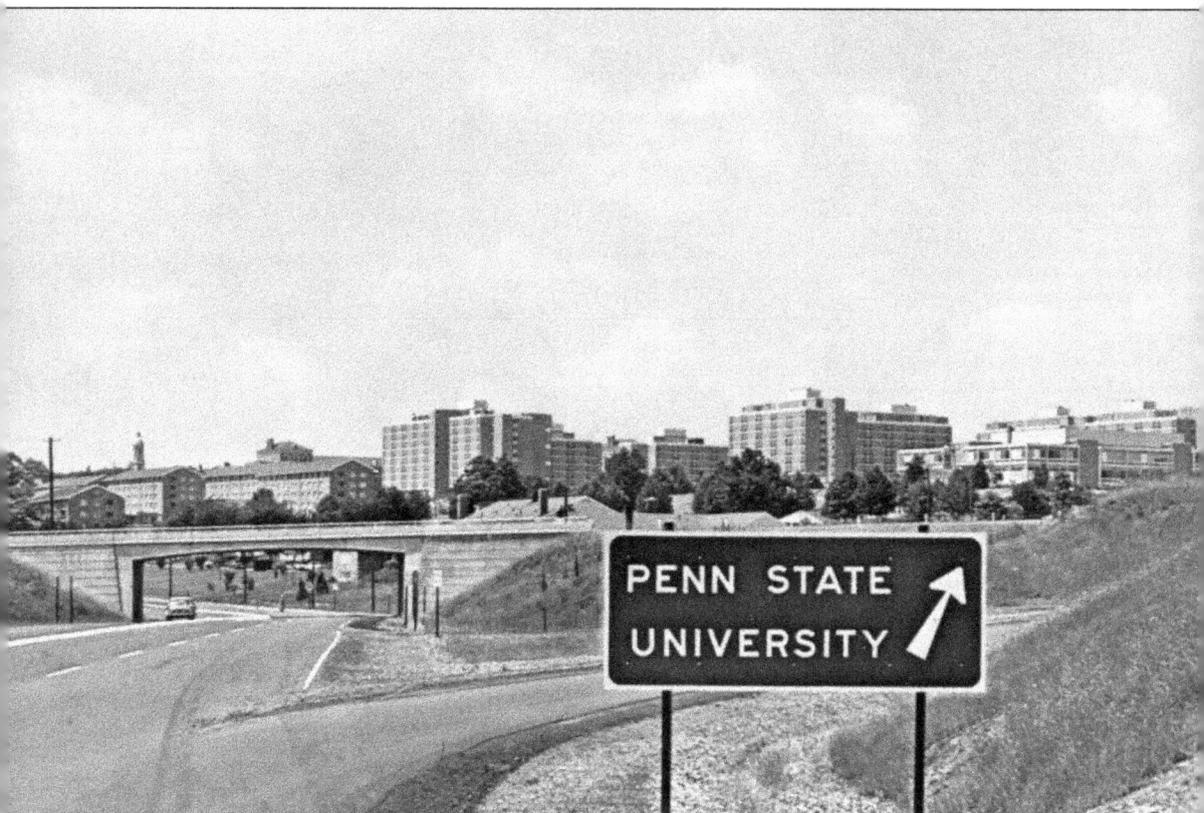

There are a few different ways of getting to Penn State. The three major entry points are Route 99 (north or south), Route 322 (east or west), or Route 26 (north or south). This sign is posted at the entranceway to Penn State going south on Route 26, right before the edge of downtown State College.

ON THE FRONT COVER: This multiview postcard shows some of the Penn State landmarks. Those featured in the center keystone include the Nittany Lion Shrine, a gift from the class of 1940; Old Main, home of the Penn State administration; and Beaver Stadium, the second-largest stadium in the nation. Also pictured on the card are, clockwise from upper left, the Hammond Building, a courtyard, East Halls, and the mall of elm trees.

ON THE BACK COVER: One of the most iconic buildings at Penn State is Old Main; however, this is not the original Old Main. This version was constructed in 1930.

POSTCARD HISTORY SERIES

Penn State University

Thomas E. Range II
Foreword by Roger L. Williams

ARCADIA
PUBLISHING

Published by Arcadia Publishing
Charleston, South Carolina

Library of Congress Control Number: 2016940451

For all general information contact Arcadia Publishing at:
Telephone 843-853-2070
Fax 843-853-0044
E-mail sales@arcadiapublishing.com
For customer service and orders:
Toll-Free 1-888-313-2665

Visit us on the Internet at www.arcadiapublishing.com

*For my father, Thomas E. Range Sr., who taught me
the love of history, the pleasure of collecting, and the joy of writing.*

CONTENTS

FOREWORD

In my 12 years as executive director of the Penn State Alumni Association, I have been privileged to know thousands of extraordinary Penn State alumni—extraordinary for their accomplishments in life after Penn State, but even more so for their passion, involvement, support, and love for our alma mater. Without doubt, Penn Staters are some of the most ardently devoted alumni in the world; because of them, the university stands as one of the top 100 global institutions of higher education, as survey after survey demonstrates.

The book you are about to read was compiled and written by an alumnus whose love for Penn State is second to none. Since graduating in 1989 with a degree in mathematics, Tom Range has stayed engaged with the university in many ways. Of particular note, he and Sean Smith produced an outstanding history of the university's signature instrumental group with *The Penn State Blue Band: A Century of Pride and Precision* (1999). Ten years later, he and Lew Lazarow updated that history with *Into the Game: The Penn State Blue Band 1999–2009*. In between those volumes, Tom served two terms on the Alumni Council and, after the mandatory two-year break, was reelected to a third term. Tom also served the alumni association as president of the Alumni Blue Band Association, an affiliate program group of the Penn State Alumni Association; as the newsletter chair and editor of the Alumni Blue Band's newsletter, the *Fanfare*; and as a member of numerous committees for both the Alumni Council and the Alumni Blue Band. Due to his efforts, the Penn State Alumni Association awarded Tom the Philip Philip Mitchell Alumni Service Award in 2003.

My favorite recollections of Tom, however, are in a less formal guise—as prime mover, motivator, and director of the Alumni Pep Band, a group of 20 to 40 Blue Band alumni who Tom musters out for special events, including homecoming, football pep rallies, and Penn State Day at Knoebels Amusement Park. Aside from enjoying the music, it is equally exciting to watch Tom in action. He is an enthusiast by nature, and his infectious good humor, pride, and spirit inject tremendous energy into any event in which he is playing a role. He is as good a cheerleader as we have ever had at Penn State.

Now, Tom is channeling his pride and spirit into yet another vital contribution to the life of our great alma mater with the postcard history *Penn State University*. As you will see, it is a labor of love—not only for Penn State, but also for his late father, Thomas E. Range Sr., who over his lifetime collected most of the postcards presented herein.

Tom's book also becomes a valuable addition to the body of work on Penn State history and heritage, including the three institutional histories by Erwin Runkle (1932), Wayland Dunaway (1946), and Michael Bezilla (1985), as well as my own work on Pres. George Atherton and the land grant college movement (1991). The collection also includes various histories of our campuses, colleges,

and academic departments that have been produced over the years. The decades-long outpouring of articles and books on aspects of Penn State history by Lee Stout and the many historical contributions of *Town & Gown* magazine over the last 50 years add to this impressive historical record, as do the dozens of campus historical markers sponsored by the alumni association.

Penn State's history is not a continuous, unbroken trajectory of progress over the last 160 years. There have been fits and starts, some retrograde motion, and some very fast progress, especially since 1950. It all started as a state-sponsored agricultural college headed by a brilliant young president, Evan Pugh (1859–1864). After a tragic early death in 1864, Pugh was succeeded by five troubled presidencies that nearly destroyed the institution. George Atherton (1882–1906) brought the school back from the brink of ruin, restored stability, built it up, and set it on a successful path for the 20th century. Edwin Sparks (1908–1920) consolidated and built upon Atherton's gains. John Thomas (1921–1925) came in with a grandiose plan for the university that found no support from the state, and he quickly left for greener pastures. Ralph Hetzel (1927–1947) provided stability over two decades of Depression and war. Milton Eisenhower (1950–1956) got Penn State moving again, ensuring its election to the prestigious Association of American Universities in 1958. Eric Walker (1956–1970) engineered an era of explosive growth across the university induced by the baby boomer movement. John Oswald (1970–1983) kept things intact over a decade of student unrest and economic downturn. Bryce Jordan (1983–1990) moved Penn State into national prominence, gains consolidated by Joab Thomas (1990–1995), and Graham Spanier (1995–2011) moved the university into international prominence.

It is an amazing story. Despite all that has been written about Penn State thus far, it is no easy task to make history come alive. Yet, in this task, Tom succeeds enormously. He wisely selected the best postcards from his father's vast collection to illustrate the physical essence of Penn State's long history, focusing on the University Park campus. He has organized the book into five sections that address the entirety of the Penn State experience and has written succinct but compelling captions for each image.

In an increasingly frenetic digital age, this is a book to savor, linger over, and return to time and again. After enduring the institutional trauma that began in 2011, every Penn Stater will find pleasure in returning to our collective roots, seeing how the university grew and developed over time, and delighting in these idyllic campus scenes. In doing so, we will be reminded of all that is great and glorious about Penn State and the wonderful town that surrounds it. There is no place like it on earth, and we are grateful to Tom Range for showing us, over the decades, the university WE ARE privileged to love and cherish.

—Roger L. Williams, 1973, 1975g, 1988g
retired associate vice president and
executive director of the Penn State Alumni Association
and affiliate associate professor of higher education

ACKNOWLEDGMENTS

First and foremost, I must thank my father for this volume you currently hold. When he passed in January 2014, I inherited his postcard collection and found that his Penn State collection was quite extensive. On most of the cards, he already had notes in his own hand explaining the person the building was named after. He planned to write this book.

I also must thank Roger Williams for his support of this project, as well as Sean Smith and Lew Lazarow. All three are Penn State historians who have written books and held presentations on the topic.

A lot of research was accomplished to present this book. I especially want to thank Jackie Esposito, Michael Bezilla, and Lee Stout. Jackie Esposito is the university archivist and a great historian. She is also the contact person for the Penn State University Libraries' Digital Collections, which holds over 70 sub-collections that have all been digitized for the world to see. The digitized collections of Penn State Images, La Vie, Penn State Historic Photo Archive, and the University Park Campus History were especially useful for this book. Though no images from those collections were used in this volume, the information gathered there was invaluable.

If there were two books that I would consider a must-read for any Penn Stater, they are *An Illustrated History of Penn State* by Michael Bezilla and *This Is Penn State* by the staff of the Penn State Press. Both offered information used for this text.

Lee Stout has long been known as one of the great historians of Penn State. His online articles on Penn State, as well as his written texts, are fascinating.

I also need to thank the staff of the Centre County Historical Society and Arcadia Publishing. Mary Sorensen, Christine Tate, Johanna Sedgewick, Cathy Horner, and Sharon Childs of the historical society helped immeasurably in procuring additional postcards. At Arcadia, I must thank Erin Vosgien and Stacia Bannerman for their help in producing this book.

And, finally, thank you to my loving family, Maureen, Megan, and Mitchell, who supported and encouraged me to write this book in my father's memory.

INTRODUCTION

It is hard to believe that what began as the Farmers' High School of Pennsylvania over 160 years ago has become the Pennsylvania State University. When the school started, there was but one main building, which was called the College Building at the time but would eventually become known as Old Main. The building housed everything from dormitory rooms and a cafeteria to classrooms and a library. From that humble beginning came Penn State, with close to 100,000 students a year, including the commonwealth campuses, and the strongest and largest dues-paying alumni association in the world.

The Farmers' High School of Pennsylvania was founded in 1855. The state legislature at the time wanted a state school and had to decide where it would be placed. James Irvin of nearby Centre Furnace, Pennsylvania, offered to donate 200 acres of land to the state for the school. To ensure the school would be placed in Centre County, Irvin then offered an additional 200 acres at a reduced rate. The legislature agreed, and the Farmers' High School of Pennsylvania was born.

The first students did not arrive until 1859. At the time, the main building was not completely finished. The first president of the school was Evan Pugh, who would remain at this post until 1864. He would see the name of the school change from the Farmers' High School of Pennsylvania to the Agricultural College of Pennsylvania in 1862. President Pugh was instrumental in having the college designated as Pennsylvania's land grant institution. The Morrill Act of 1862 allowed the sale of 30,000 acres of public land for each senator and representative the state had. The funds from the sale were then placed in an endowment that would go to the land grant institution. Many colleges in Pennsylvania vied for this designation, but Pugh was influential in having it assigned to the Agricultural College of Pennsylvania. Unfortunately, Pugh died in office in 1864, just a few months before the completion of the President's House, which he had helped pay for.

The name Agricultural College of Pennsylvania did not last long, being officially changed to the Pennsylvania State College in 1874.

Though the funds from the Morrill Act did not come immediately, the college eventually would expand and construct additional buildings. The Botany Building was erected in 1887, followed by the Armory in 1888 due to the military tactics requirement for land grant institutions. Then came the Chemistry and Physics Building in 1890 and the Old Engineering Building in 1893. To accommodate the increase of women at Penn State, the Ladies Cottage was built behind Old Main in 1890. The Botany Building is the only one of those just mentioned that is still standing in its original form. The original Old Main, the Armory, the Chemistry and Physics Building (later called Walker Building), the Ladies Cottage, and the Old Engineering Building were either torn down or, in the case of the Old Engineering Building, destroyed by fire.

A second building phase of Penn State started in the early 1900s. Most of the buildings constructed at that time still exist. Schwab Auditorium was built in 1903, and the Carnegie Building (then known as the Carnegie Library) was constructed in 1904. Schwab Auditorium is still used for plays and concerts, while the Carnegie Building was used as a library until 1940, when the Pattee Library was built. The Armsby Building was constructed in 1905, then known as the Agricultural Building. The McAllister Building (formerly McAllister Hall) was also constructed in 1905. Originally built as an additional male dormitory, McAllister Hall would later become a female dormitory and then a building that housed classrooms and offices.

All of the aforementioned construction was completed under the watchful eye of the college's eighth president, George W. Atherton. Known as the college's "second founder," Atherton served as president from 1882 to 1906. He died in office and is the only president buried on campus. His grave is located on the north side of Schwab Auditorium, directly across from the Botany Building.

As the school grew, so did the campus. In 1909, the football field located behind the Chemistry and Physics Building was moved to the northwest corner of campus. The football field, as well as the baseball field, known together as Beaver Field, would remain there and expand even more until 1960, when it was moved to its present location in the northeast corner of campus. At one time, the northwest corner was the athletic hub of the college. The football and baseball fields were located there, and then Recreation Hall (better known as Rec Hall) was built in 1929, giving the college a place to hold basketball games. The Nittany Lion Shrine, erected in 1942, was situated near all these sporting venues.

Other landmarks around campus that have either been moved or removed include Old Willow, the Ghost Walk, the Open Air Theatre, the Cottages, the Stock Judging Pavilion, and the Creamery, plus many others. All have been long forgotten, moved, or changed in such a way that they are no longer recognizable.

Amazingly, almost all these famous landmarks and buildings have been captured on postcards. This book is dedicated to explaining how Penn State has changed over the years, using postcards to illustrate this history across five chapters. The first chapter describes how the campus has changed over time. The aerial view of Penn State in 1909 is quite different from that of 1980. The second chapter details the buildings on campus where learning takes place. Not every building at Penn State is discussed, and the buildings reviewed in this volume were limited to the ones shown on postcards. The third chapter offers a brief look at some of the activities and sports available at Penn State, of which there are so many that listing all of them would take five books, if not more. The fourth chapter provides an overview of student accommodations. Though not every fraternity or dormitory is mentioned, the reader should get a good feel for student life. The last chapter focuses on the town of State College and the surrounding area. The college experience is more than just the school itself. It is important to have a well-rounded community to support the school and its student population.

Unless otherwise noted, all postcard images used in this text are from the personal collection of Thomas E. Range Sr. Others that are part of the Cannon Postcard Collection of the Centre County Historical Society have been marked with the abbreviation CPCCHS.

The statements, views, and opinions contained in this book are solely those of the author. This book has not been authorized or endorsed by The Pennsylvania State University nor does it necessarily reflect the views of the university.

One

A WALK THROUGH CAMPUS

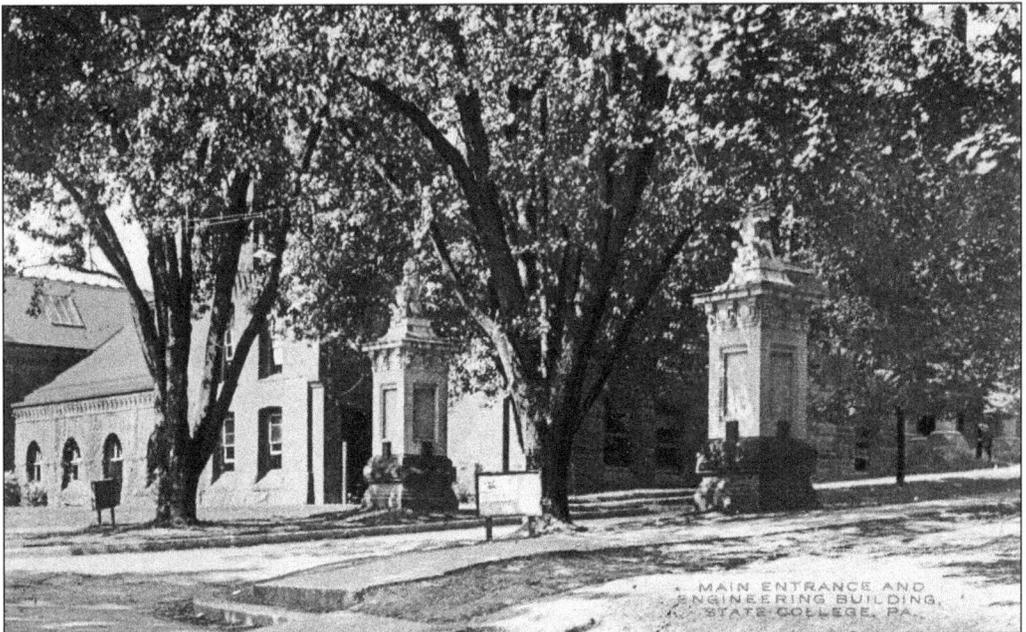

From the very beginning, the entranceway to Penn State was impressive. This postcard shows a side view of the main entrance across from Allen Street. The structure to the left of the original pillars is the Old Engineering Building, which would only stand for a few years before succumbing to a fire in 1918. (CPCCCHS.)

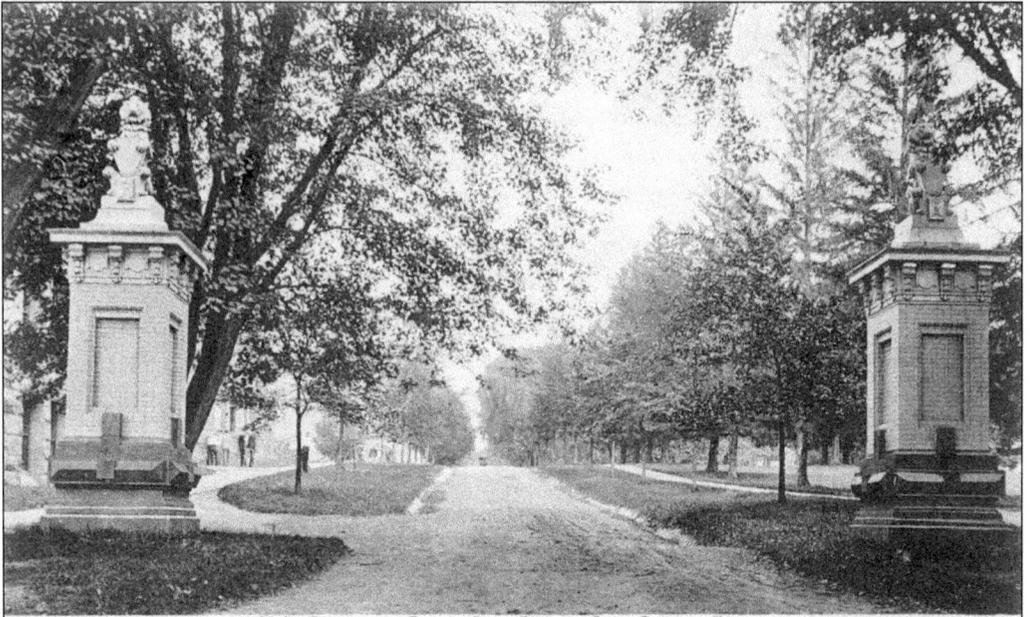

Main Entrance to Penna. State College, State College, Pa.

While there are many ways to access the University Park campus, the first and main entrance is located on College Avenue, across from Allen Street. This view shows that there was a road that went to some of the original buildings (Carnegie, Schwab, and so on). That road has since been covered in grass, and now a fence stands between the two pillars. Note the young age of the famous elm trees in this postcard from 1911.

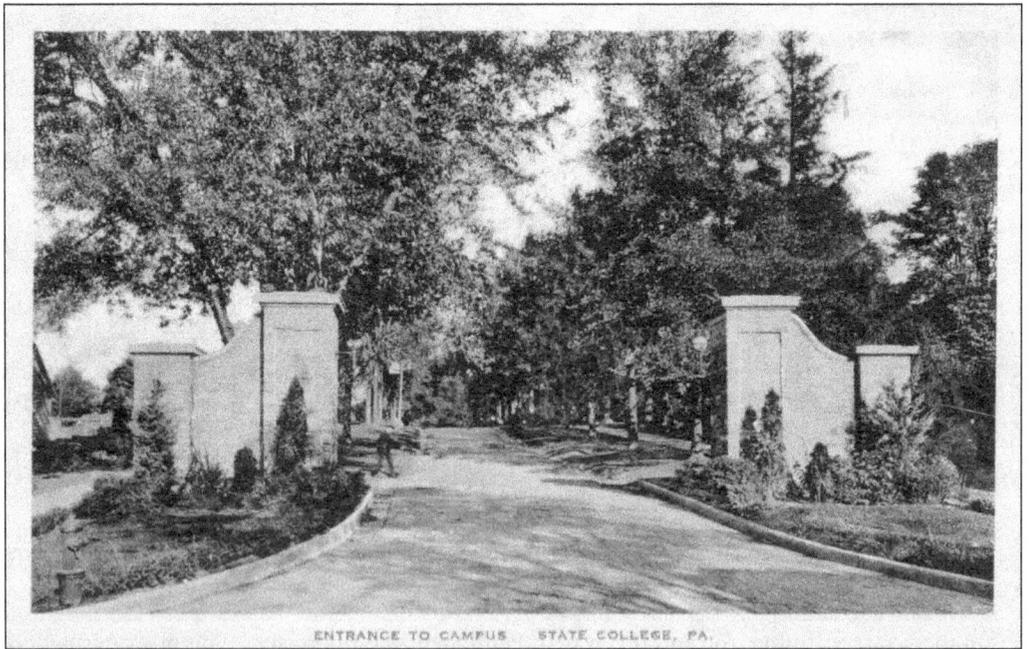

ENTRANCE TO CAMPUS STATE COLLEGE, PA.

The class of 1916's gift to the college was the reconstruction of the main entrance. The new pillars were constructed in 1917. Note the absence of the two lion statues (named Ma and Pa) that sat atop the old pillars. These were lost during the construction period.

12

PENN STATE®

Though the main entrance was closed to automobile traffic in 1924, an iron grill was added in 1930, effectively blocking the road into the heart of campus. The mall was then covered in grass, and the entranceway was only accessible by foot. Parts of the Hammond and Sackett Buildings are seen in the background. (Photograph by Robert L. Goerder.)

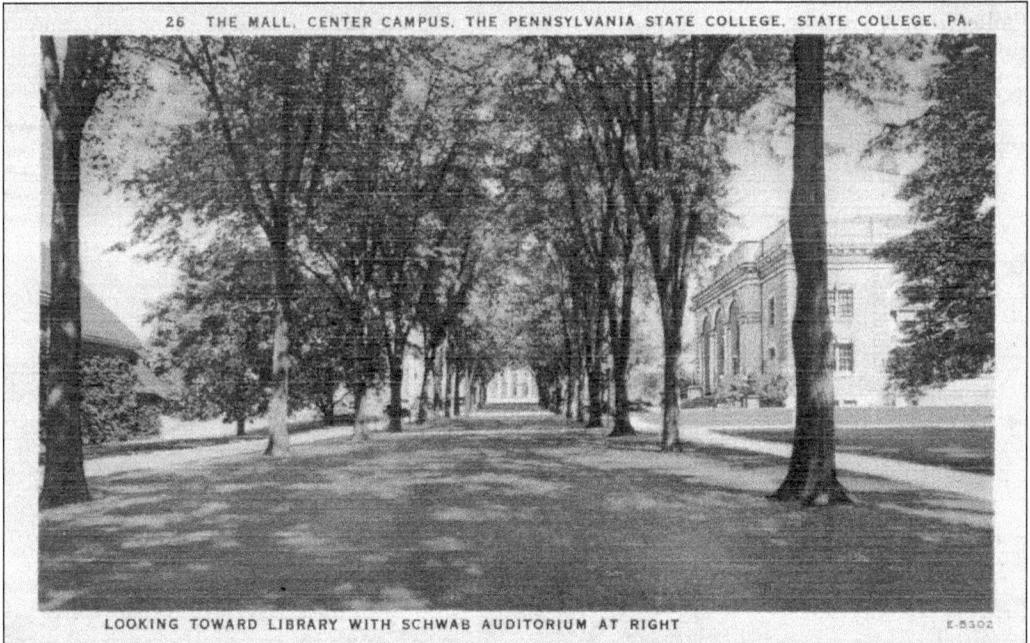

26 THE MALL, CENTER CAMPUS, THE PENNSYLVANIA STATE COLLEGE, STATE COLLEGE, PA.

LOOKING TOWARD LIBRARY WITH SCHWAB AUDITORIUM AT RIGHT

In this view looking north, the Armory is on the left, and Schwab Auditorium is on the right. The newly built Pattee Library can be seen in the distance at the very end of the mall. The sender of this 1942 postcard was correct in writing, "They have a beautiful campus here."

13

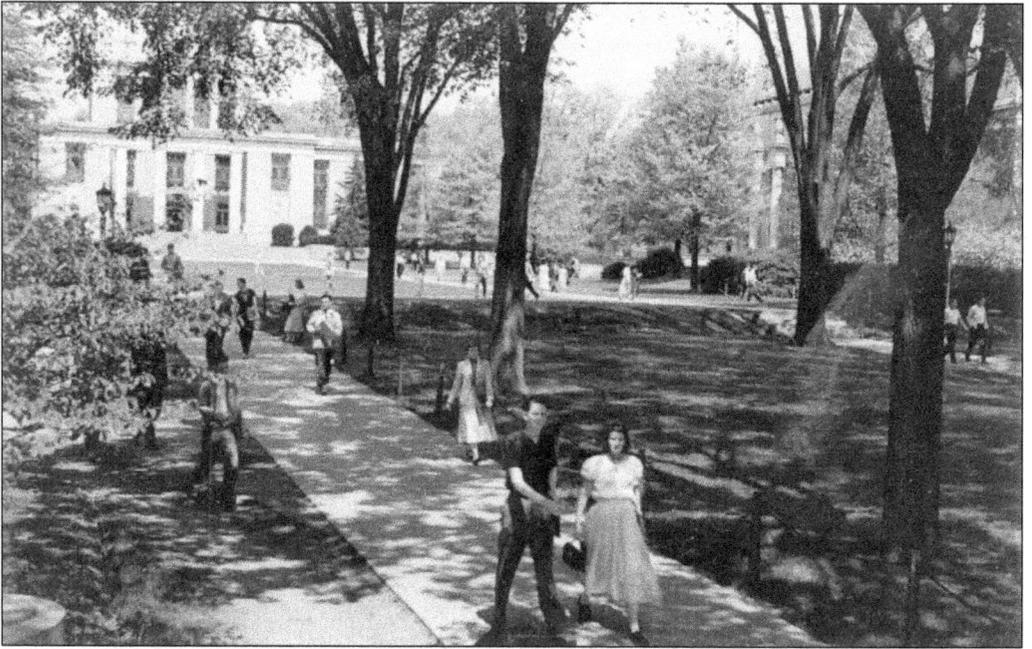

At the end of the walkway up the mall is the Pattee Library (now Pattee-Paterno Library), with Burrowes Building to the right. Both scenes must have been taken in between classes, as students and professors alike are shown strolling to their next classes. Unfortunately, quite a few of the elms contracted Dutch elm disease or elm yellows disease and had to be removed. Wood from the fallen trees has been used to make assorted Penn State souvenirs through the Penn State Elms Collection. A portion of the proceeds from the sale of these items is used to plant replacement trees. (Photographs by Richard C. Miller.)

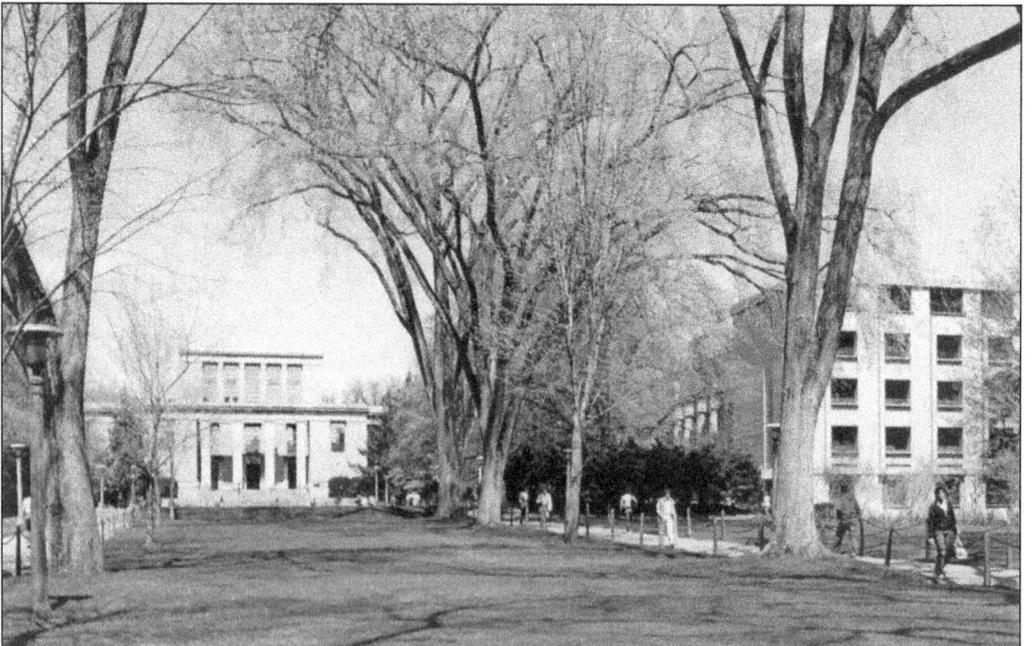

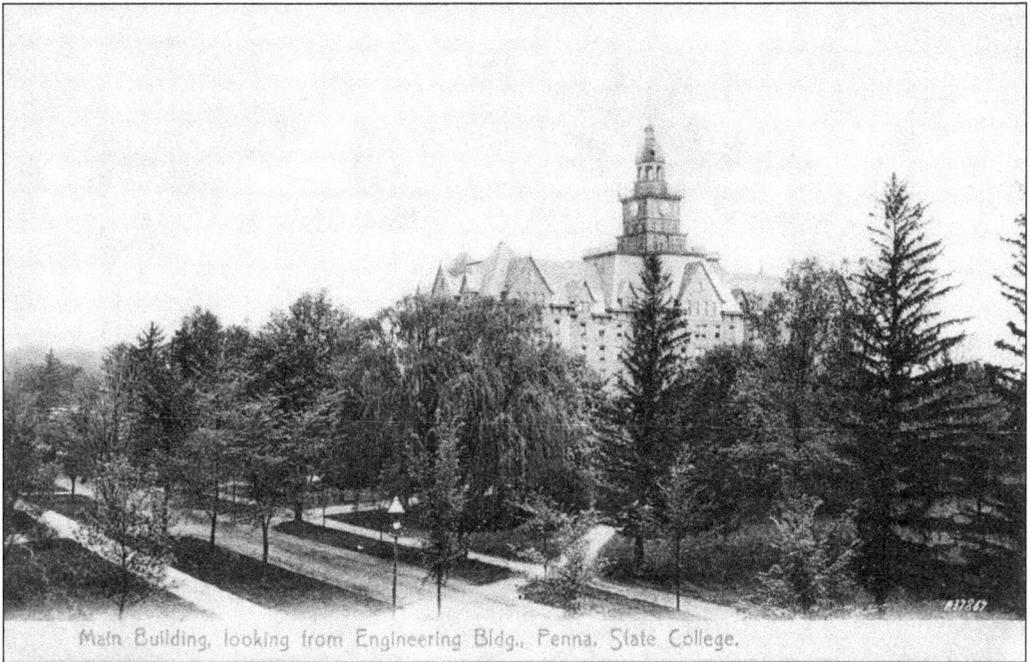

Main Building, looking from Engineering Bldg., Penna. State College.

As mentioned before, there once was a road extending from Allen Street to Old Main, Schwab Auditorium, Carnegie Building (Library), and the Armory. In this 1909 view from the Old Engineering Building, young elm trees line the original entrance road, along with a much older weeping willow tree.

Another scene from 1909 provides a better view of the tree known as "Old Willow," pictured here next to a young elm. Prof. William Waring planted Old Willow in 1858. It was actually a cutting from one of Alexander Pope's willow trees in England that newly appointed president Dr. Even Pugh had brought with him when he started his position at Penn State.

OLD MAIN

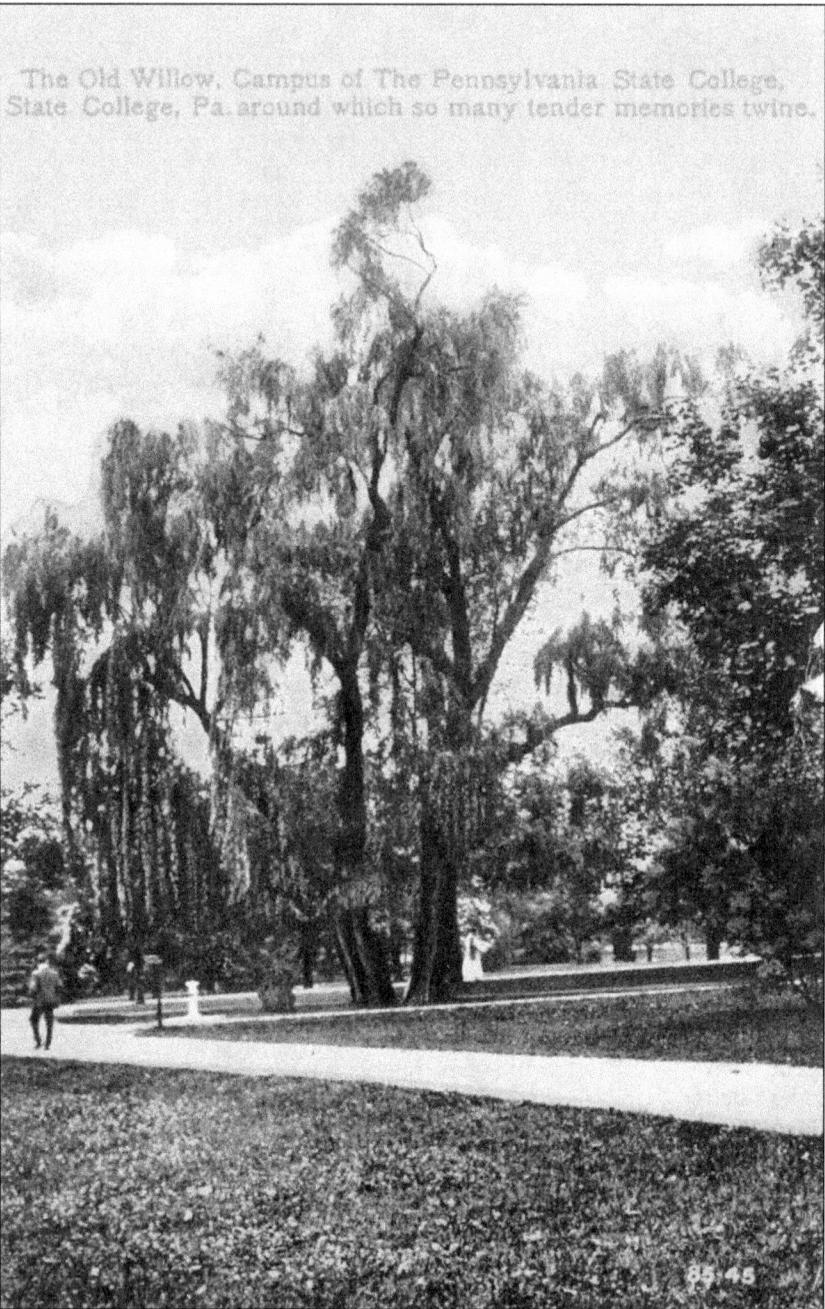

The Old Willow, Campus of The Pennsylvania State College, State College, Pa. around which so many tender memories twine.

Old Willow served as a meeting place for students for many years until it was decimated during a storm in the early 1920s (multiple sources have stated a date from 1921 to 1923). After Old Willow was destroyed, numerous cuttings were planted in the same spot. The last of those planted in that area survived until 1976, when disease felled the offspring. Other descendants of Old Willow can be seen in the Arboretum at Penn State, at the homes of former trustees Anne Riley and George Henning, and just east of Old Main. In this scene postmarked 1916, the water fountain to the left of the tree was a gift from the class of 1914 and no longer exists. A historical marker now identifies where Old Willow once stood.

16

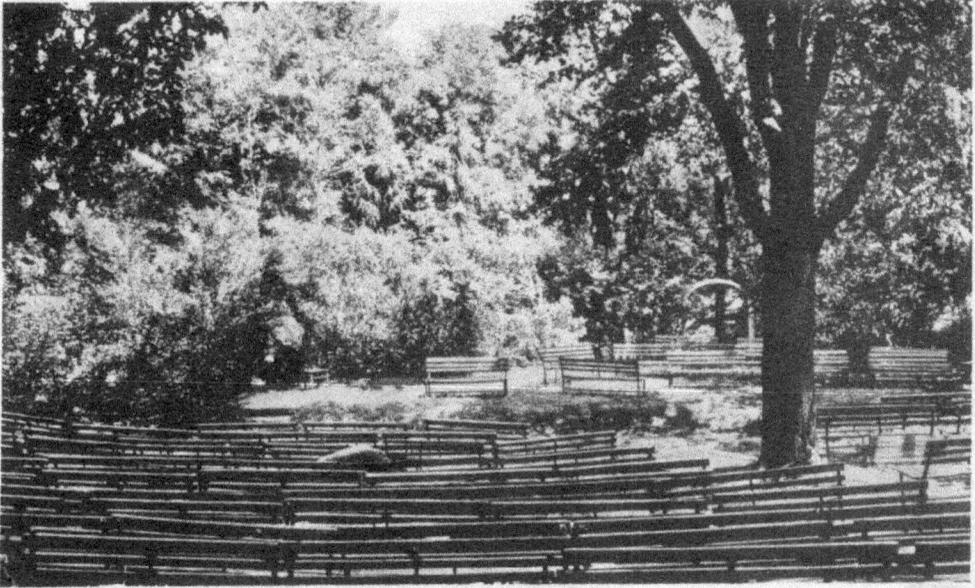

OPEN AIR THEATRE, PENNSYLVANIA STATE COLLEGE, STATE COLLEGE, PA.

When the original Old Main was built, limestone was excavated from its front lawn. One area in particular was cleared, and a dip in the landscape occurred. This dip made a natural open-air theater in the southeast corner of the lawn. A historical marker identifies the location of the quarry and, in essence, the site of the theater.

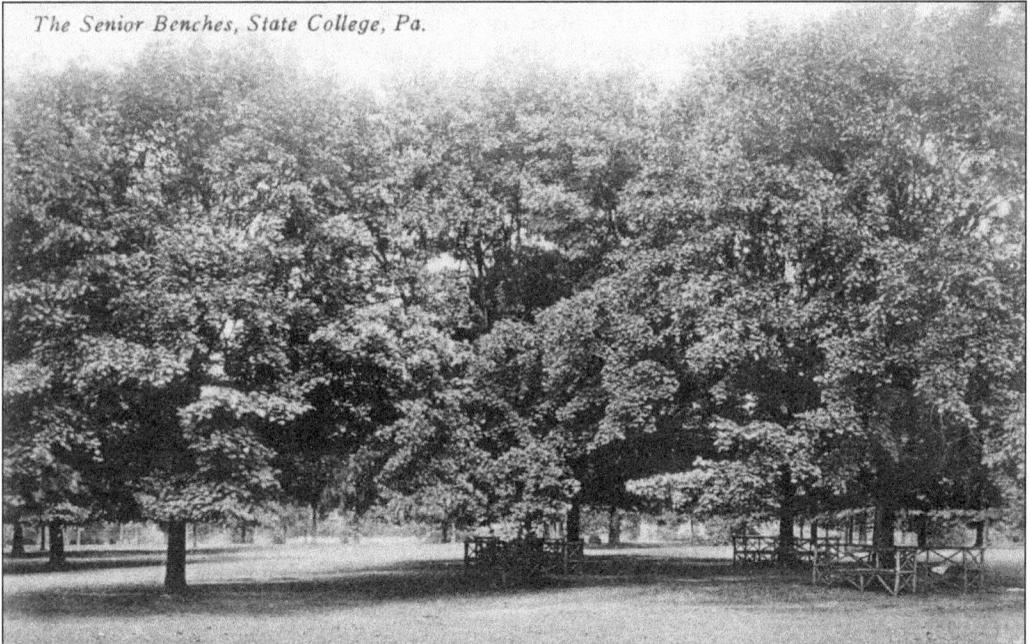

The Senior Benches, State College, Pa.

The class of 1900 gifted 50 benches to the college, as well as a portrait of George W. Atherton. A portion of what were called the Senior Benches is pictured here. This card was postmarked in October 1911.

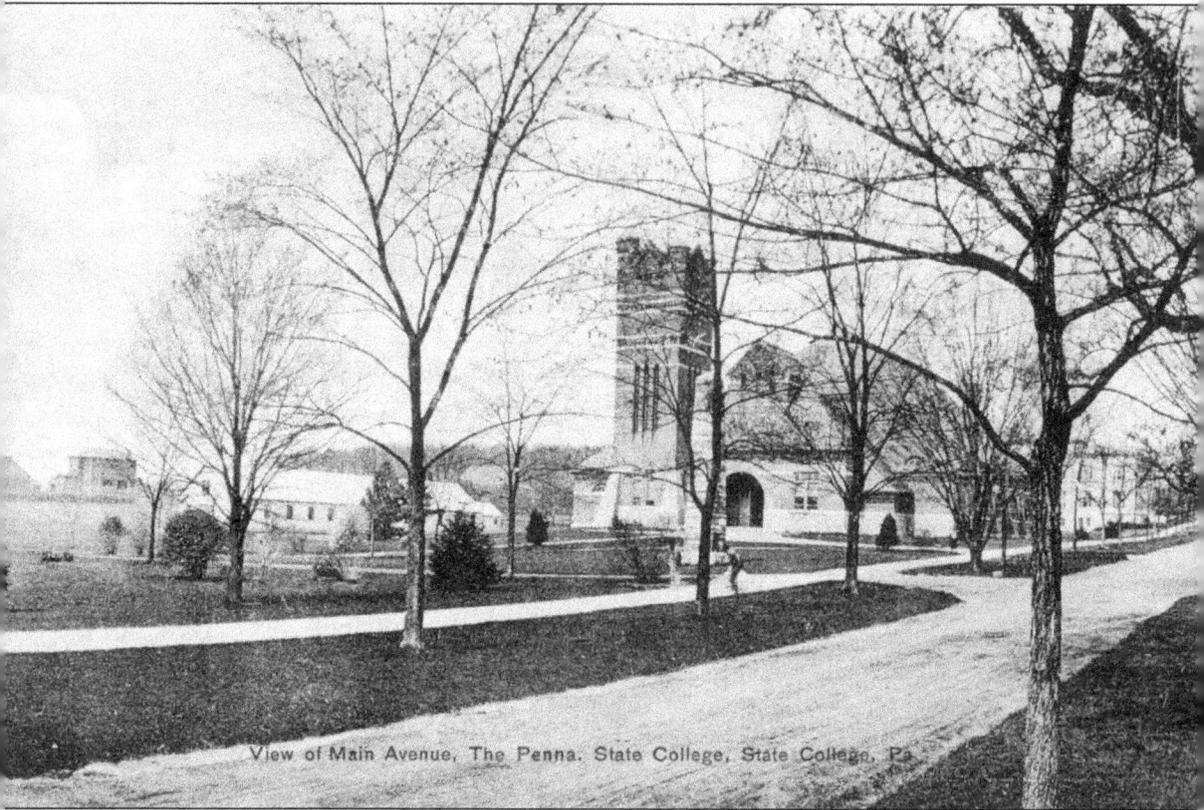

View of Main Avenue, The Penna. State College, State College, Pa.

This oversized postcard shows Penn State as it appeared in 1908. On the left side of Main Avenue, which is currently the mall leading to the Pattee-Paterno Library, are the Obelisk (originally known as the polylith) and the Armory, with the Carnegie Building just behind it. To the far left is an open area where military maneuvers were held. On the right side of the road is

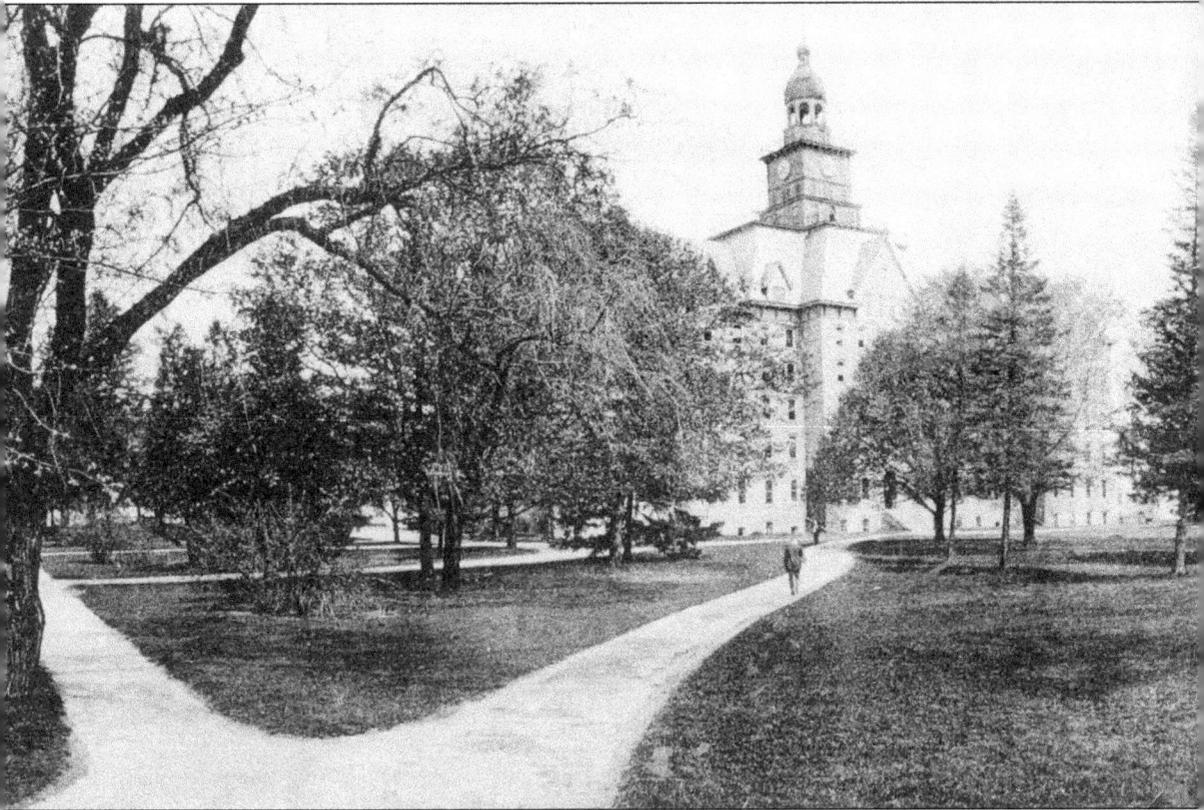

the pathway to the original Old Main. This street view also shows the elm trees at an early age, along with a young willow tree at right. A note written on the back of the card states, "Buy a Sunday North American on the 22, and read all about State College football team of 1908." This postcard was sent to a recipient in Hanover, Pennsylvania, on November 19, 1908.

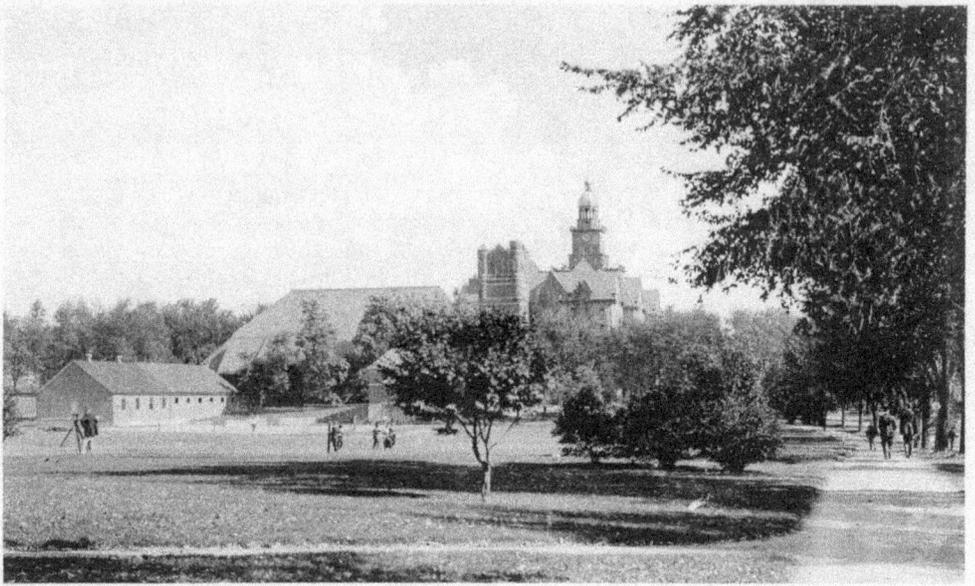

ARMORY AND OLD MAIN FROM PLAYGROUND. STATE COLLEGE, PA.

In another scene from the west side of campus, the top of Old Main and the tower of the Armory can be seen above the trees. At the time, this section of campus was known as the "playground." The tennis courts are visible beside the building to the left. The open space near the Armory was used for military exercises.

The Ghost Walk, a secluded pathway lined with dense trees, started behind the Botany Building, then traveled through what is now the Burrowes Building and past the library, and ended near the Music Buildings and the Schultz Child Care Center. It no longer exists due to construction of those buildings. (CPCCCHS.)

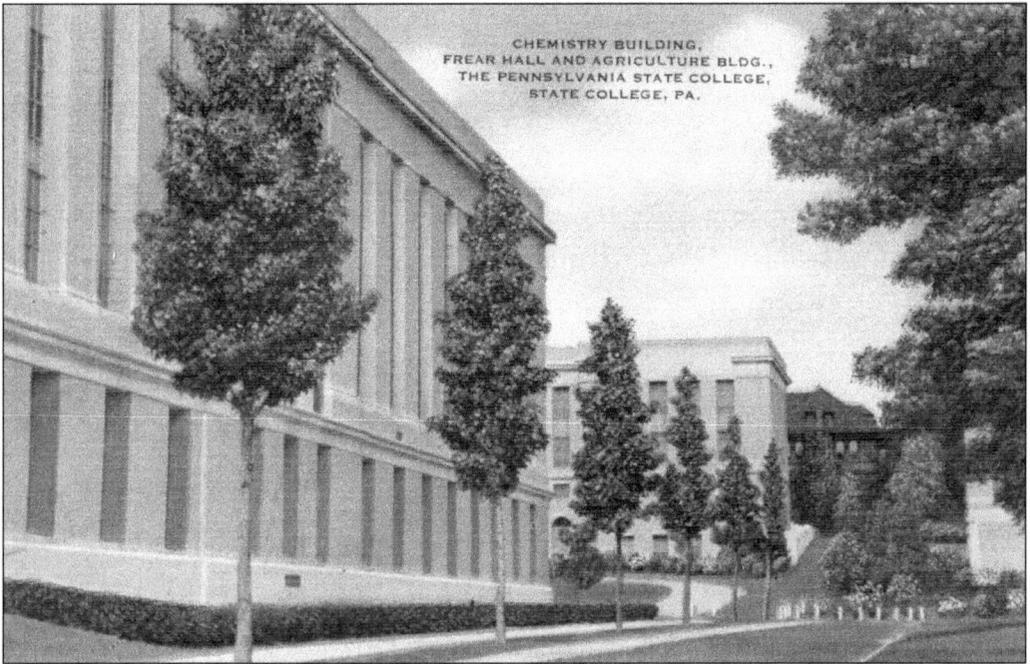

CHEMISTRY BUILDING,
FREAR HALL AND AGRICULTURE BLDG.,
THE PENNSYLVANIA STATE COLLEGE,
STATE COLLEGE, PA.

Three academic buildings are highlighted on this postcard. From front to back are the Chemistry Building (now Pond Laboratory), Frear Hall (now Frear Laboratory), and the Agricultural Building (now the Armbsy Building). A small sliver of Buckhout Laboratory can also be seen at right.

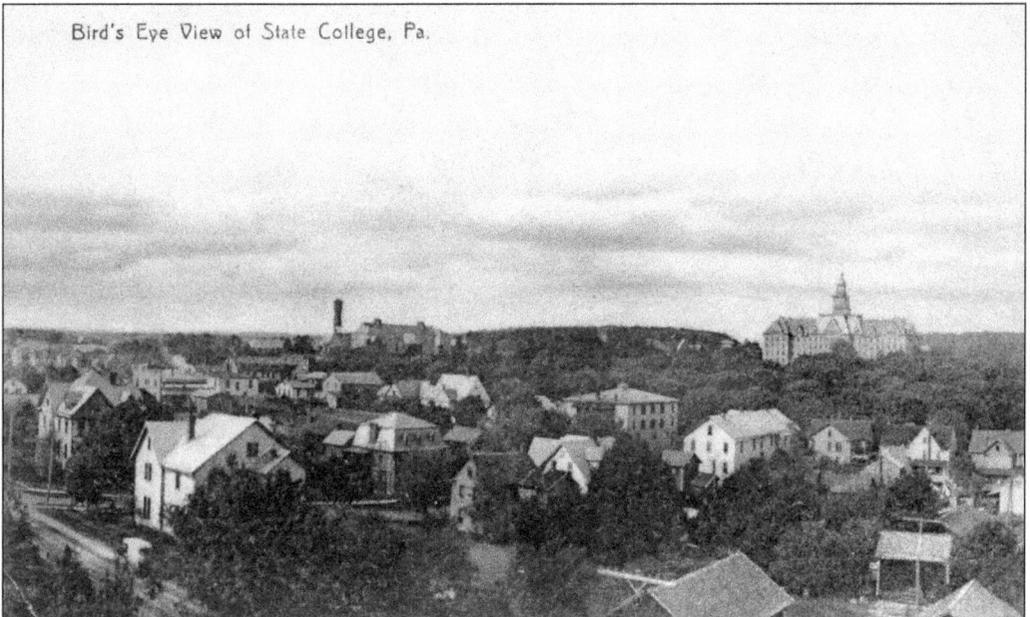

Bird's Eye View of State College, Pa.

In this view of Penn State looking from State College, Old Main is the major building seen to the right, with what was then a newer roof. Near the smokestack at the center is the top of the Old Engineering Building. This card was postmarked on January 8, 1912.

21

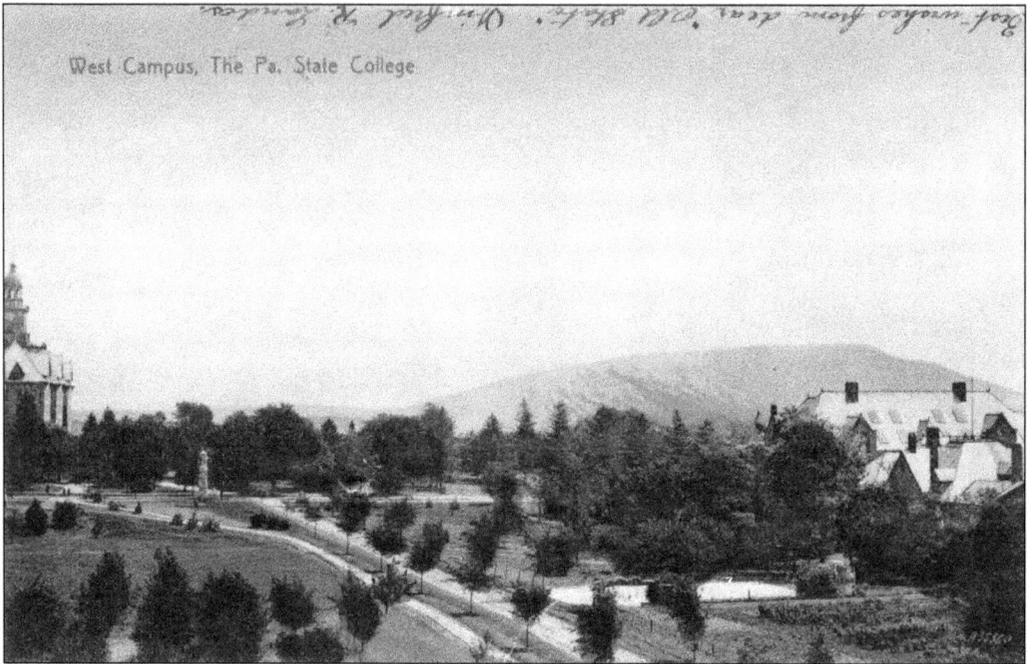

This scene from the west depicts the campus at a similar point in time. To the left is the Obelisk (called the polylith when first created), as well as the side of Old Main, and to the right is the President's House, with the larger Old Engineering Building behind it.

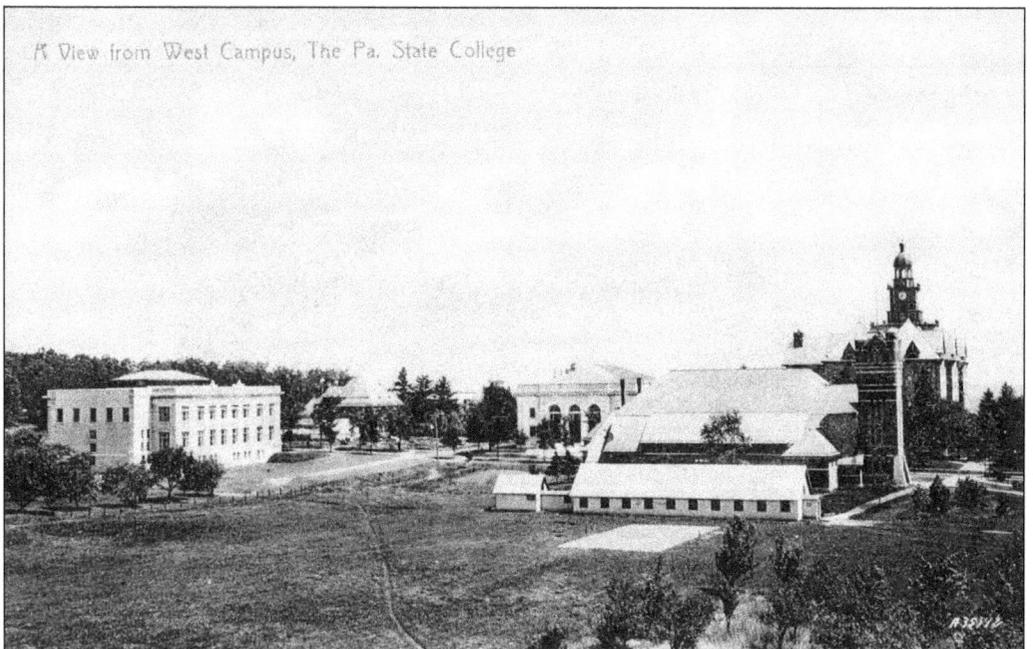

In the northward continuation of the previous card is the open area beside the Armory, where military exercises were once performed. Also present is the newly constructed Carnegie Library at left and Schwab Auditorium at center. The roof of the Botany Building can be seen between these two structures. (CPCCCHS.)

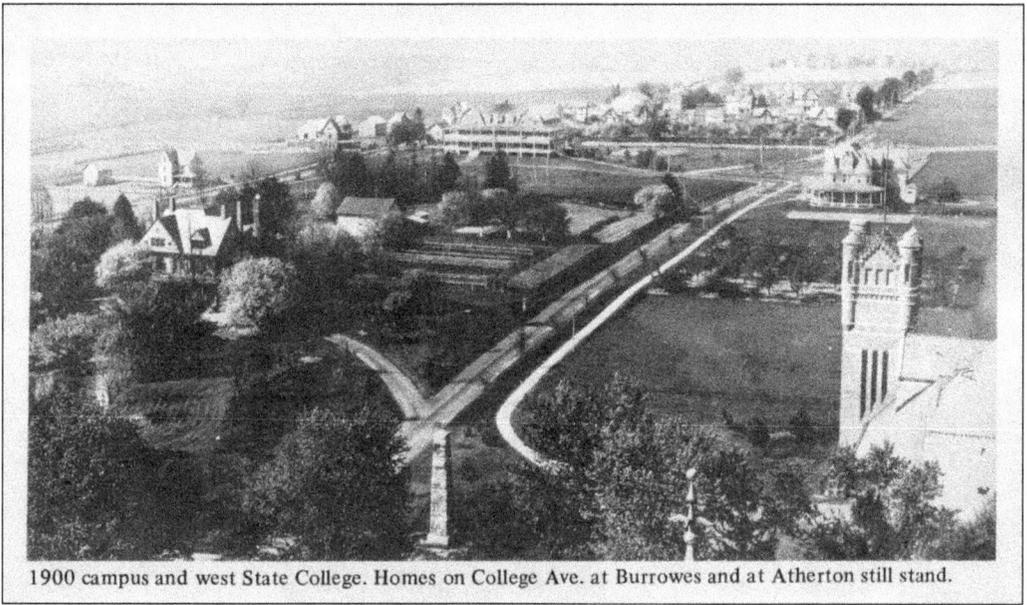

1900 campus and west State College. Homes on College Ave. at Burrowes and at Atherton still stand.

In this view looking west from the Old Main tower in 1900, part of the Armory is to the right, the Obelisk is in the center, and the President's House is to the left. The town of State College is just starting to become established. This postcard was printed from a photograph of the Penn State Collections for the Central Counties Bank.

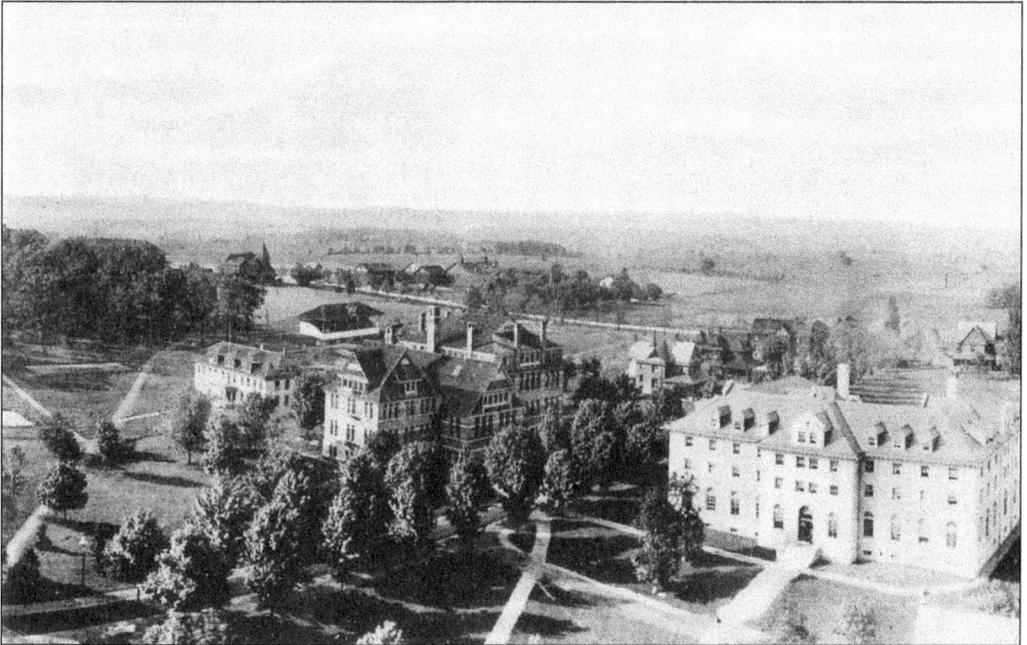

Looking northeast from the Old Main tower is a view of McAllister Hall (dormitory at the time) and the Chemistry and Physics Building in the early 1910s or late 1800s. Behind the Chemistry and Physics Building is the grandstand of the old Beaver Field. The three cottages at the edge of Beaver Field were used for faculty and visitors. (CPCCCHS.)

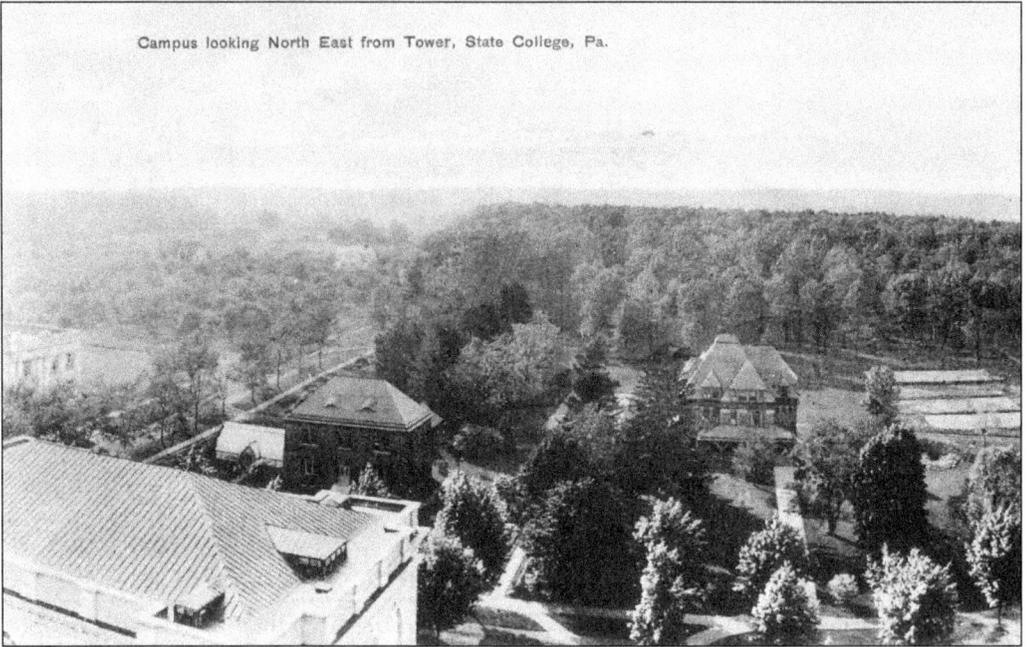

This view looking north from the Old Main tower is also from the early 1910s or late 1800s. The Ladies Cottage is near the center. To the left are the Botany Building, the roof of Schwab Auditorium, and a small section of the Carnegie Library. (CPCCCHS.)

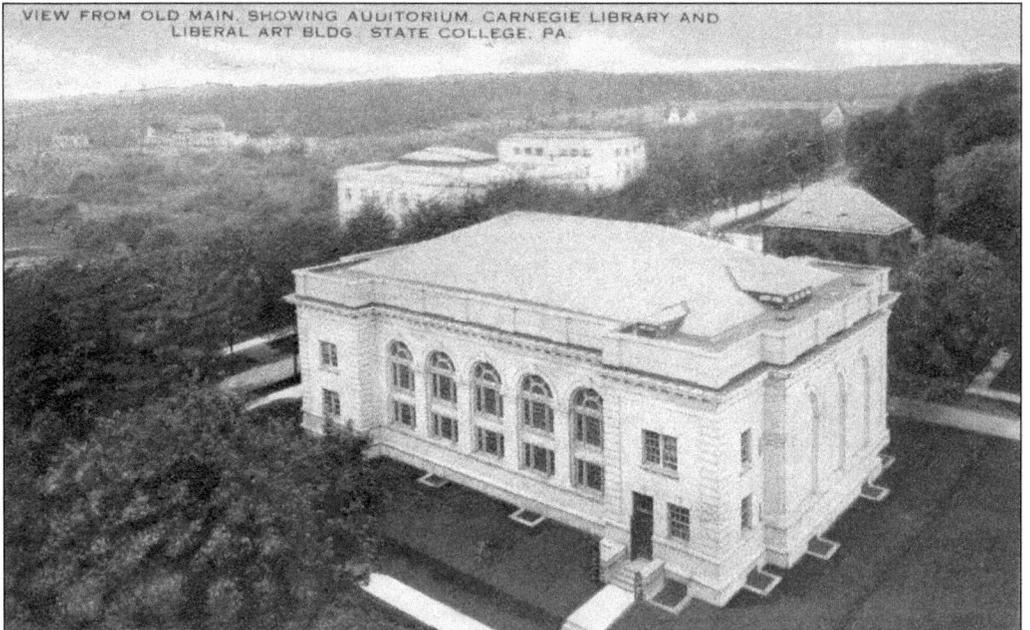

In this view looking northwest from the Old Main tower in 1918, Schwab Auditorium is in the foreground, along with the top of the Botany Building. Behind them are the top of the Carnegie Building (still the library at the time) and the top of the Liberal Arts Building (later part of the Sparks Building). The Liberal Arts Building was constructed between 1915 and 1916.

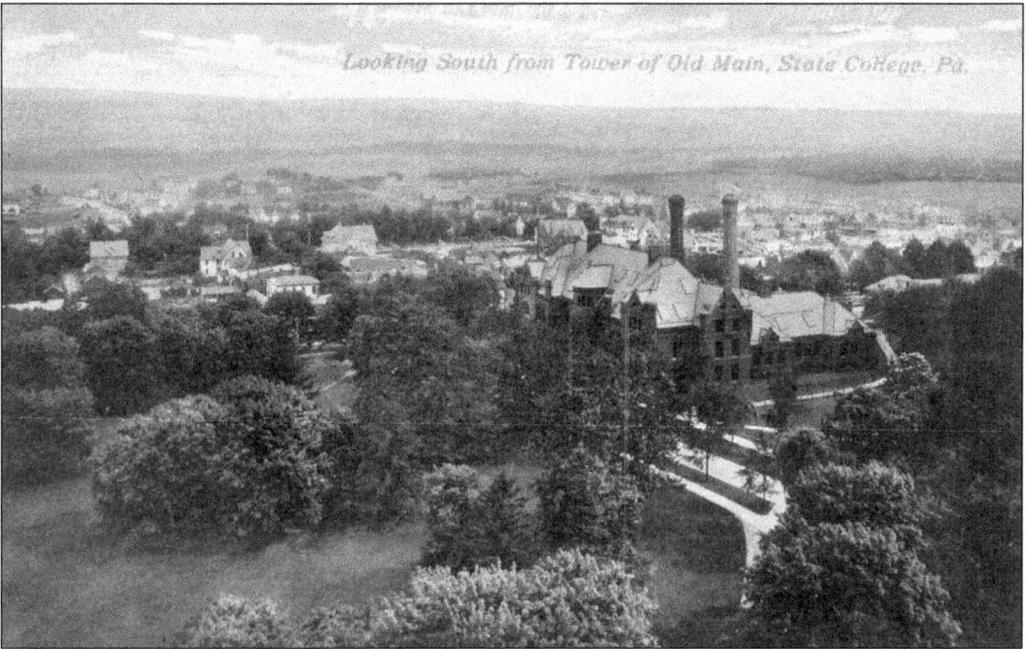

This view looking south from the original Old Main tower shows the massive size of the Old Engineering Building in 1910. To get an idea of scale, compare the size of this building to the homes in downtown State College.

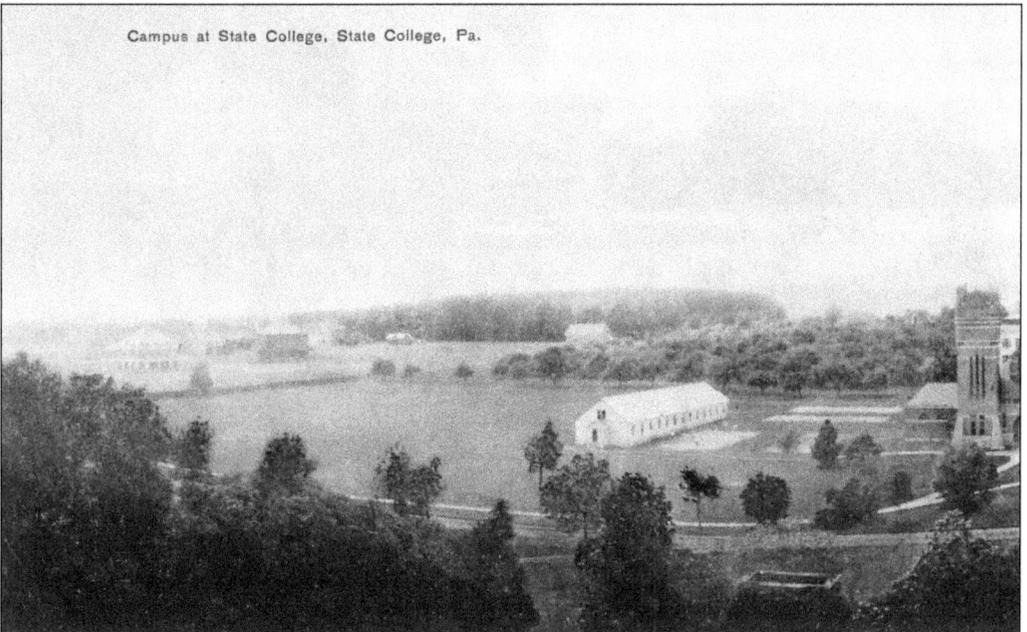

This postcard shows the open area to the west of the Armory, the tower of which is seen to the right. Next to the Armory tower are a tennis court and a long one-story building, which might have been used to store equipment. (CPCCCHS.)

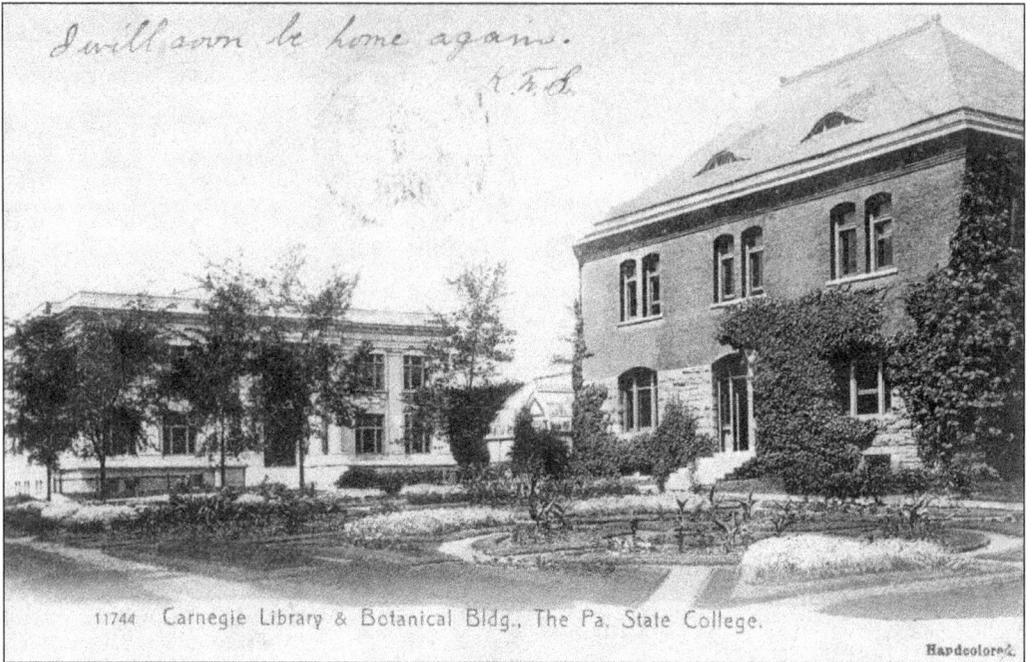

I will soon be home again.

11744 Carnegie Library & Botanical Bldg., The Pa. State College.

Handcolored

This postcard shows a closer view of the Botany Building. The beginnings of a flower garden are seen in front of the building, and a small part of the greenhouse is seen to the west. To the left is the Carnegie Library. This card was postmarked on February 12, 1908.

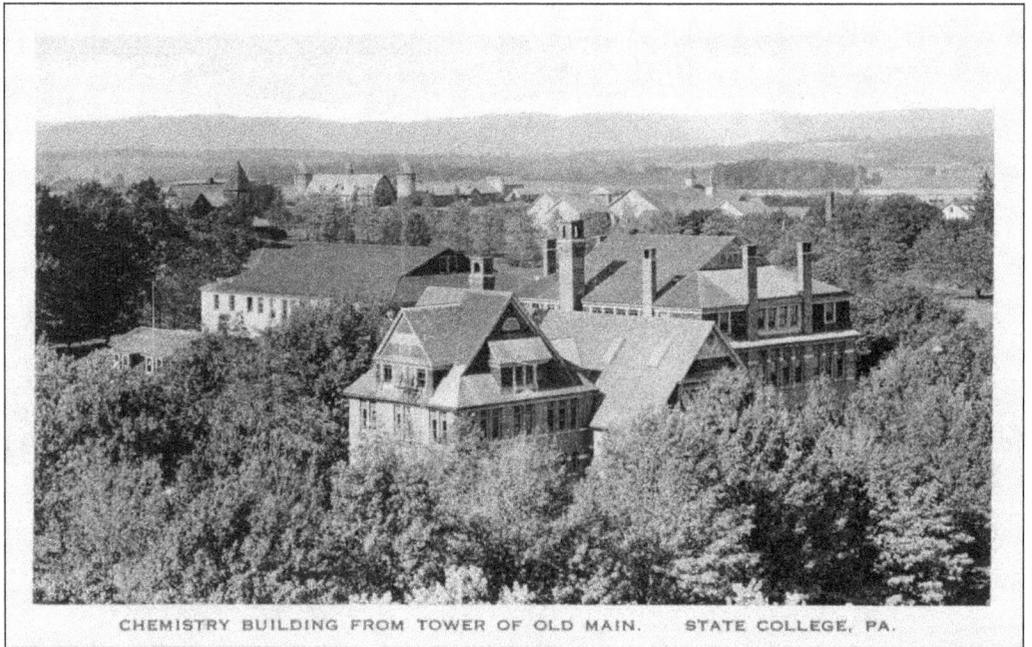

CHEMISTRY BUILDING FROM TOWER OF OLD MAIN. STATE COLLEGE, PA.

In this closer view of the Chemistry Building (later known as the Walker Building), the football field is no longer seen behind the structure. The field was moved to the northwest corner of campus in 1909. The barns in the distance mark the location of Ag Hill.

26

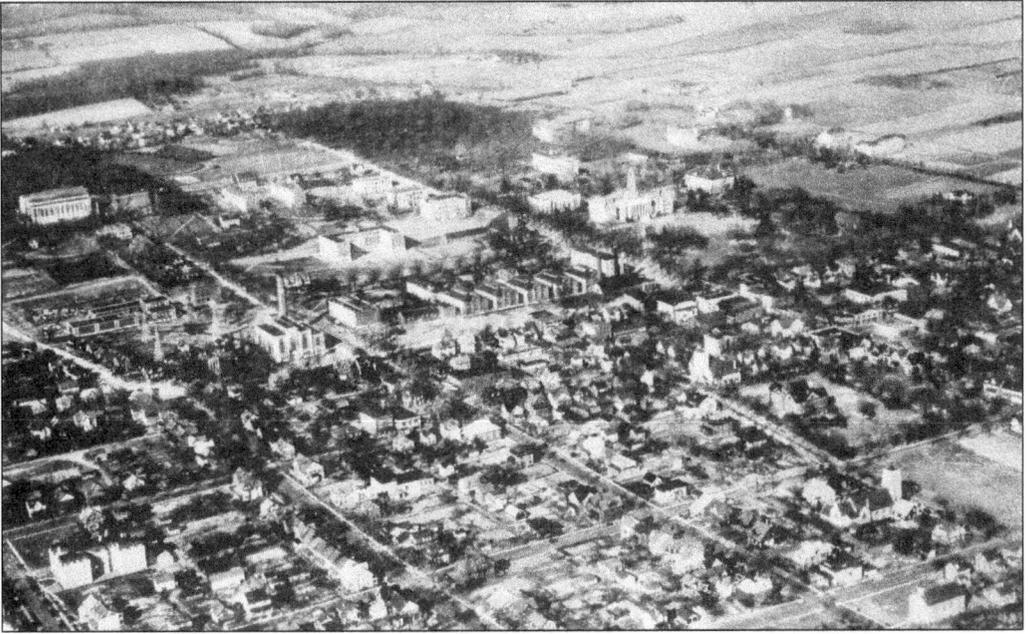

This aerial view of Penn State was taken in the 1930s, prior to construction of the Pattee Library in 1940. The major buildings seen to the left are Rec Hall and the Power Plant, which were erected in 1929 and 1931, respectively. Notice the C-shape of the Steidle Building in the center. A later addition would change its form to an E-shape. (CPCCCHS.)

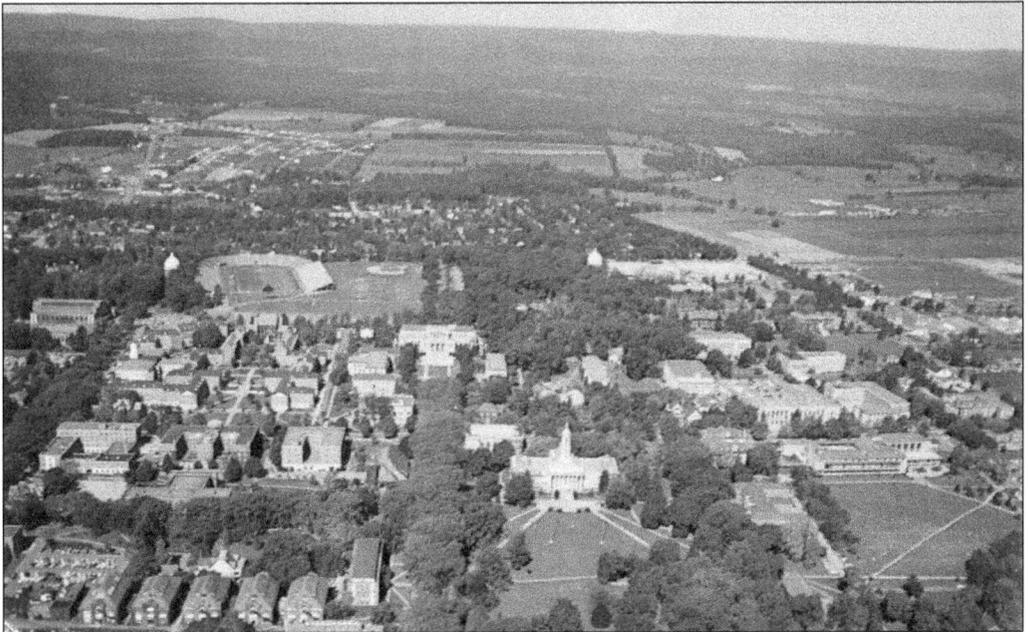

This view shows the campus sometime between 1949 and 1960. The precurser of Beaver Stadium once stood in the approximate location of the Nittany Parking Deck. In the 1930s, the wooden and concrete stands were replaced with steel. The stands were shaped like a horseshoe for the 1949 season. Beaver Field was moved to the east in 1960 and renamed Beaver Stadium. (Photograph by Richard C. Miller.)

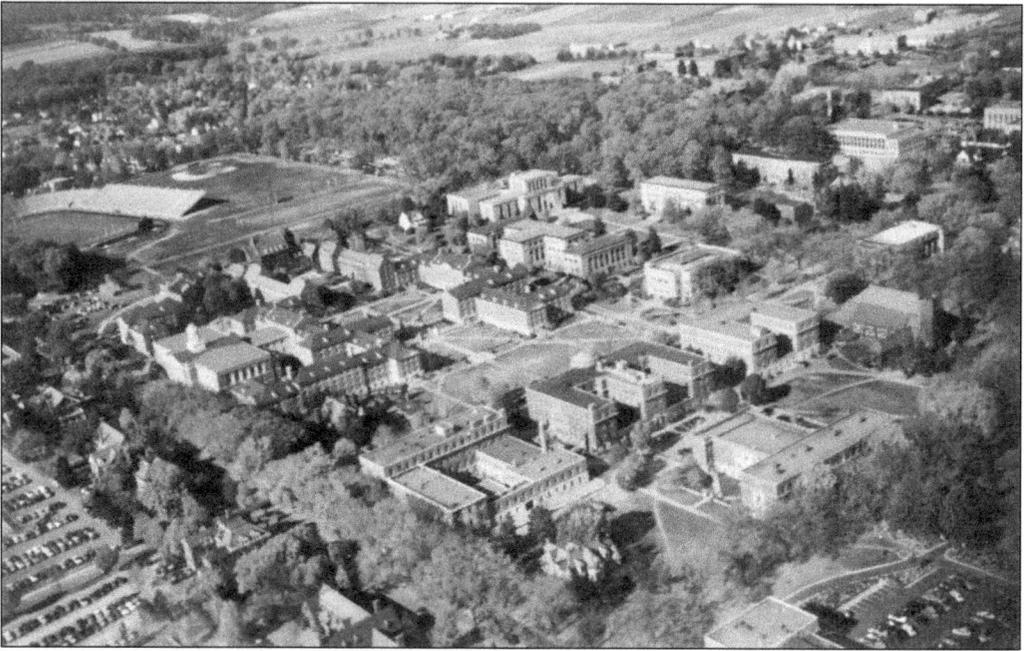

In this closer aerial view, the Steidle Building is now an E-shape, and Beaver Field is still located in the northwest corner of campus. In the center foreground is the second house of Beta Theta Pi. The fraternity's second house was razed to make way for the Deike Building, which was constructed between 1963 and 1964. (Photograph by Herbert Lanks.)

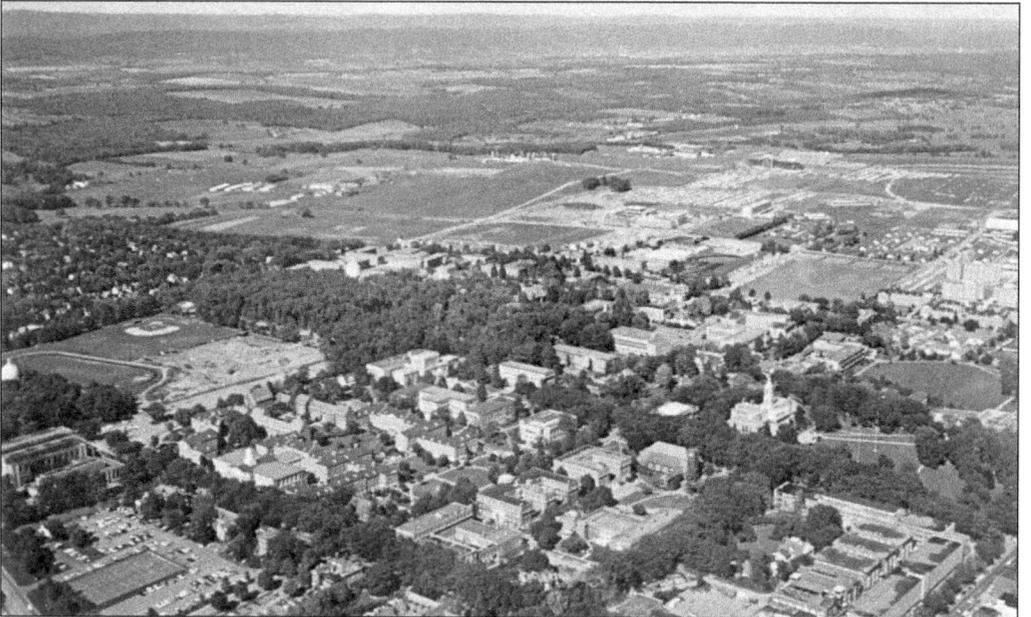

The university continued to expand through the second half of the 20th century, as seen in this view looking east. Even though the card was postmarked in 1966, the photograph must have been taken in the early 1960s. The Armory (replaced by the Willard Building in 1964) is still present, but Beaver Stadium (relocated in 1960) has been moved to the east, and a portion of East Halls (built from 1959 to 1967) has been established. (Photograph by Richard C. Miller.)

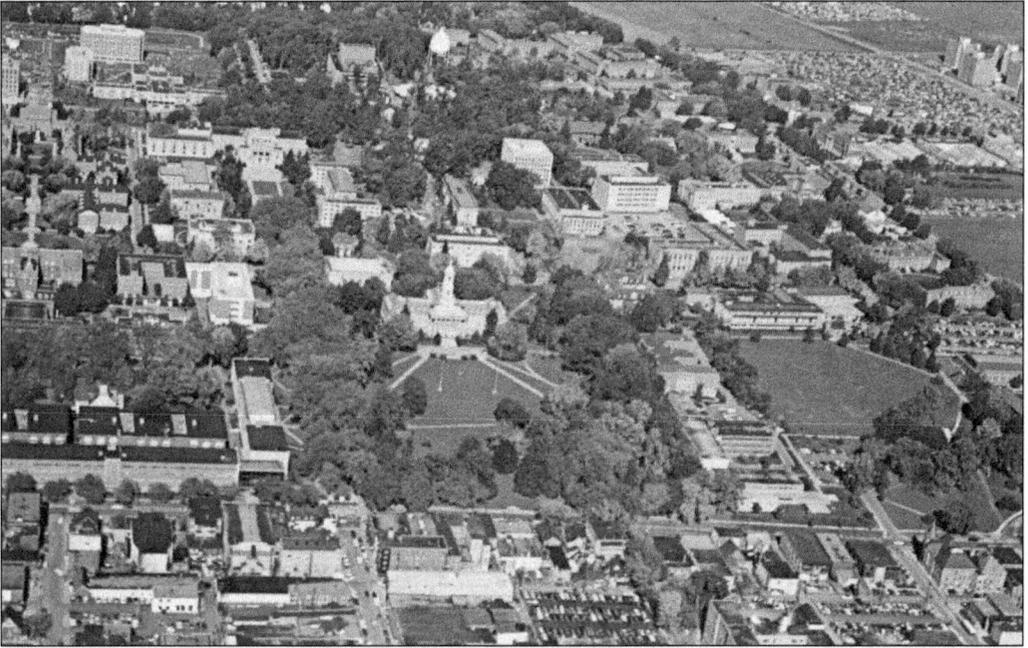

In this more contemporary scene, the Armory no longer stands to the left of Old Main, and the Willard Building has been enlarged to its current size. The expansion to the north has also begun, with the construction of Chambers, Rackley, and Moore Buildings. Part of East Halls is seen at upper right. (Photograph by Richard C. Miller.)

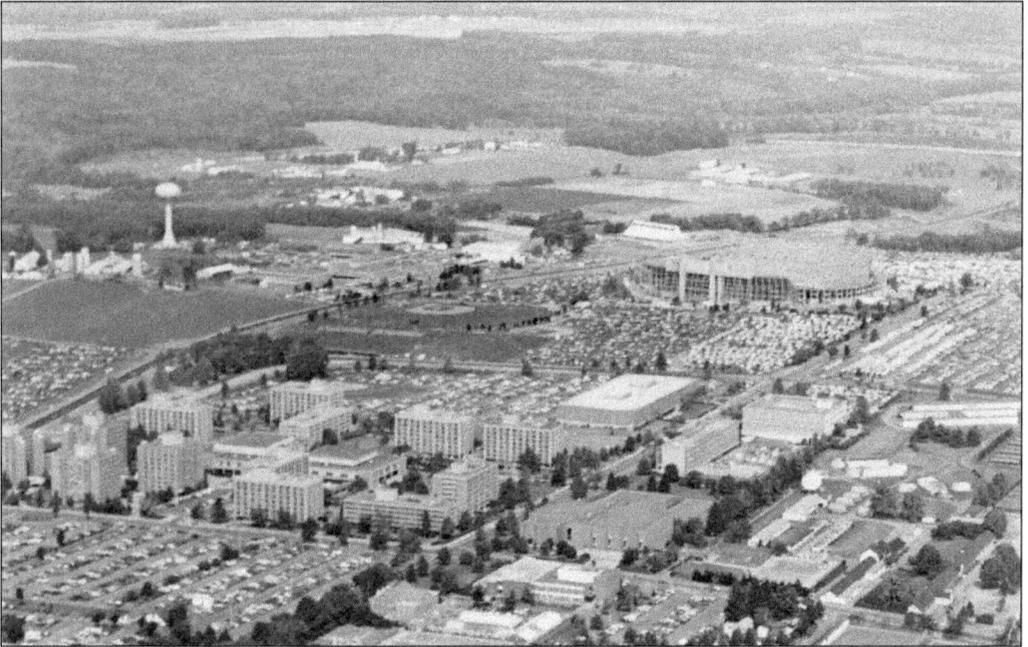

On this postcard, all of East Halls and Beaver Stadium are shown. This view was taken before any of the other decks were added to the stadium. The Natatorium, Shields, Wagner, and Intramural Buildings can also be seen. Next to East Halls was Lot 80, now the East Parking Deck. (Photograph by Bron Miller.)

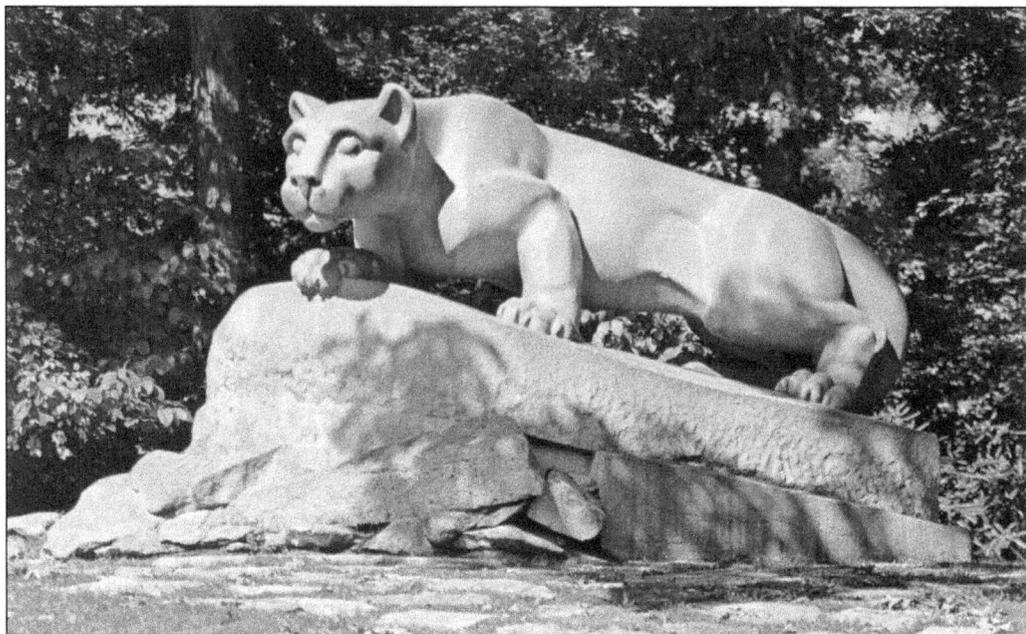

The Nittany Lion Shrine was a gift from the class of 1940. It was presented to the college at the homecoming game on October 24, 1942. Originally, the shrine was located near the entrance to Beaver Field. When the stadium was moved to the northeast corner of campus in 1960, the shrine remained in the northwest section of campus, across from West Halls. Heinz Warneke sculpted the shrine from a solid 13-ton block of Indiana limestone. The lion's right ear was defaced in 1978 when vandals used some sort of blunt instrument to chip it off the statue. Warneke returned to the university at the age of 84 to sculpt a replacement. Vincenzzo Palumbo, a master stonecutter, aided in the creation and reattachment of the new ear. (Photographs by Richard C. Miller.)

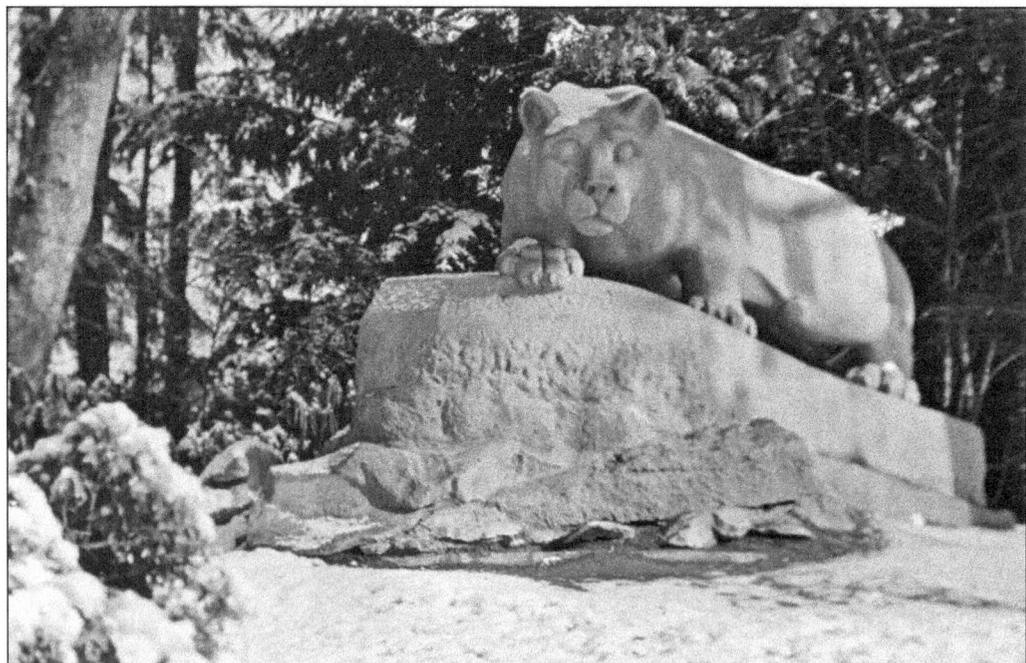

Two

WHERE LEARNING
TAKES PLACE

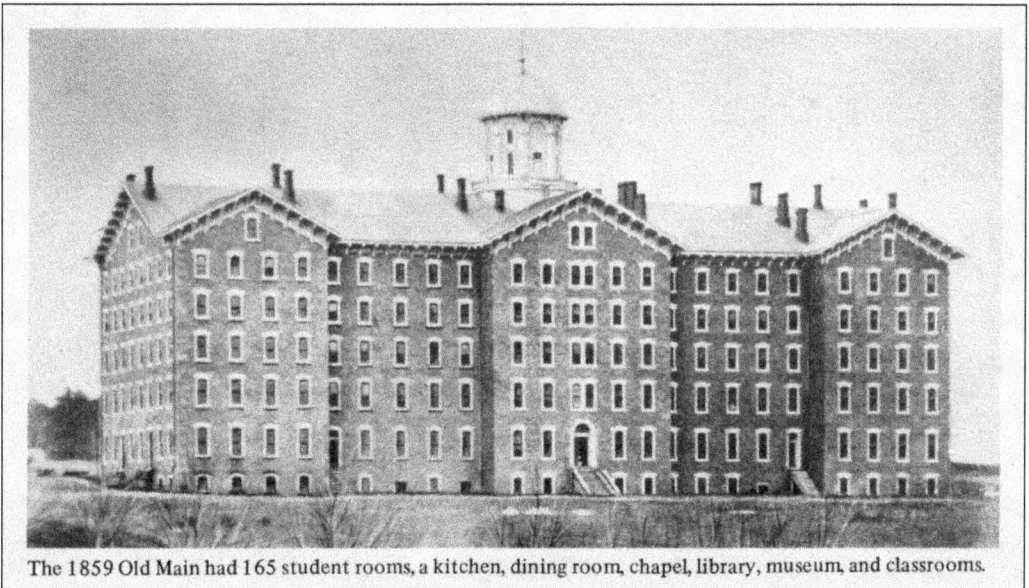

The 1859 Old Main had 165 student rooms, a kitchen, dining room, chapel, library, museum, and classrooms.

The original Old Main, constructed from 1859 to 1863, was still being completed when students first arrived. The all-purpose building housed dormitories, dining facilities, a museum, and a library. It was located in roughly the same spot as the current structure. This postcard was printed from a photograph of the Penn State Collections for the Central Counties Bank.

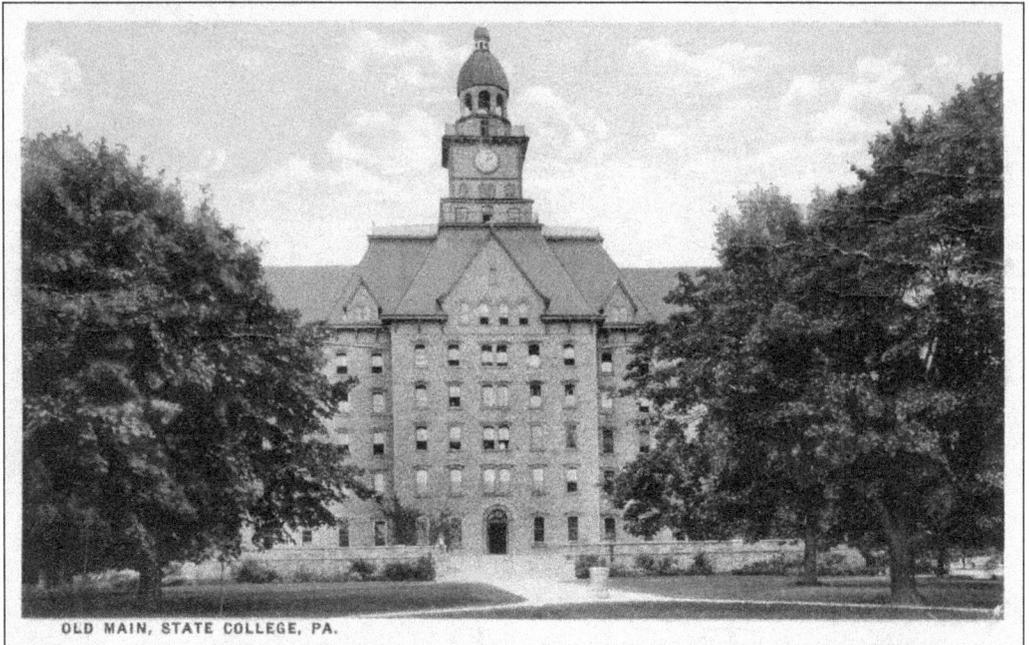

OLD MAIN, STATE COLLEGE, PA.

In 1892, a fire in Old Main destroyed part of its roof. When repairs were made to the structure, the roof and the upper floors were redesigned, and a bell tower was added. The building was also expanded to house more students and additional classrooms. For years, Old Main served as the only academic building.

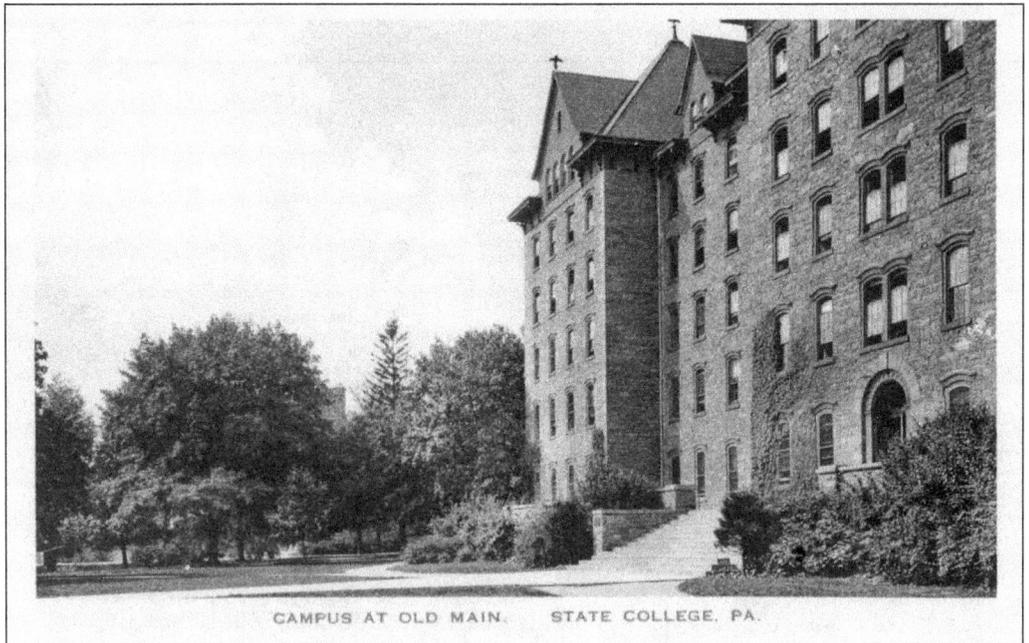

CAMPUS AT OLD MAIN. STATE COLLEGE, PA.

To this day, the lawn in front of Old Main has been left vacant for recreational use. This side view shows part of the front lawn. At five stories tall, the original Old Main (or College Building, as it was called during its first few years) was much larger than the current Old Main, which only has three stories.

32

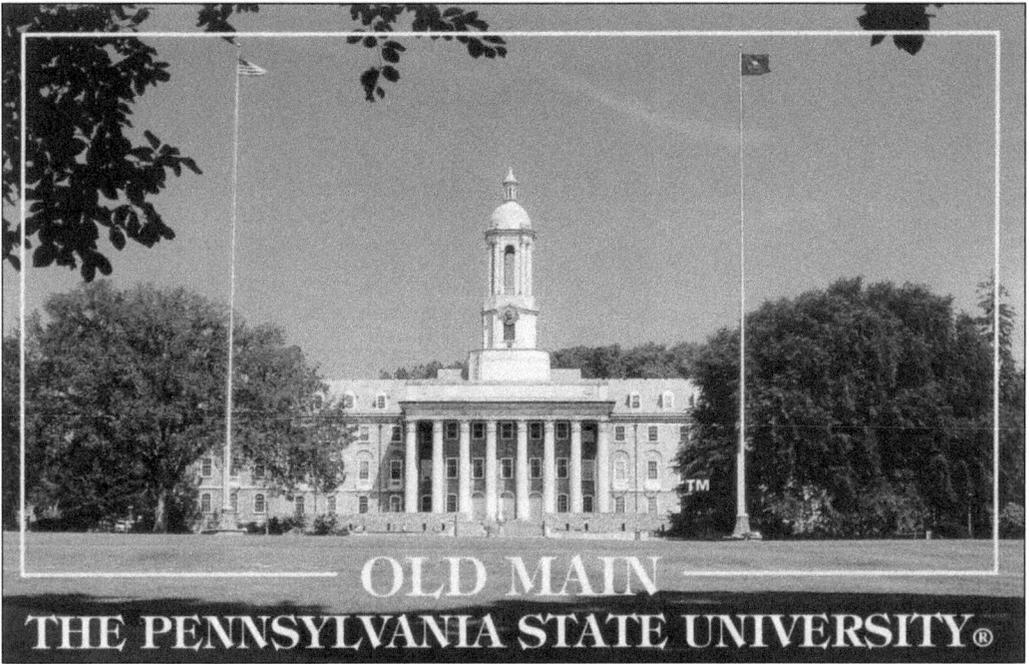

OLD MAIN

THE PENNSYLVANIA STATE UNIVERSITY®

In 1930, the new Old Main opened its doors to students and faculty. The new building was constructed using limestone from the original structure, which was dismantled due to its obsolete facilities. The dormitories and library in the building were no longer necessary. Old Main currently houses the Penn State administration. (Photograph by C.G. Wagner Jr.)

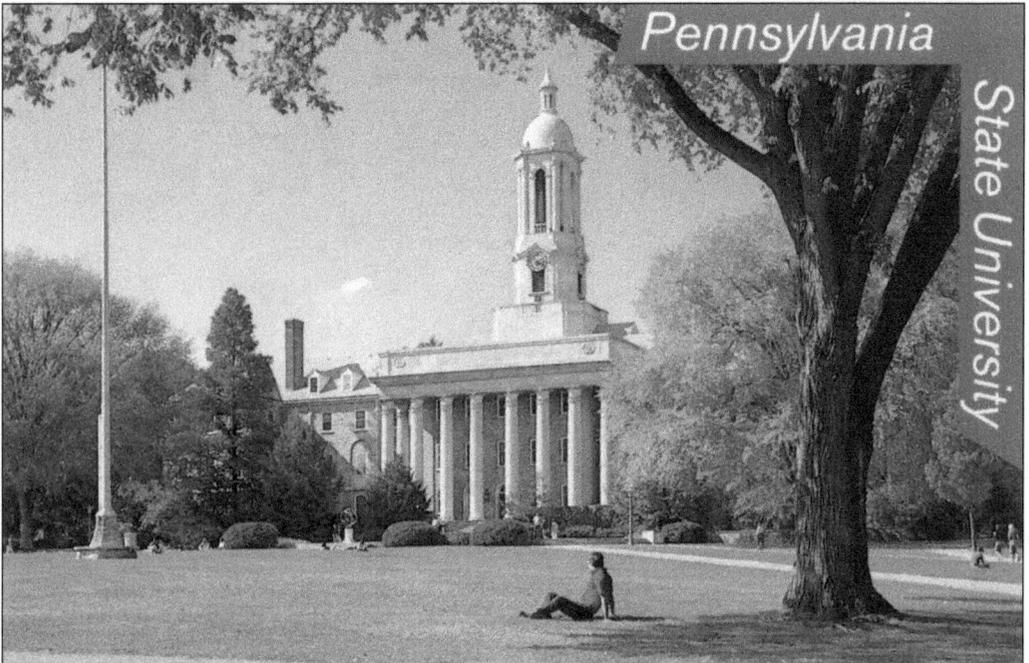

This more contemporary postcard shows the vast area in front of Old Main. Much of the student body has used the lawn to play pickup games of football and Frisbee or to relax and enjoy the sunshine and fresh air. Open-air concerts are also held on the lawn.

33

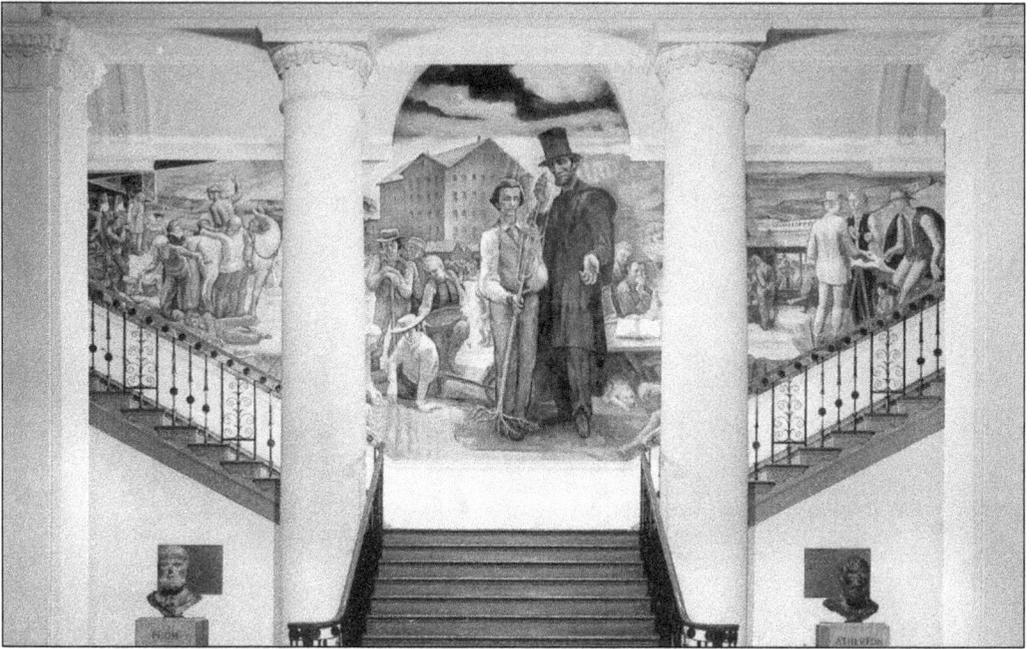

Visitors to Old Main can view the *Land-Grant Frescoes* mural by Henry Varnum Poor from the main entrance lobby. Penn State was designated a land grant institution in 1862 and benefitted from the sale of federally owned land. A gift from the class of 1932 and the undergraduate students of 1946, the fresco was painted during the years of 1940 to 1949.

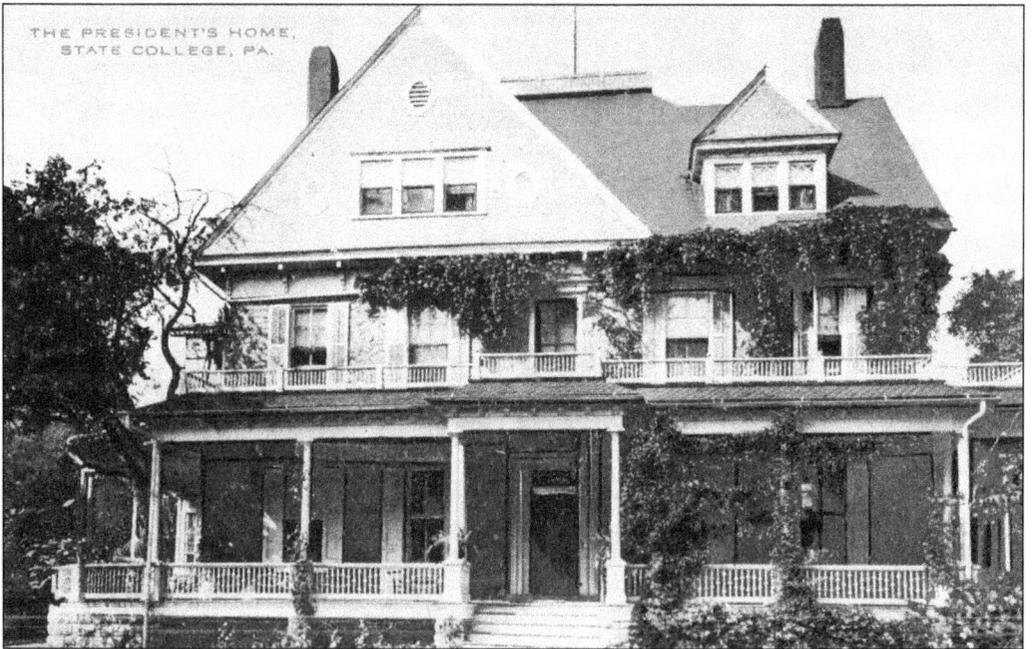

The President's House was built in 1864 for then president Evan Pugh. The residence would house the college president until 1969, when it was converted into a venue for social gatherings. It was renamed the University House in 1970, and with the construction of the Hintz Family Alumni Center, the building became part of the alumni complex in 2001. (CPCCCHS.)

34

Outside the Hintz Family Alumni Center (formerly the President's House, then the University House) is a garden and open space for students, alumni, and families to enjoy the outdoors. This view from one of the benches shows the back of the Sackett Building. To the left is the newer section of Sackett, while to the right is a portion of the original building. (Photograph by Barbara L. Clouser.)

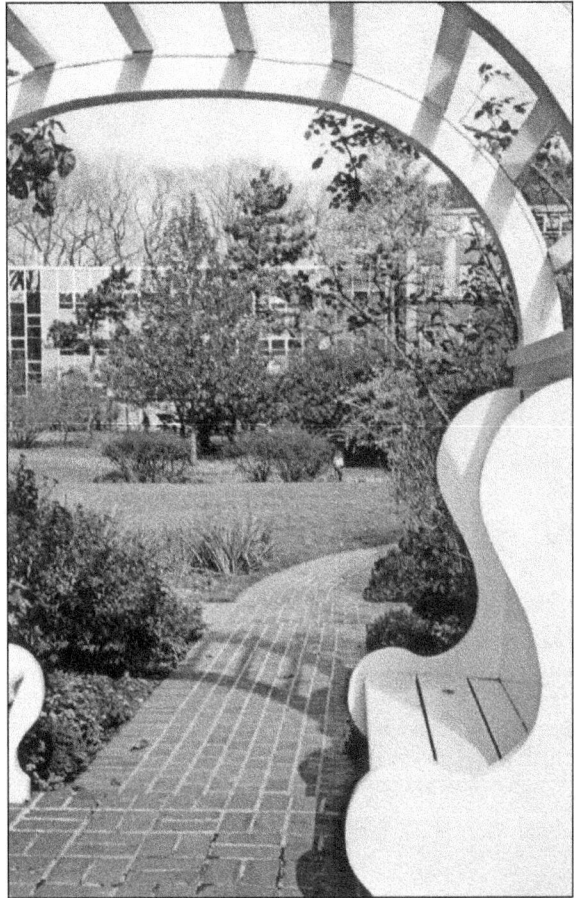

In this view of the Botany Building from 1916, the greenhouse and botanical gardens are still intact. Constructed between 1887 and 1888, the building still exists across the street from Schwab Auditorium and the Carnegie Building, but the greenhouse was removed in 1930.

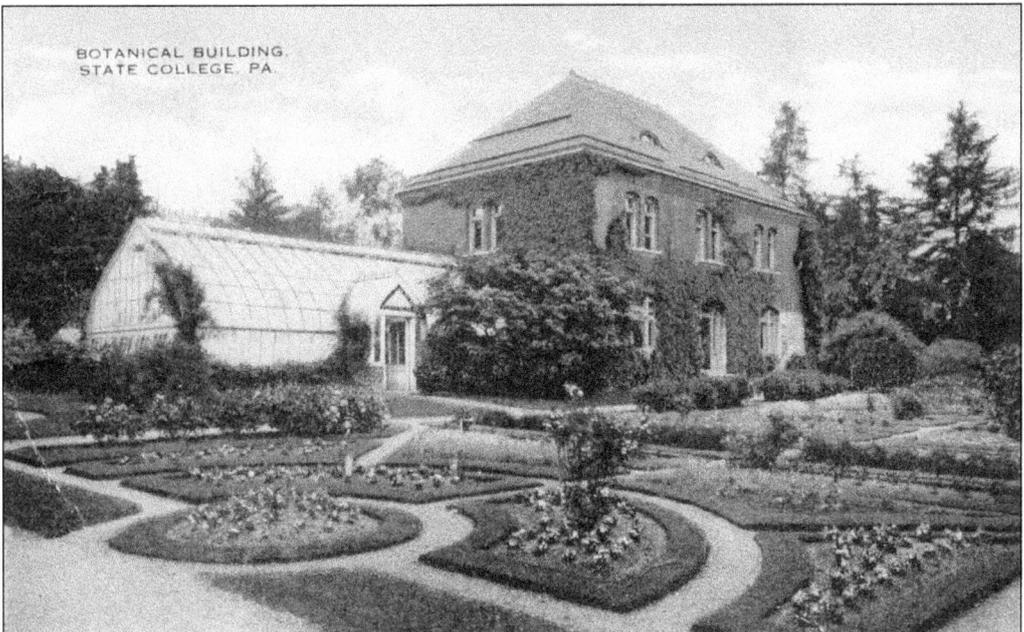

BOTANICAL BUILDING.
STATE COLLEGE, PA.

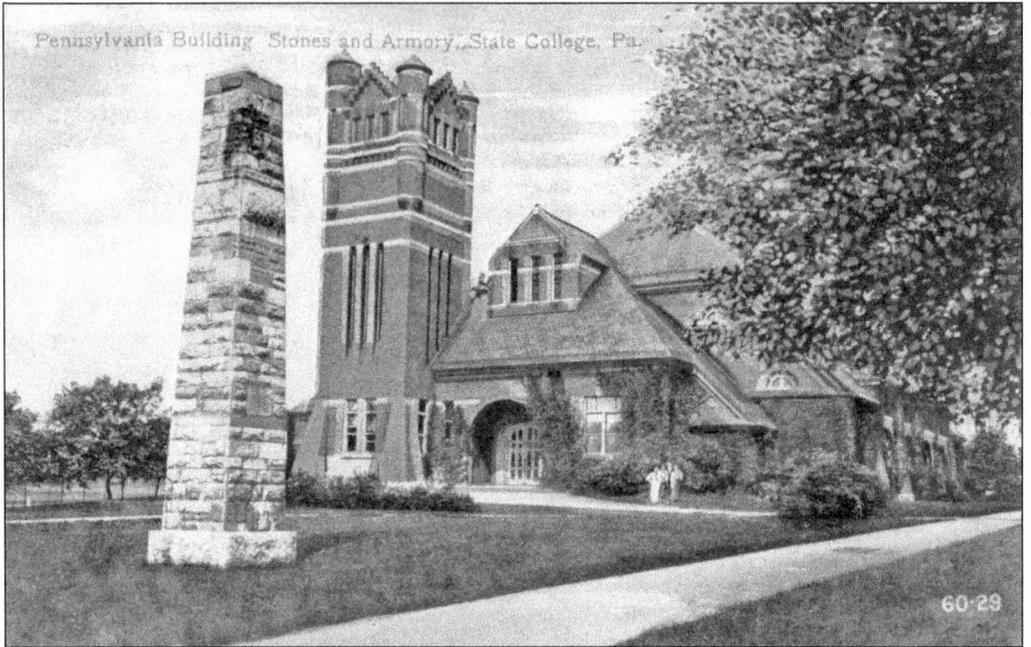

Built from 1888 to 1892, the Penn State Armory was located next to the Obelisk in the heart of campus, where it was home to military training, dances, and many activities. Though the Obelisk remains, the Armory was torn down in 1964 to make room for an expansion of the Willard Building. In its last few years of use, the Armory housed the Reserve Officers Training Corps.

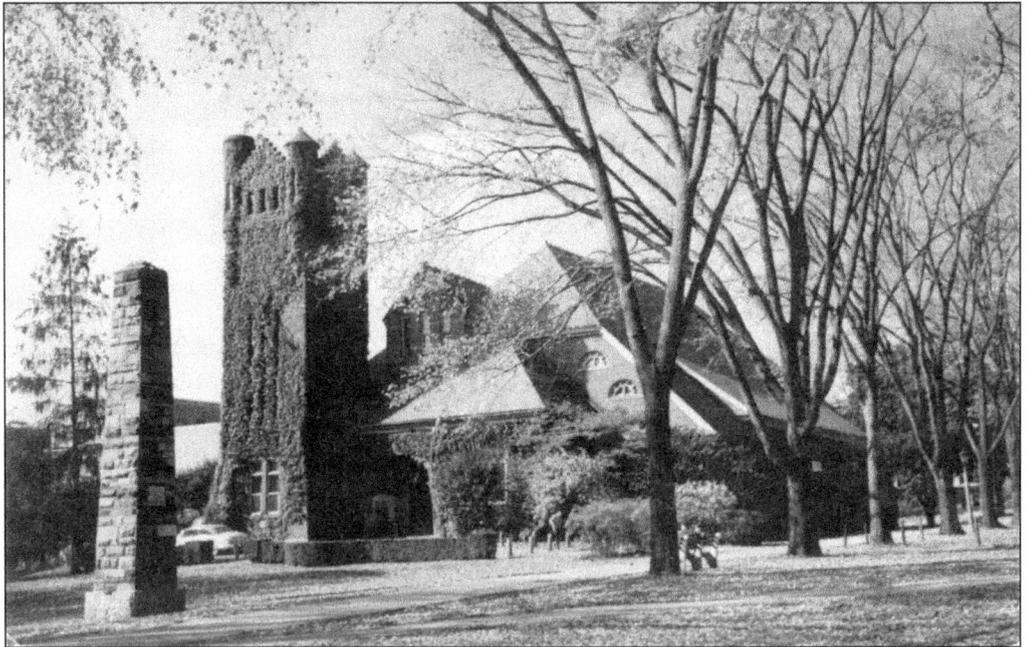

In a later view of the Armory, the tower is completely covered in ivy, which was a gift from the class of 1909. The Armory was used for dramatic productions until 1902 (Schwab Auditorium was dedicated in 1903) and physical education until 1928 (Rec Hall was constructed in 1929). The College of Earth and Mineral Sciences built the Obelisk in 1896. (Photograph by Herbert Lanks.)

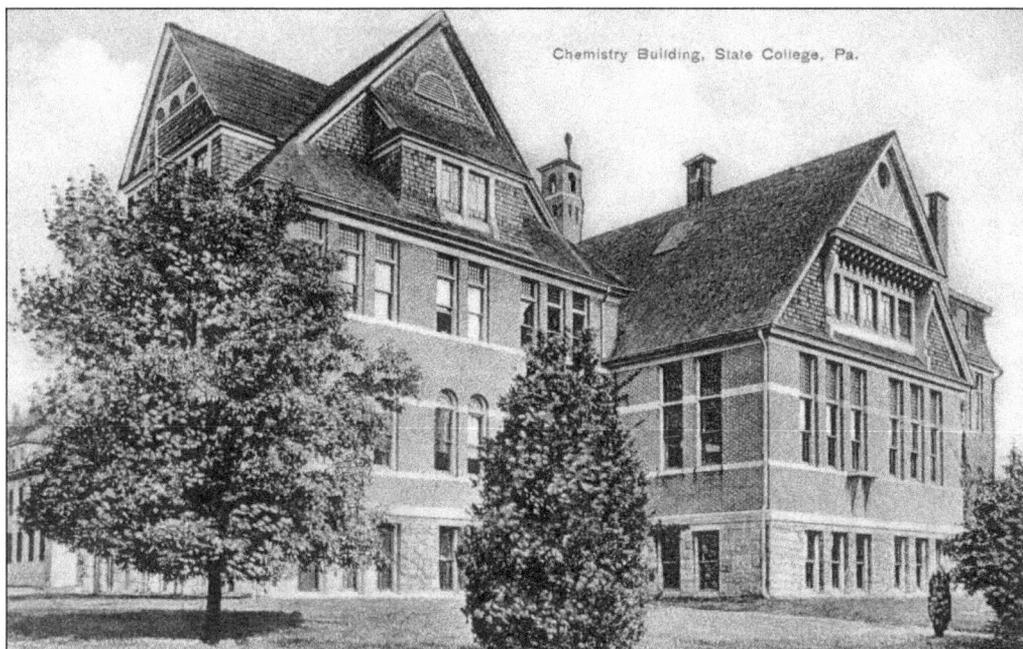

The Chemistry Building, sometimes known as the Chemistry and Physics Building, was constructed in 1890 and stood for almost 80 years. It was renamed Walker Laboratory in 1948 in honor of William H. Walker, a trustee of Penn State from 1907 to 1927. The building was demolished in 1969.

According to the back of this card, "Old and new are depicted in this autumn scene." Whitmore Laboratory was built behind Walker Laboratory in 1953 and named after Frank Whitmore, who was dean of the College of Chemistry and Physics from 1929 to 1947. Walker Laboratory was demolished to make room for Davey Laboratory, but Whitmore Laboratory still stands today.

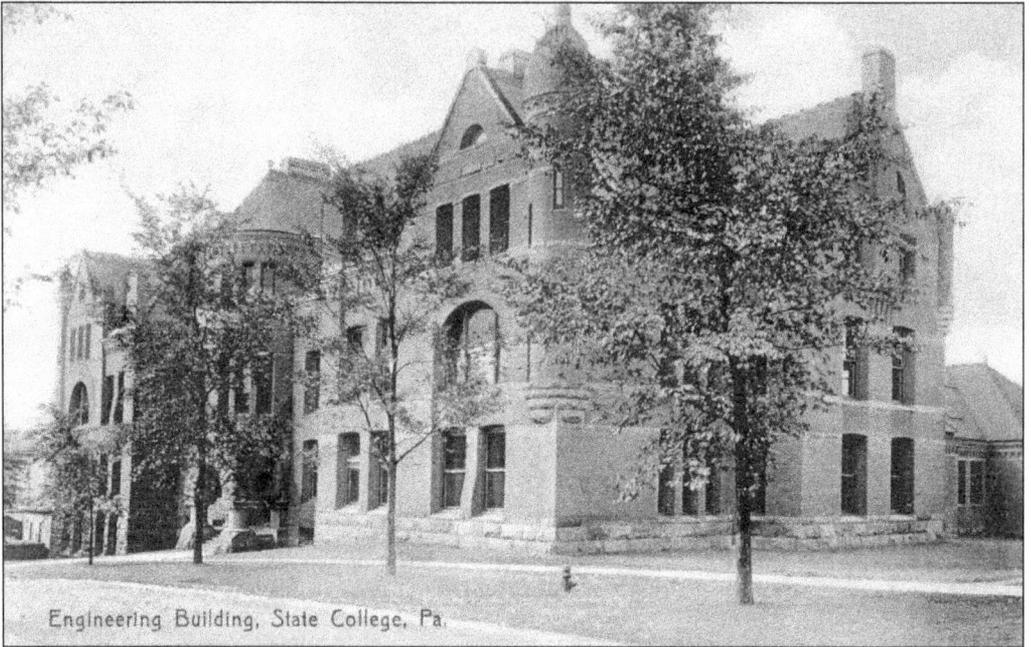

Engineering Building, State College, Pa.

This impressive Engineering Building no longer exists at Penn State. Built in 1893, the edifice was situated right near the main entranceway, where the newly planted elm trees are just starting to grow in this image. A fire devastated and destroyed the building in 1918. The Sackett and Hammond Buildings later replaced it.

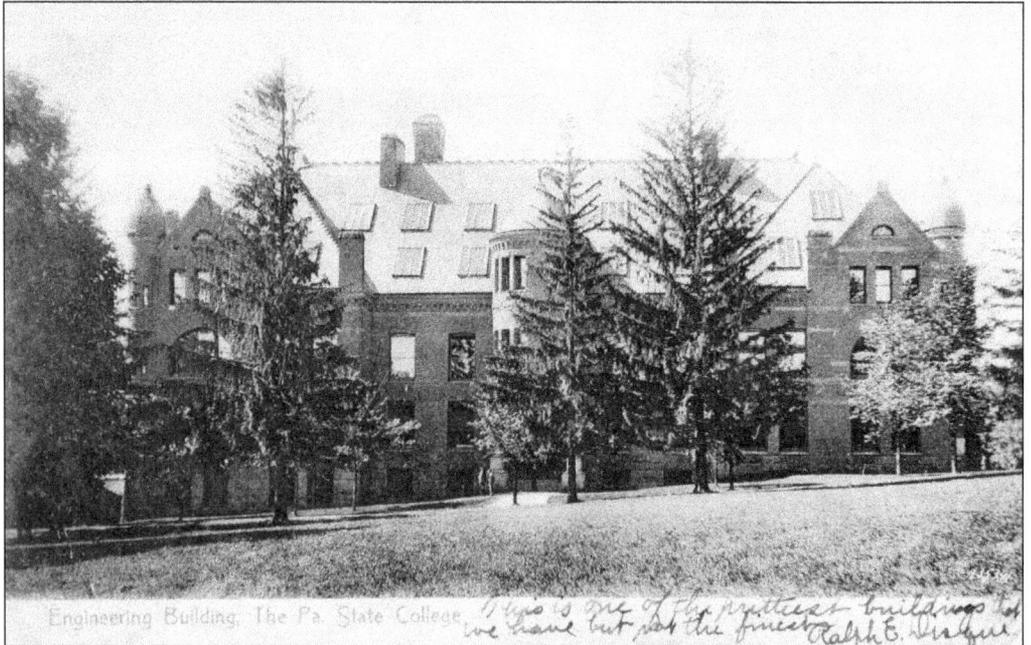

Engineering Building, The Pa. State College

In a slightly later view than the previous image, the Engineering Building still looks impressive, and the elm trees have continued to grow. The sender Ralph E. Disque writes, "This is one of the prettiest buildings that we have but not the finest." This card was postmarked on February 25, 1907.

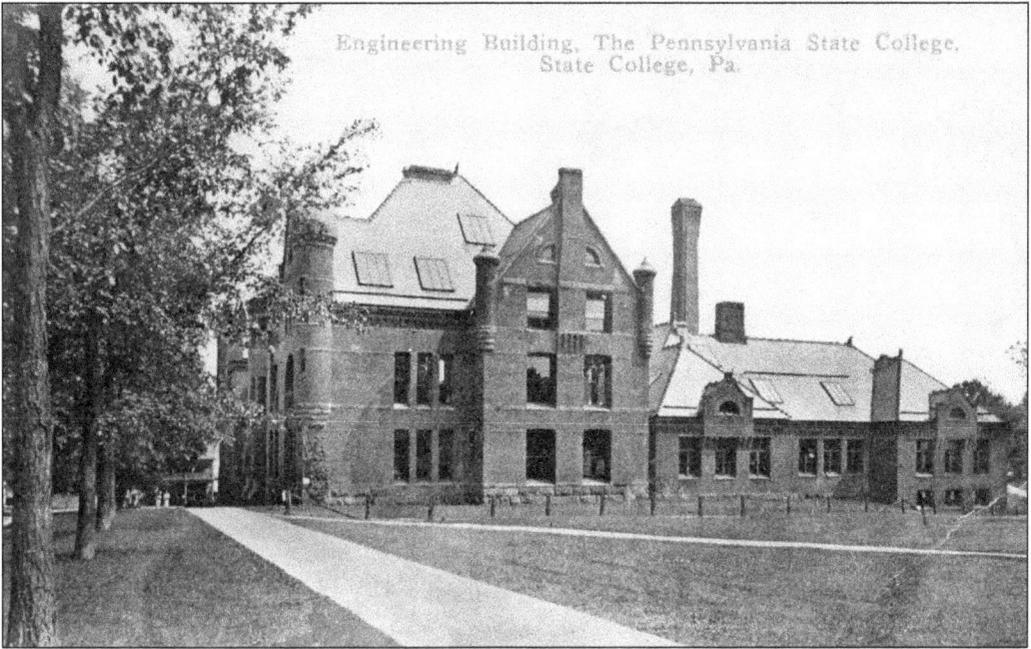

This view looking south down the mall shows the enormity of the Old Engineering Building, as seen from the side. The back of the structure is to the right. The canopy/balcony of the State College Hotel can be seen at the very end of the main walkway.

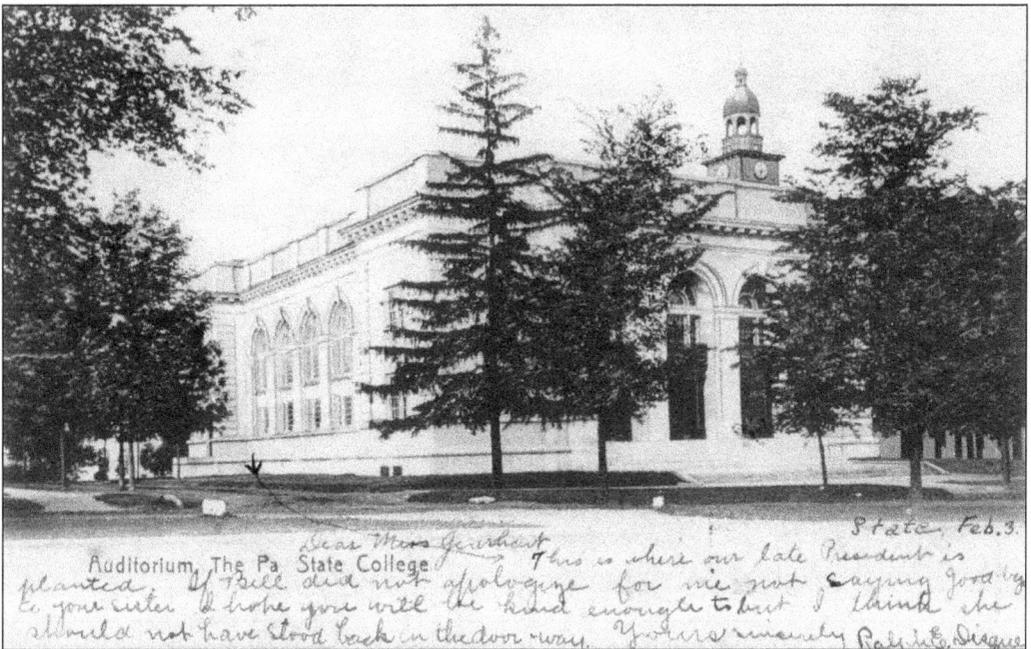

Auditorium, The Pa. State College

The original Old Main tower is seen in the upper right corner of this early view of Schwab Auditorium, which was dedicated in June 1903. The sender Ralph E. Disque marked the spot "where our late President is planted." George Atherton passed away in office on July 26, 1906, and was buried next to the auditorium. This card was postmarked on February 4, 1907.

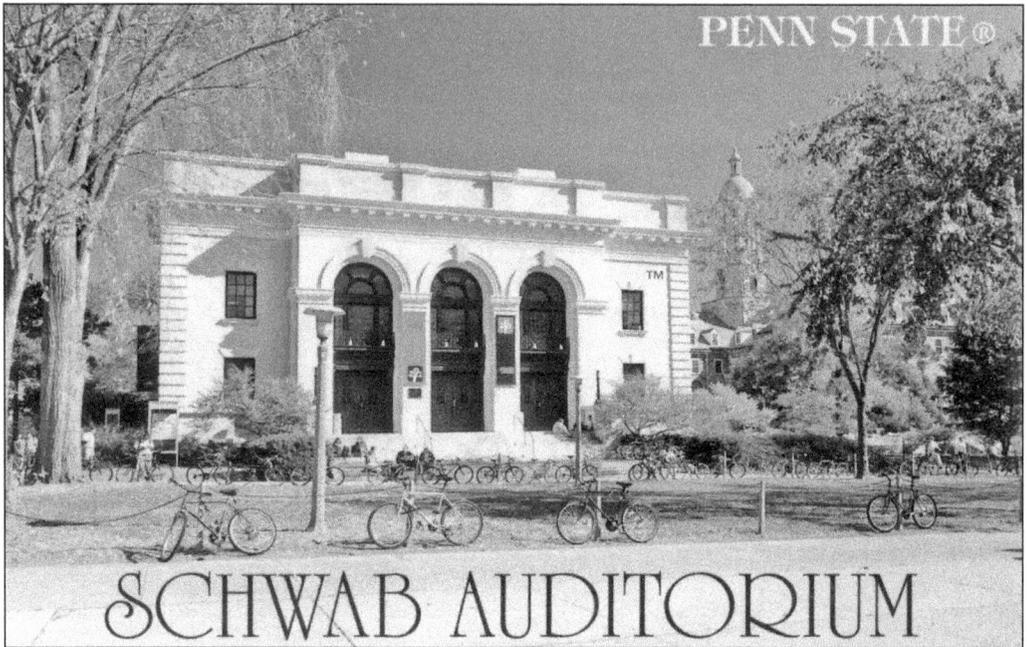

SCHWAB AUDITORIUM

In this more contemporary view of Schwab Auditorium, Atherton's gravesite is seen to the left of the building, about where the banner is hanging off the building. Notice the two bronze lamps on either side of the entranceway. These lamps were a gift from the class of 1916, who presented them to the school during their freshman year of 1912. (Photograph by C.G. Wagner Jr.)

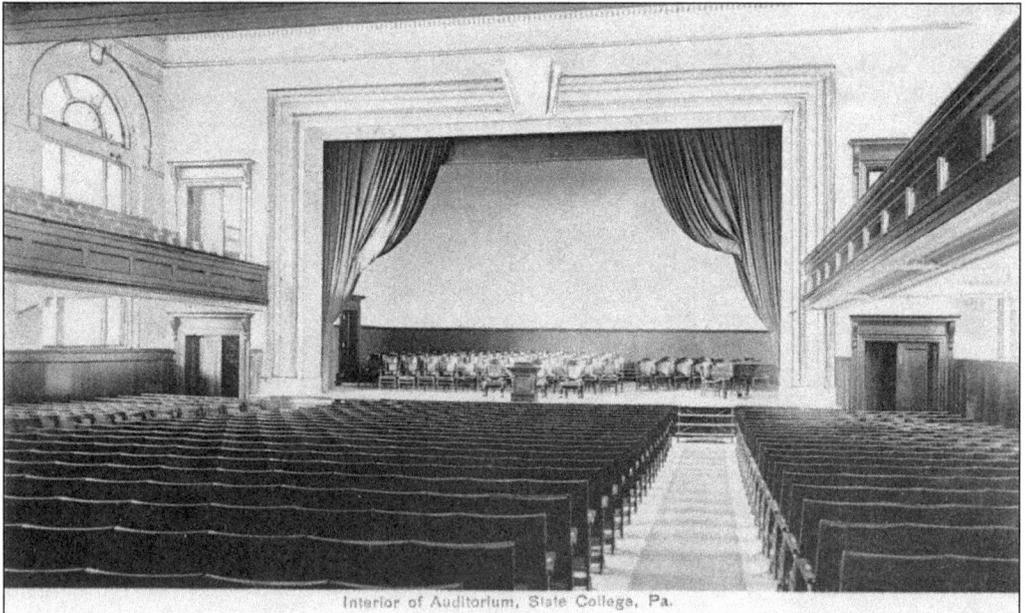

The interior of Schwab Auditorium has not changed much in the past 100 years. It is still used for concerts, classes, and plays for the Penn State Thespians. On July 27, 2015, a small section of the balcony collapsed during the Spend a Summer Day program for incoming students interested in majoring in engineering. Only one of the 500 students required medical attention for minor injuries.

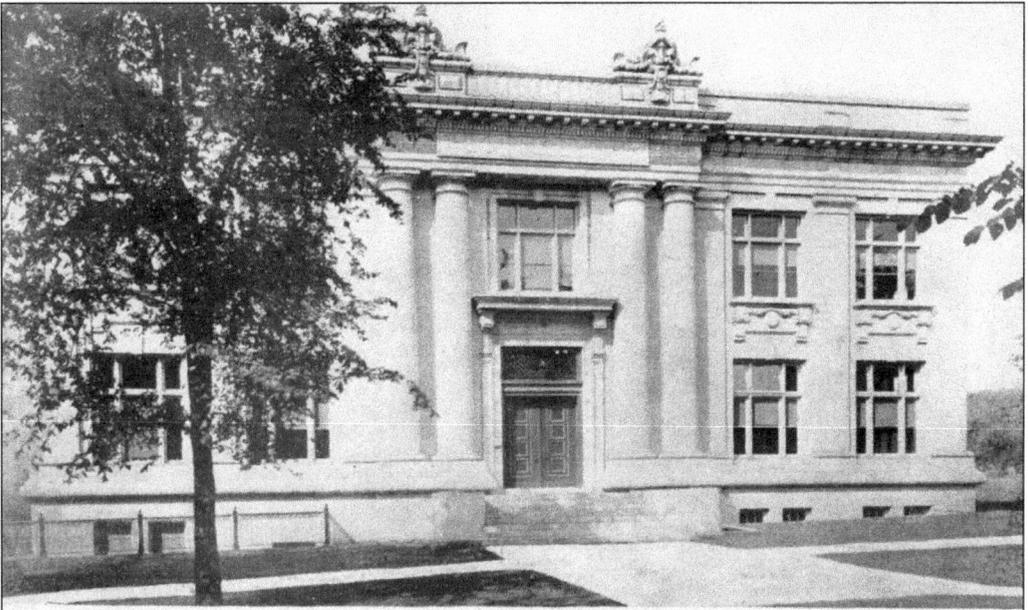

Carnegie Library, State College, Pa.

Before the Pattee Library was built, the present-day Carnegie Building served as the library from 1904 to 1940. The many volumes of books were moved from Old Main to Carnegie in 1904, then from Carnegie to Pattee in 1940.

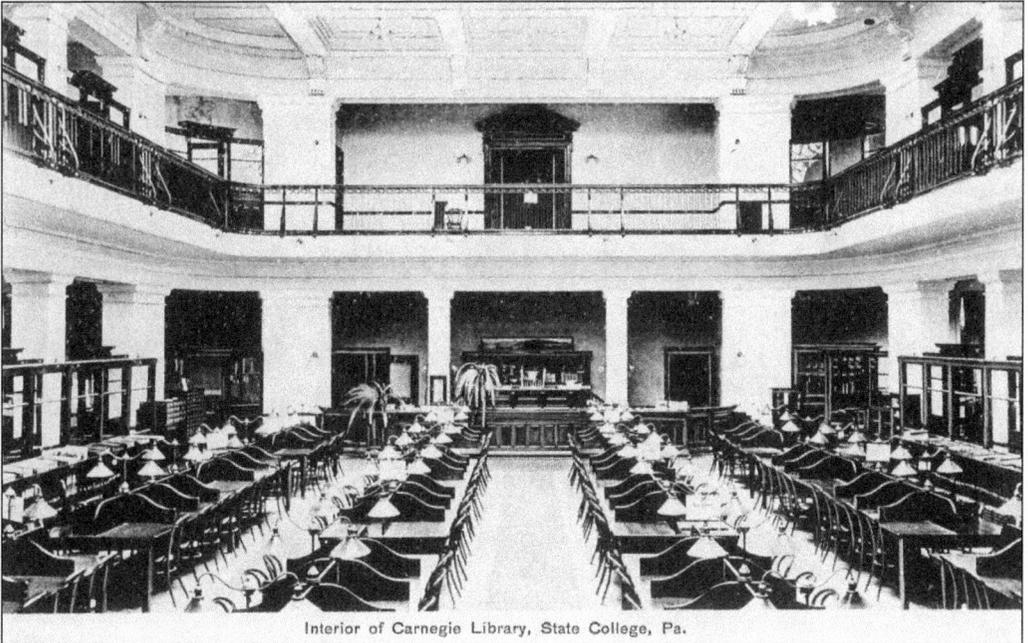

Interior of Carnegie Library, State College, Pa.

In this early view, the interior of the Carnegie Building is seen when it was the campus library. Students had a place to sit down and read after searching for volumes of texts. Once the Pattee Library was built, the Carnegie Building received its current name, and since then, many groups have used the space, including the Penn State Blue Band and the *Collegian* student newspaper. (CPCCCHS.)

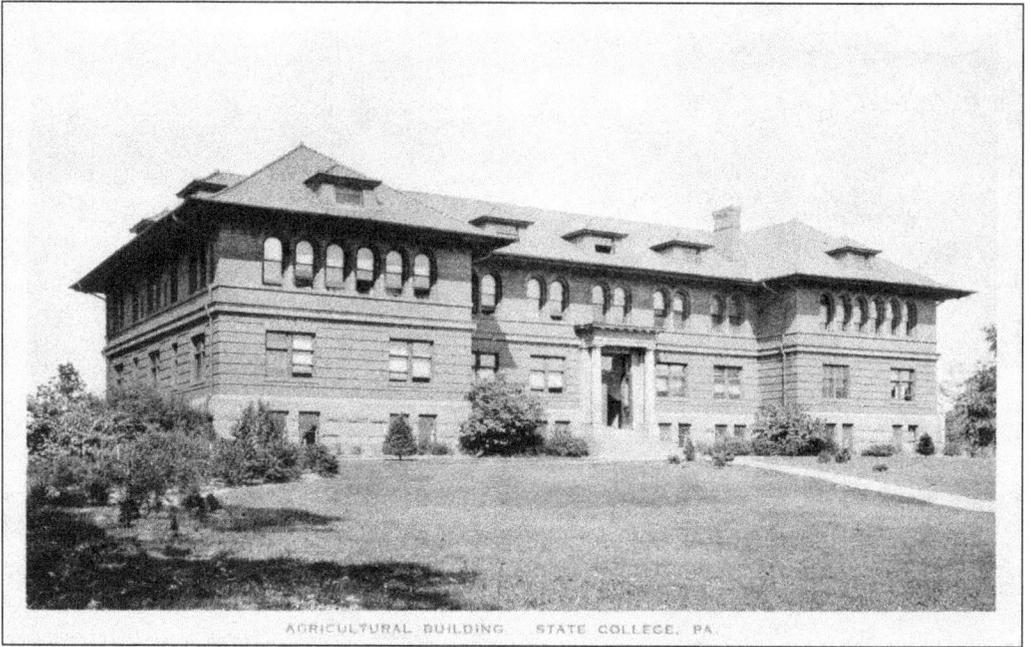

The Armsby Building, first known as the Agricultural Building or the Horticultural Building, was erected in 1905 for the purpose of "instruction and investigation of various branches of agriculture." A sum of $100,000 was appropriated by the state legislature and approved by then governor of Pennsylvania Samuel Pennypacker for funding construction of the building.

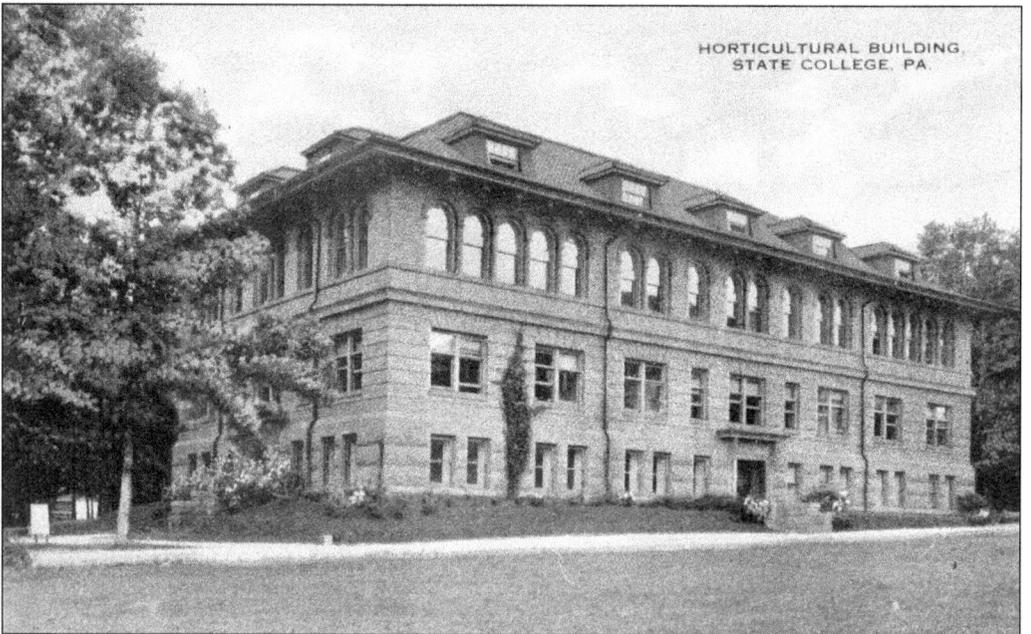

In 1956, the Agricultural/Horticultural Building took the name of Henry Prentiss Armbsy, director of the Agricultural Experimental Station in 1887 and dean of the School of Agriculture from 1895 to 1902. The Armsby Building is now one of the oldest structures still standing at Penn State.

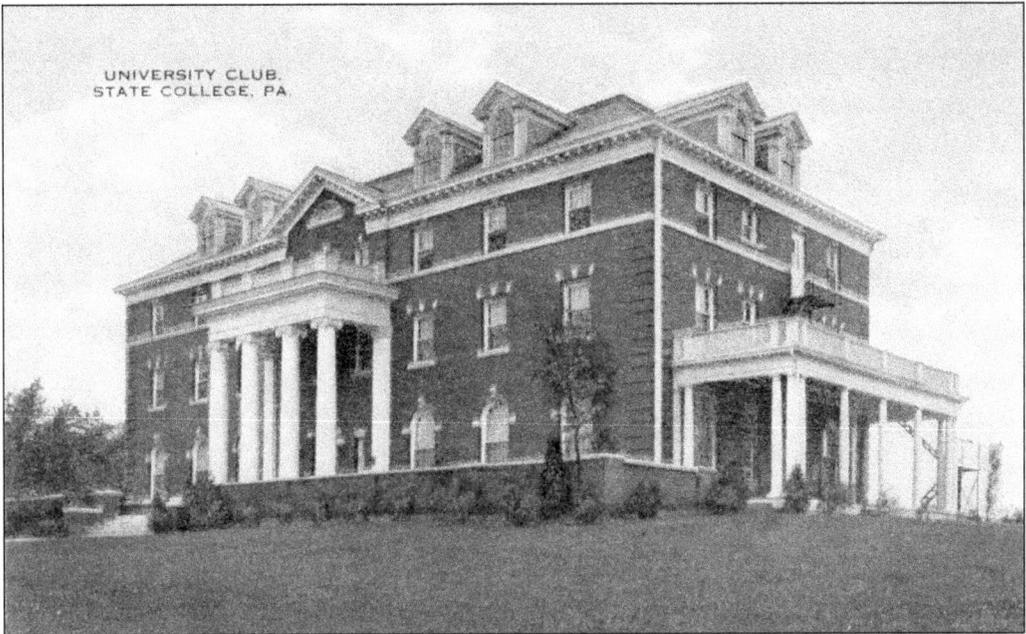

Constructed in 1908 as a social club for faculty, the University Club currently provides housing for graduate students and visiting professors to Penn State. It can also be rented as a venue for special events, such as weddings and receptions. The building is located on College Avenue along the southern border of campus.

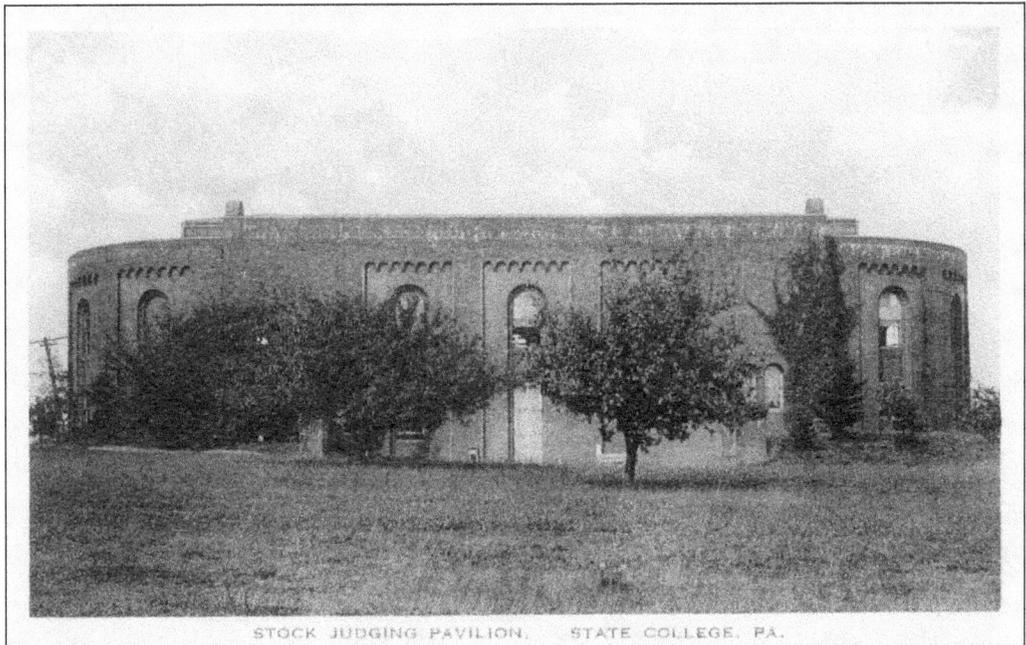

Constructed in 1914, the Stock Judging Pavilion was used as a judging area for farm animals. The structure was reconfigured as a theater-in-the-round in 1960. The 300-seat arena theater provides a unique setting for thespian productions. The Pavilion Theatre is located across the street from the Boreland Building, just down the road from Eisenhower Auditorium.

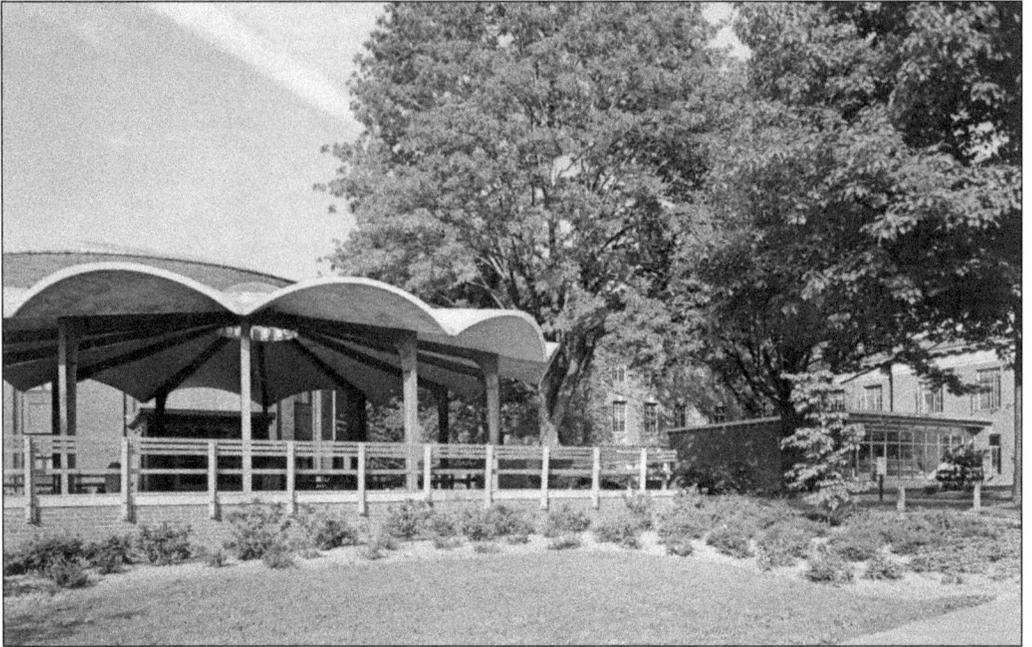

A canopy of sorts was added to the entranceway of the Pavilion Theatre to provide cover from the elements. In this scene, the old Penn State Creamery can be seen across the street, where many a customer would buy cones or shakes and then go to the Pavilion to sit and relax. (Photograph by Richard C. Miller.)

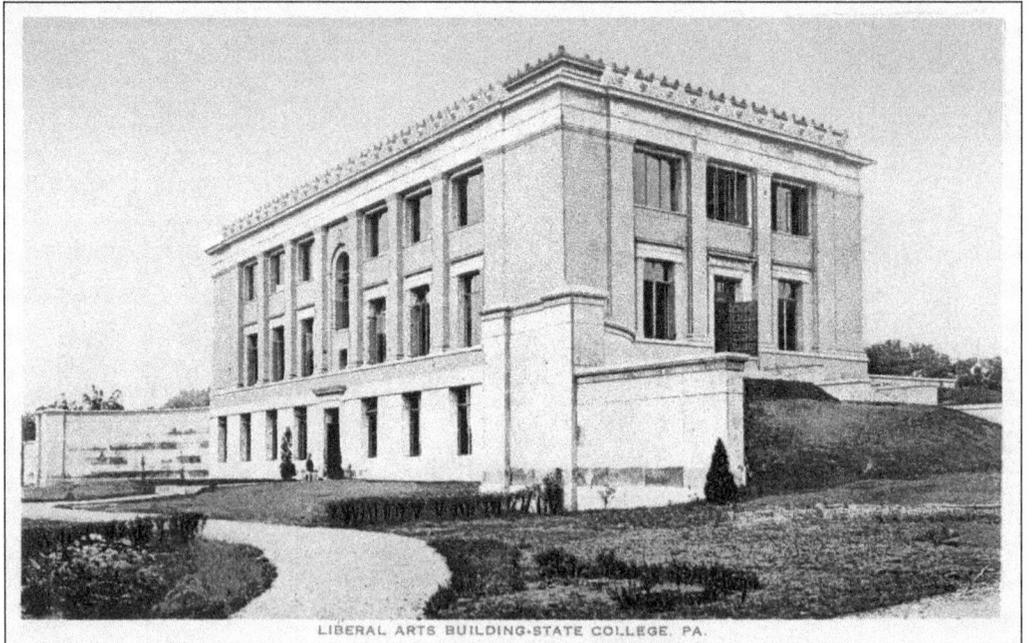

LIBERAL ARTS BUILDING·STATE COLLEGE, PA.

The former Liberal Arts Building stood slightly to the north of the Carnegie Building. Constructed between 1915 and 1916, it is now the southernmost part of the Sparks Building, which is comprised of three different structures. Edwin Earle Sparks was president of the university from 1908 to 1920.

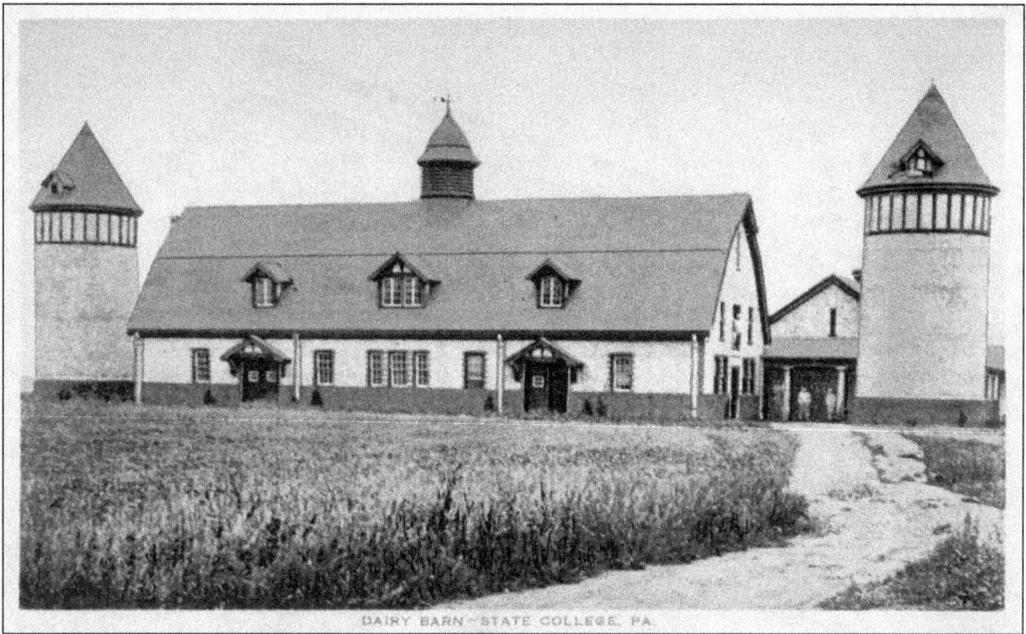
DAIRY BARN—STATE COLLEGE, PA.

The Dairy Barns were first constructed in the area of what is now the Carnegie Building, where they stood from 1865 to 1897. A fire destroyed the barns, and the cattle were moved to a new set of barns near Rec Hall from 1897 to 1915. The barns pictured here were then built at the corner of present-day Shortlidge and Curtin Roads.

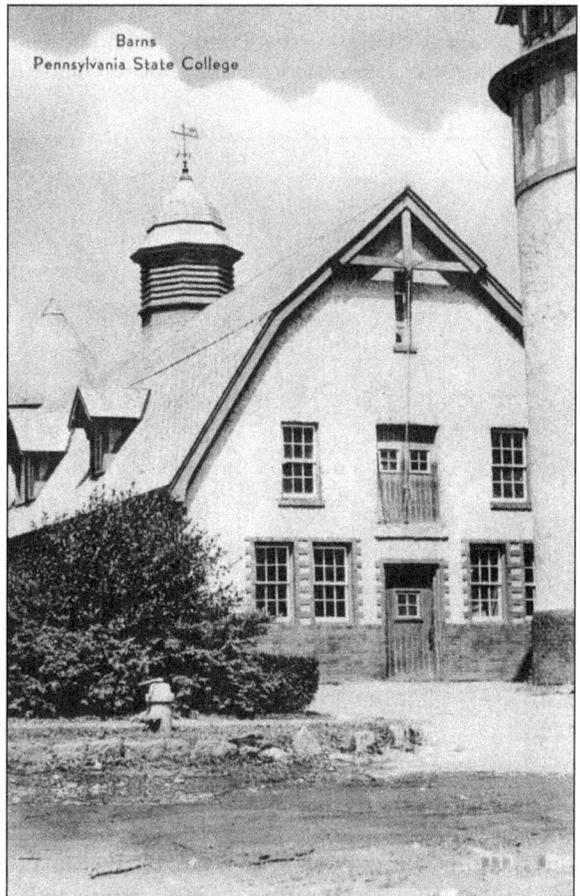
Barns
Pennsylvania State College

This postcard shows a side view of the latter Dairy Barns. The cattle were housed here from 1915 to 1969, when another fire destroyed these barns as well. At least one piece of the barns survived. The weather vane seen atop the center tower is housed in the Pasto Agricultural Museum. The Agricultural Administration Building is now located at this site.

45

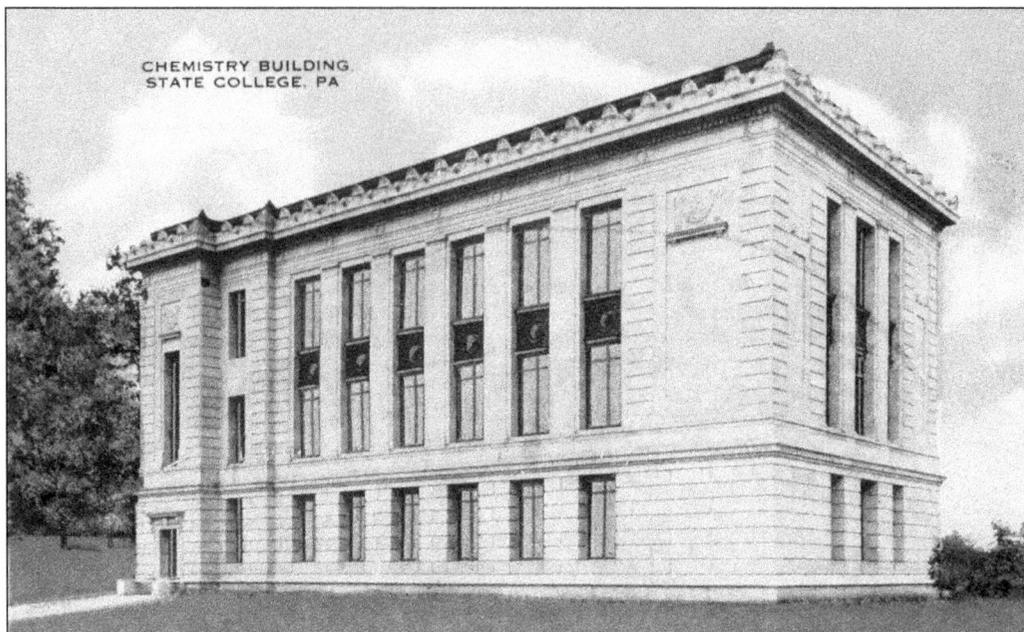

CHEMISTRY BUILDING
STATE COLLEGE, PA

The Chemistry Building, as it was known when it was constructed between 1917 and 1918, was much smaller than the current Pond Laboratory. The building was called Priestly Laboratory for a very short time after construction, but the name had changed to Pond Chemical Laboratory by 1920.

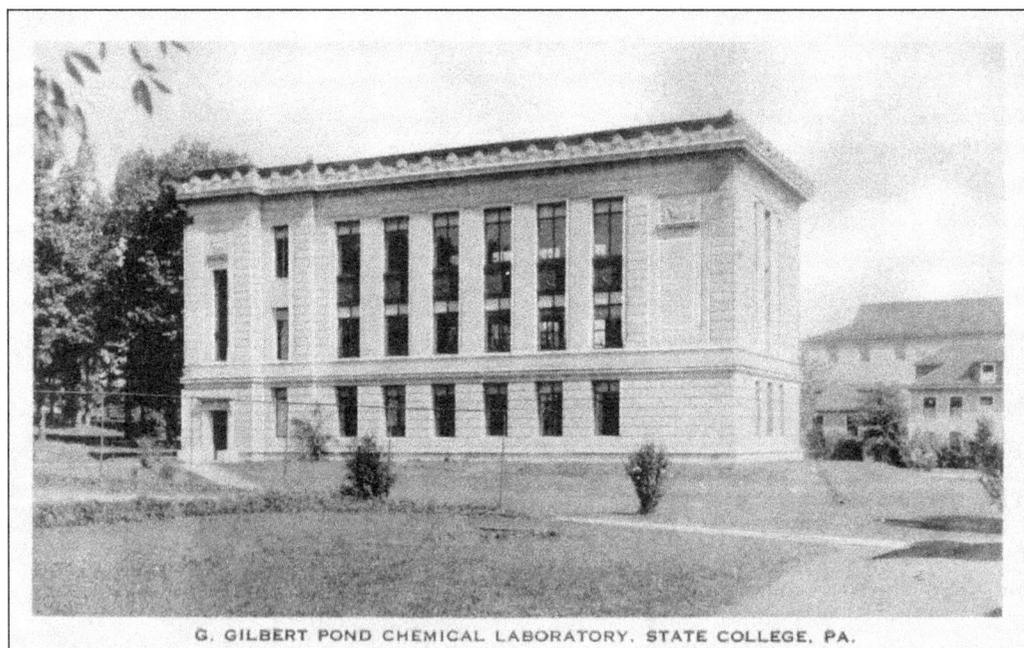

G. GILBERT POND CHEMICAL LABORATORY, STATE COLLEGE, PA.

The Pond Chemical Laboratory was named after George Gilbert Pond, who was a professor of chemistry and dean of the school of natural sciences from 1888 to 1920. Pond is credited with the chemistry program at Penn State. He died in office in 1920. The Excellence in Support of Undergraduate Education award is also named in honor of G. Gilbert Pond.

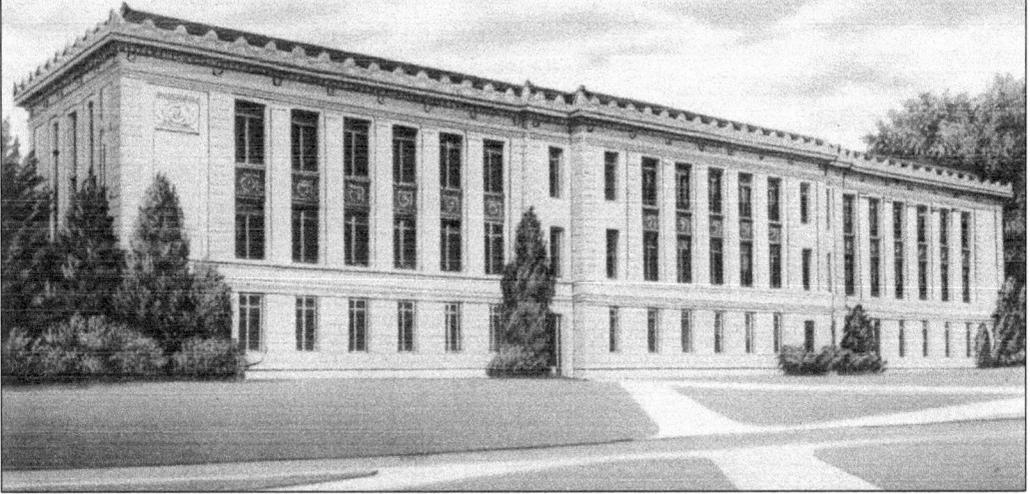

By 1930, Pond Laboratory had grown to about three times its original size. The additions perfectly match the original building, thus it is hard to determine which section was made first. Still housing laboratories and offices, the building is also home to the headquarters of Penn State's World in Conversation, where a wall of clocks displays times from different areas of the world.

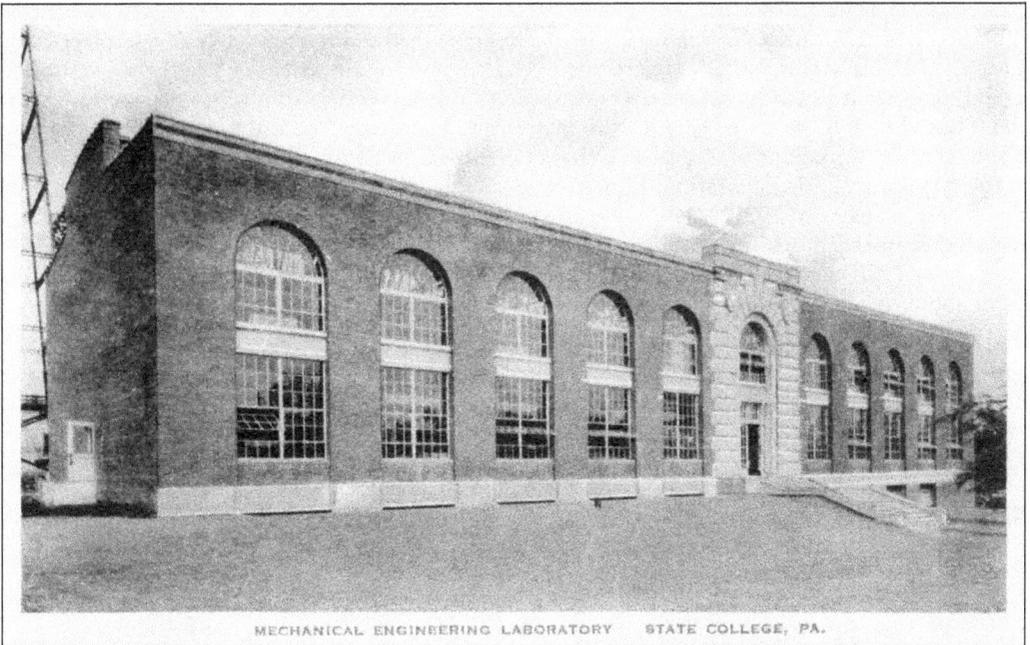

MECHANICAL ENGINEERING LABORATORY STATE COLLEGE, PA.

The Mechanical Engineering Building is located across the street from the Power Plant in the southwest corner of the university. Completed in 1921, the building is named after Loius Reber, who was the first dean of the School of Mechanical Engineering and a Penn State graduate from the class of 1880. He returned to the college as a professor in 1884. (CPCCCHS.)

47

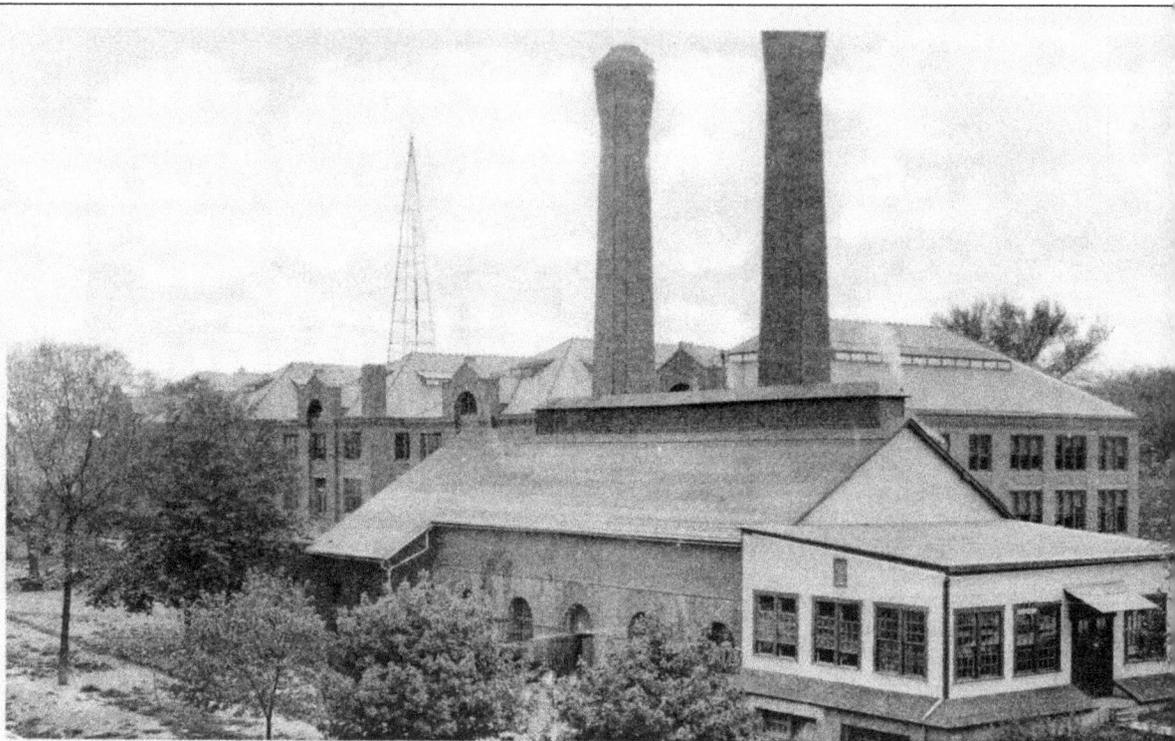

ENGINEERING UNITS. STATE COLLEGE, PA.

The Petroleum Refining Laboratory (the building with the smokestacks) was completed and occupied in 1921. It was located at the corner of College Avenue and the mall, where the Hammond Building currently stands and where part of the Old Engineering Building once stood. It was demolished in 1958 to make way for the Hammond Building. The Engineering Units behind the laboratory were built in stages. The first one, Unit E, was completed in 1913, and as such, it is the farthest from the laboratory. Unit D was completed in 1914, followed by Unit B in 1919 and Units A and C in 1920. In 1961, the dormers seen here were removed, and a flat roof was installed for all the units. In October 2010, Engineering Units D and E were demolished, while A, B, and C still exist today. Many confuse this early building with the Power Plant, which was built about one block away.

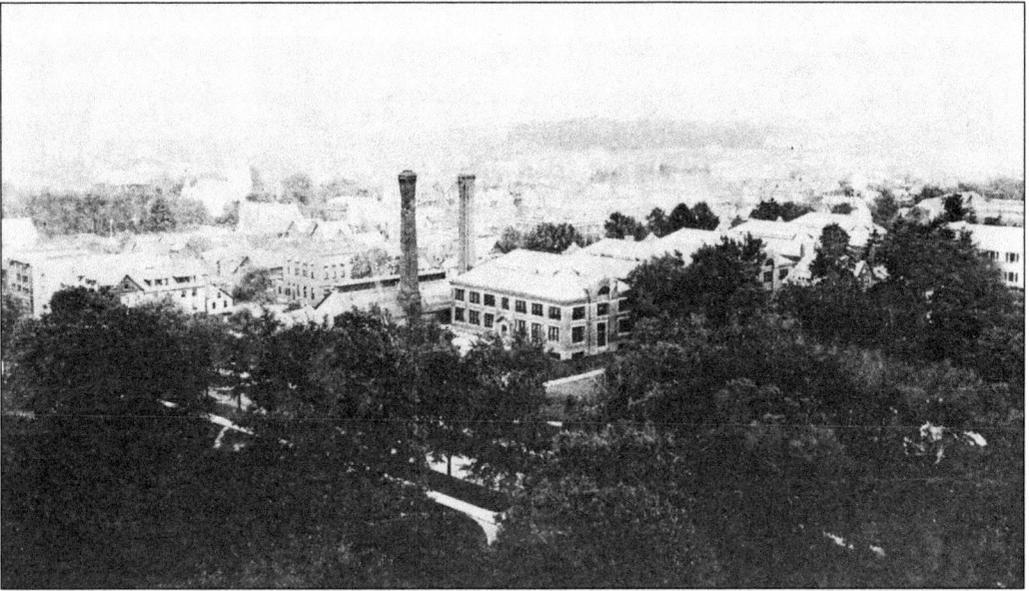

Looking south down the mall toward town, this view shows the Petroleum Refining Laboratory, as well as all of the Engineering Units. The relationship between the Old Engineering Building and the Petroleum Refining Laboratory can be seen. The smaller laboratory was built in the same footprint as the Old Engineering Building, right next to the Allen Street entranceway to campus. (CPCCCHS.)

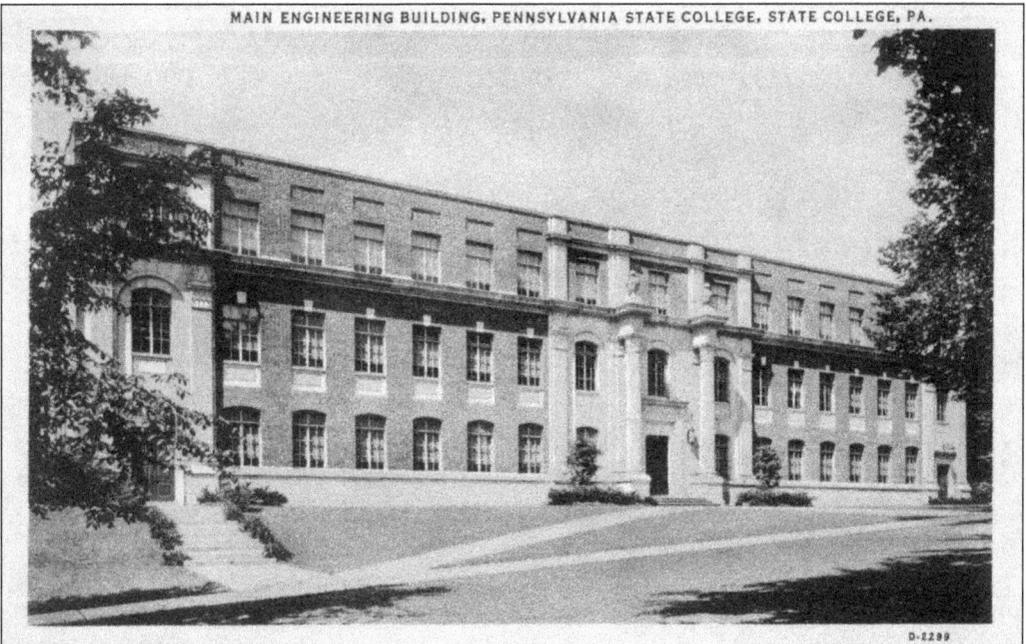

The Main Engineering Building was constructed from 1928 to 1930 to replace the original Engineering Building that was destroyed by fire in 1918. Since the Petroleum Refining Laboratory still existed at the time of construction, the new building had to be placed in between the Engineering Units and the road across from Allen Street, slightly north of where the Old Engineering Building was.

In 1957, the Main Engineering Building was renamed Sackett Building in honor of Robert Lemuel Sackett, who was dean of the School of Engineering from 1915 to 1937. The building still stands today, though a chemical fire started inside a storage room on June 21, 2013. Fortunately, graduate student Dane Kelsey noticed the fire, alerted the authorities, and helped extinguish it.

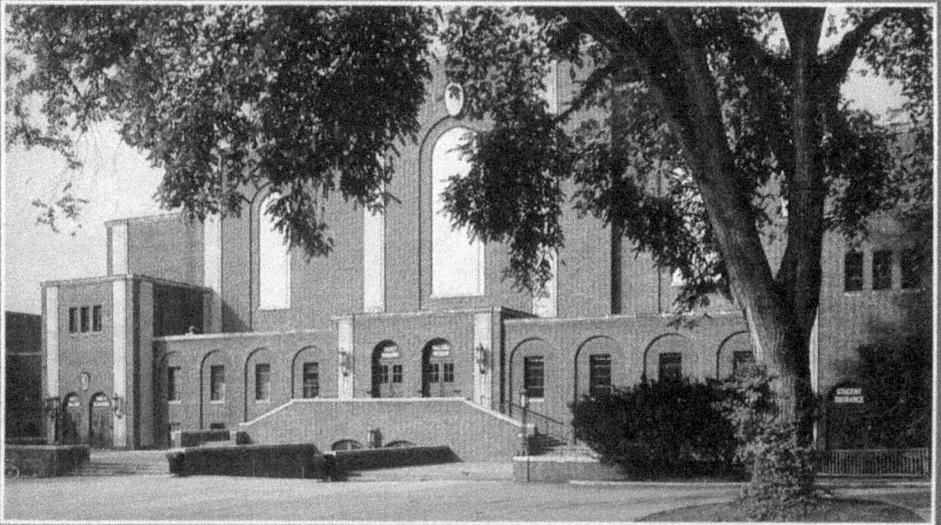

Rec Hall

PENN STATE

The Recreation Building, or Rec Hall, was home to the men's and women's basketball teams prior to the Bryce Jordan Center. This 1929 building is one of three used for physical education. It is located across the street from the Nittany Lion Shrine. (Photograph by Bron Miller.)

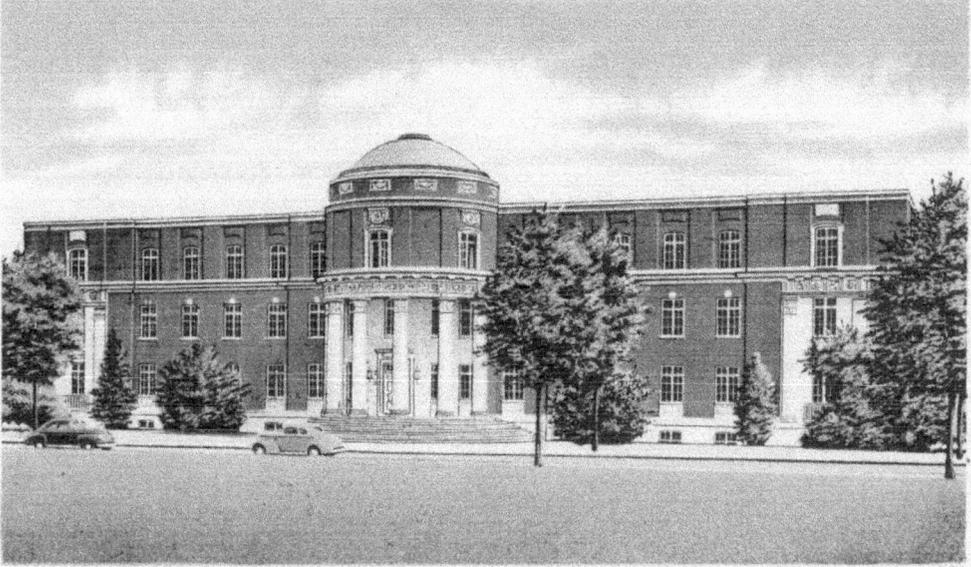

The Mineral Industries Building was constructed in 1929 to house the newly named College of Mineral Industries, originally the College of Mines and Metallurgy. The dean at the time of the construction was Edward Steidle, a Penn State graduate from 1911. Pres. Dwight Eisenhower would later appoint Steidle chair of the Federal Coal Mine Safety Board in 1957.

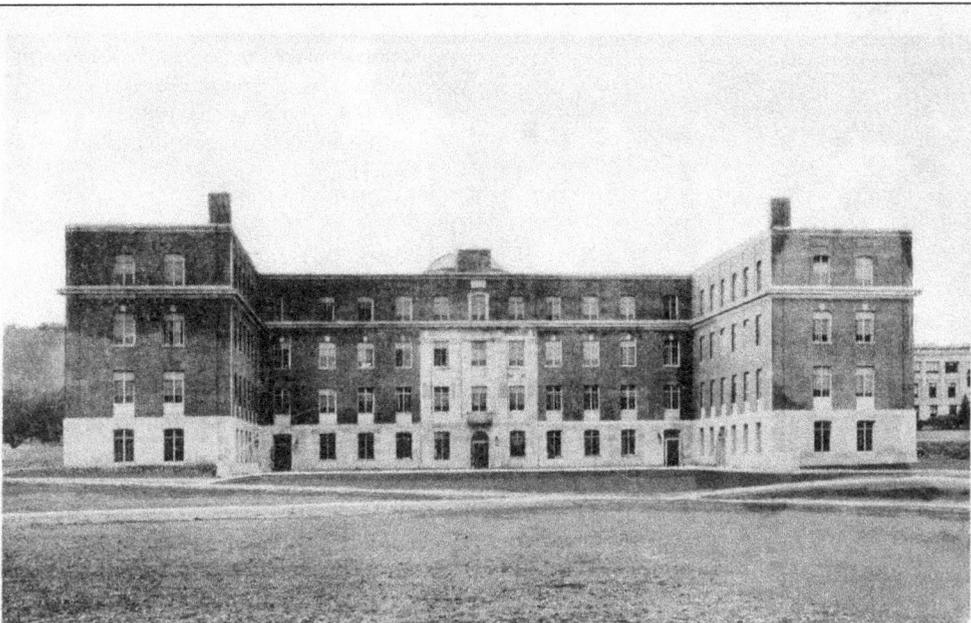

MINERAL INDUSTRIES BUILDING STATE COLLEGE. PA.

This view of the Mineral Industries Building is actually from the back side of the structure. In 1940, an addition to the middle of the building provided more lab space, thereby altering the shape of the structure from a "C" to an "E." The college would later be known as the College of Earth and Mineral Sciences, and the building was renamed the Steidle Building in 1978.

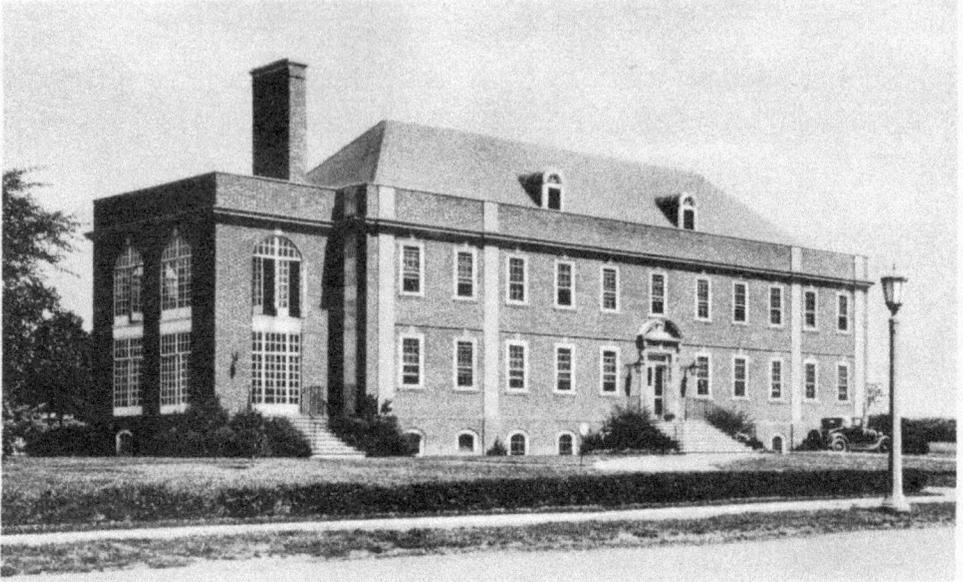

D-2298

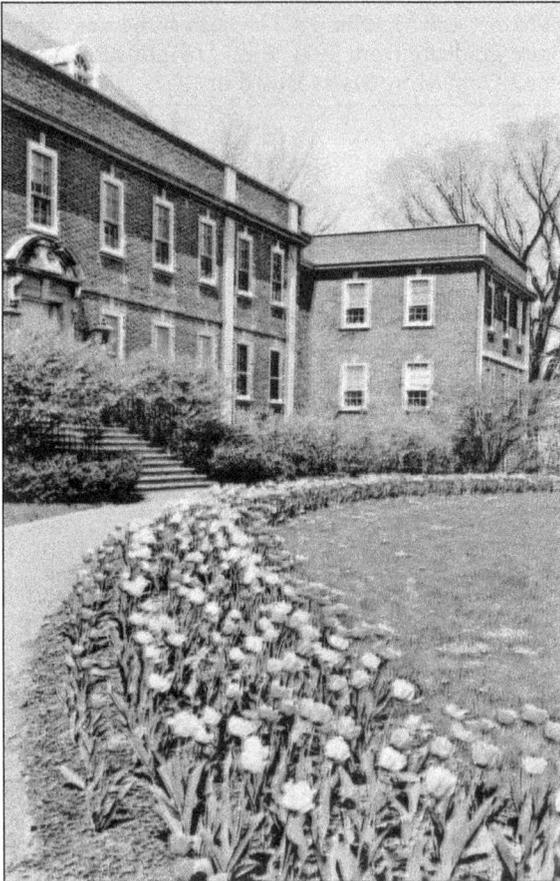

The infirmary, better known as the Ritenour Health Center, was located next to the Boucke Building, across the street from the Grange Building. Completed in 1929, the building was named after Dr. Joseph P. Ritenour, Penn State's first physician from 1917 to 1946. During the 1980s, students unfairly nicknamed the building "Wait an Hour."

The Ritenour Health Center was renovated in 1955, at which time the wings were added to either side. In this view, the eastern wing is shown jutting out from the front of the building. With the construction of the Student Health Center in 2008, the Ritenour Building is no longer used for health services and is now part of the Eberly College of Science. (Photograph by Richard C. Miller.)

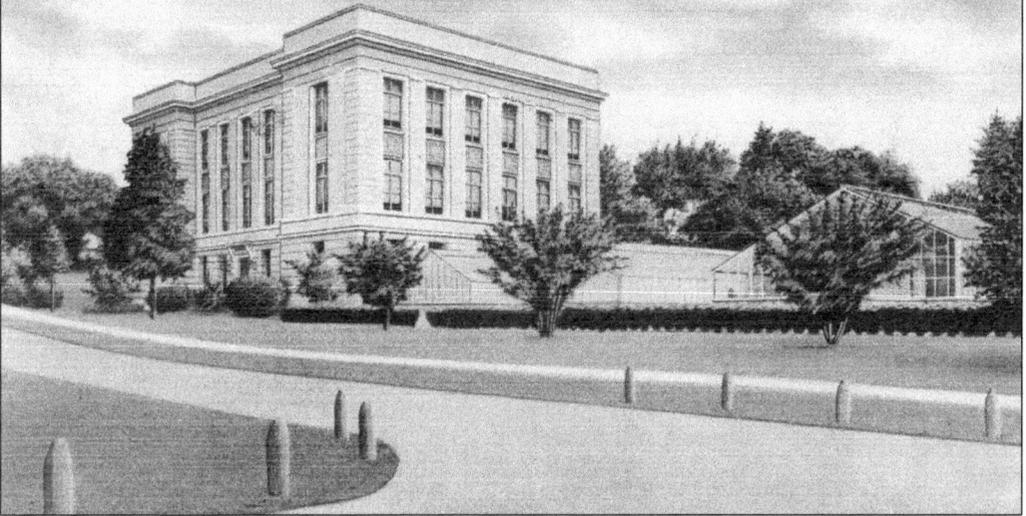

Buckhout Laboratory was named after William Buckhout, who was a professor of botany, zoology, and geology from 1871 to 1921. Completed in 1930, the building is located just north of the Boucke Building and Osmond Laboratory, among many of the university's laboratories. Both the greenhouses and the building still stand today.

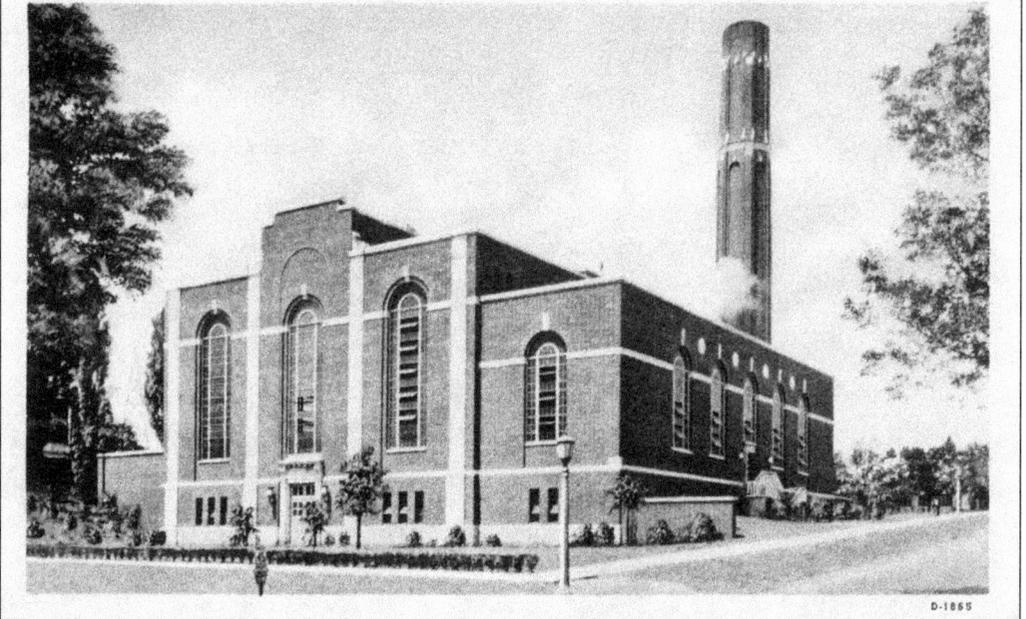

POWER PLANT, PENNA. STATE COLLEGE, STATE COLLEGE, PA.

The Power Plant at the corner of East College Avenue and North Burrowes Street provided steam heat and electricity to most of the buildings on campus. Built in 1931, it closely resembles Rec Hall, which is located just up the road. Both buildings are situated on the western side of Burrowes Street. (CPCCCHS.)

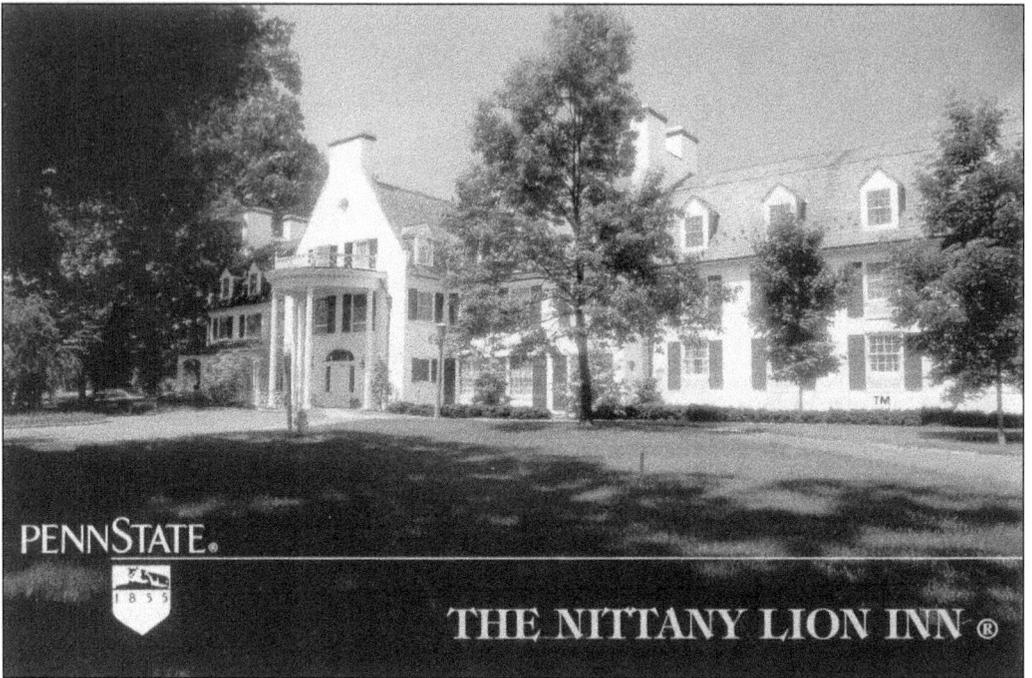

PENNSTATE.
1855

THE NITTANY LION INN ®

The Nittany Lion Inn is a four-diamond, Colonial-style hotel located near the Nittany Lion Shrine and Rec Hall in University Park. Built in 1931, the 200-room inn boasts award-winning dining and still sells out for almost every home football game. (Photograph by C.G. Wagner Jr.)

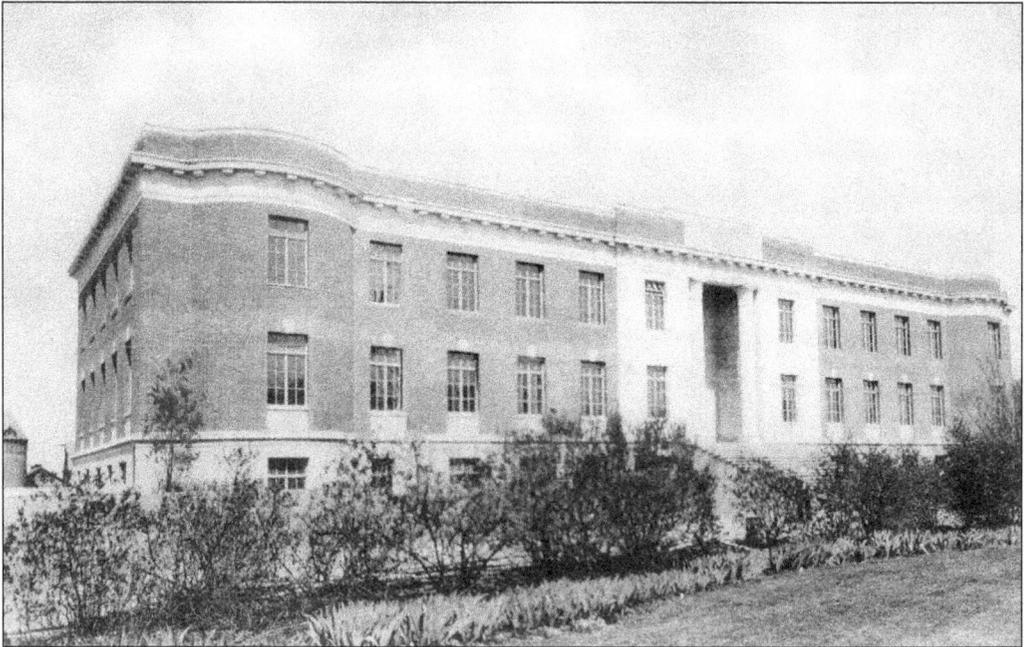

The Dairy and Husbandry Building, located across from the Pavilion Theatre (formerly the Stock Judging Pavilion), was dedicated on August 25, 1932. The building contained classrooms and the Creamery until 2006. Later, an extension to the structure housed a store that sold ice cream cones and shakes.

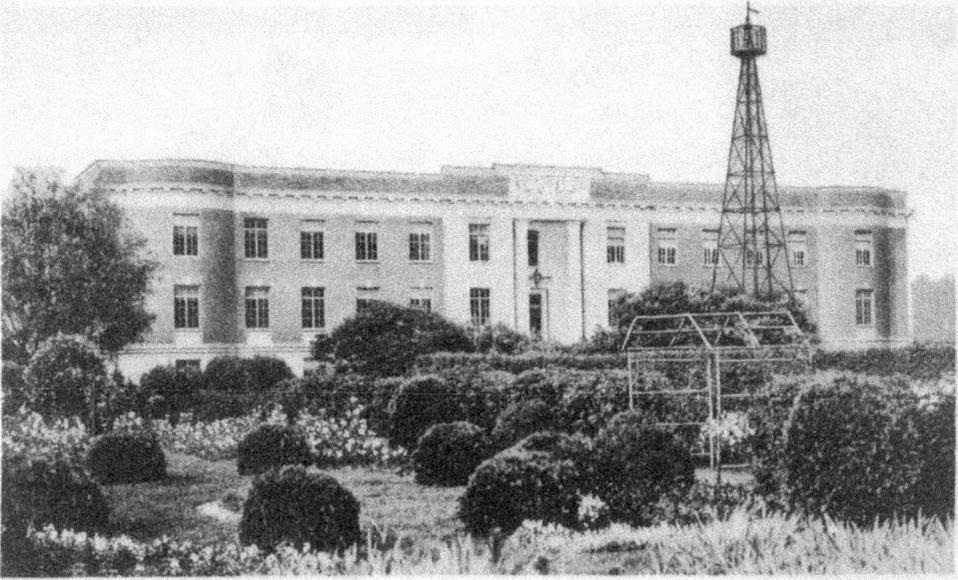

STATE COLLEGE, PA.

In 1958, this building was renamed Borland Laboratory in honor of Andrew Borland, who was head of the Department of Dairy Sciences at the time of construction. Borland served as an educator with Penn State from 1919 to 1948. It is now known as the Borland Building, which is currently used by the College of Arts and Architecture.

Penn State®

The Creamery

The Penn State Creamery was located on the side of Borland Laboratory until 2006, when it was moved a block closer to Beaver Stadium and renamed the Berkey Creamery. In this view, the back of Borland Lab can be seen, along with the small offshoot of the building that was used for ice cream sales. (Photograph by C.G. Wagner Jr.)

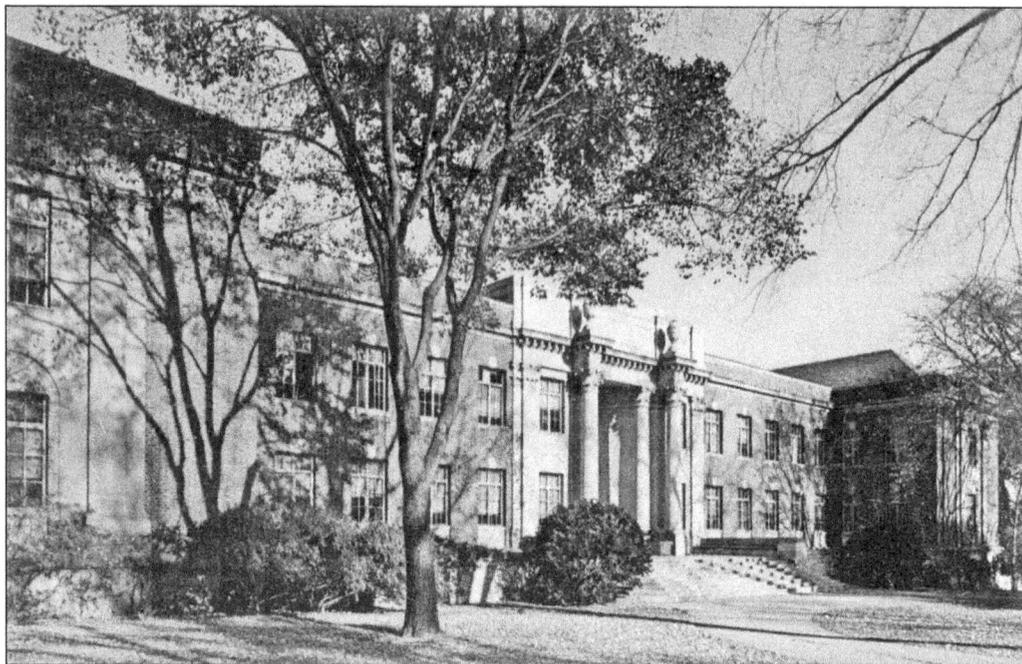

The Home Economics Building was erected just south of the McAllister Building in 1932. The building contained model kitchens and a model nursery for preschool children. In 1974–1975, it was named the Henderson Building in honor of Grace M. Henderson, dean of the College of Home Economics from 1949 to 1966. Henderson was the first female dean at Penn State. (Photograph by Richard C. Miller.)

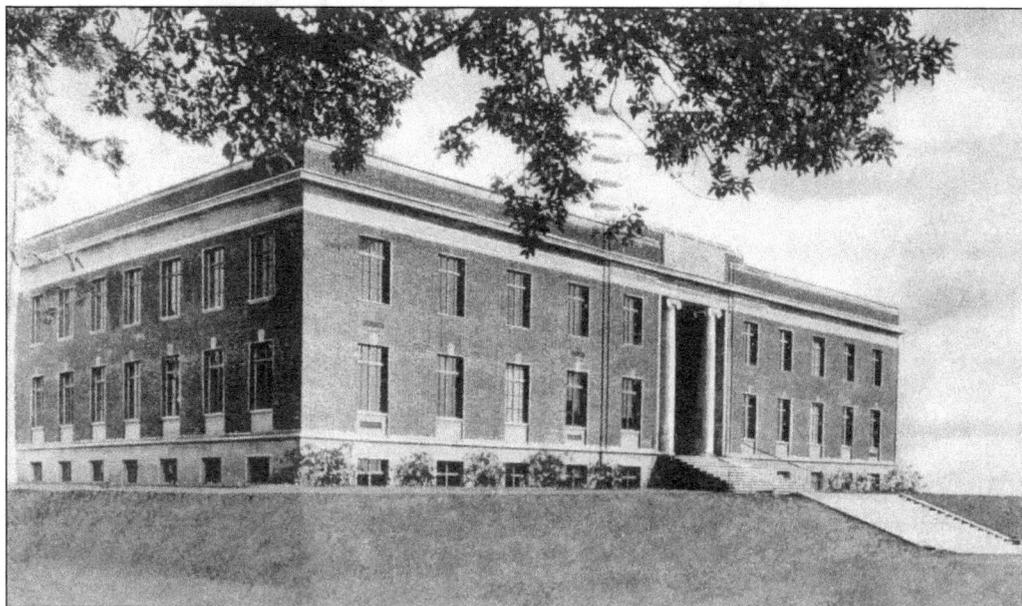

The Ferguson Building, first known as the Forestry Building, was constructed between 1938 and 1939. Located just south of the Pavilion Theatre, the building was later named for John Arden Ferguson, who was head of the School of Forestry from 1912 to 1937. The building was dedicated to him on January 7, 1967.

Frear Laboratory (called Frear Hall on this card) was constructed from 1938 to 1940 to help alleviate the need for more classrooms and laboratories in the science department. The building was named after William Frear, who was a professor of agriculture chemistry from 1855 to 1922. Today, there are two Frear Laboratories, with this one being known as Frear North.

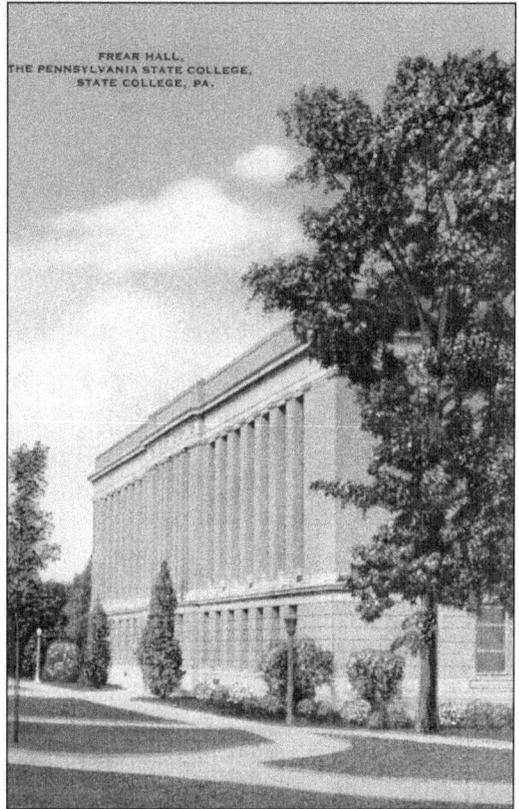

FREAR HALL,
THE PENNSYLVANIA STATE COLLEGE,
STATE COLLEGE, PA.

The original library was housed in Old Main until 1904, when the Carnegie Library was established. Within 30 years, it became apparent that the Carnegie Building was not large enough to hold the university's collection of books, so the Pattee Library was built in 1940. It is now home to nearly five million volumes. (Photograph by Bron Miller.)

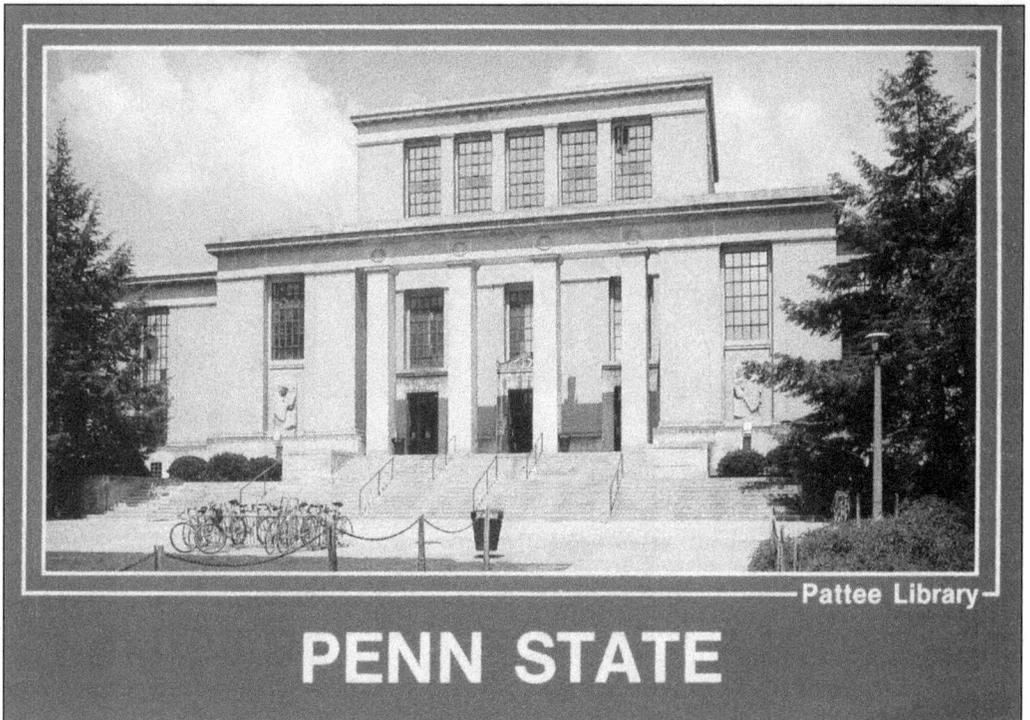

Pattee Library

PENN STATE

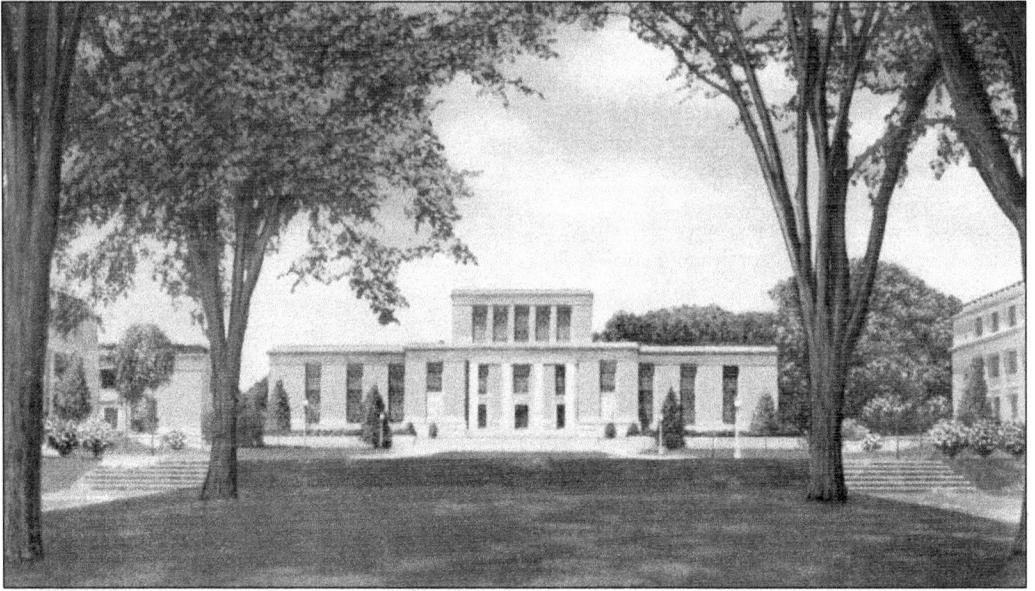

The library was named after Fred Lewis Pattee, who is considered the first professor of American literature, as well as the author of Penn State's alma mater. Two buildings can be seen flanking the Pattee Library in this older view. To the left is the Sparks Building, the first section of which was established in 1915, and to the right is the Burrowes Building (formerly the Education Building), which was constructed from 1938 to 1940.

Joe Paterno and his wife, Sue, helped raise close to $14 million to renovate the library, and in 2000, it was renamed the Pattee-Paterno Library. Located at the north end of the mall, the library is a fitting end to the short incline that passes through the numerous elm trees lining the walkway from Allen Street. (Photograph by Bron Miller.)

This view from the back of the Pattee-Paterno Library shows what are known as "the stacks." Day or night, students can be seen huddled around desks, using this quiet area to study. The stacks section of the library can be quite intimidating with its endless shelves of books. Some students get claustrophobic, and it is not uncommon that some get lost. (Photograph by Bill Coleman.)

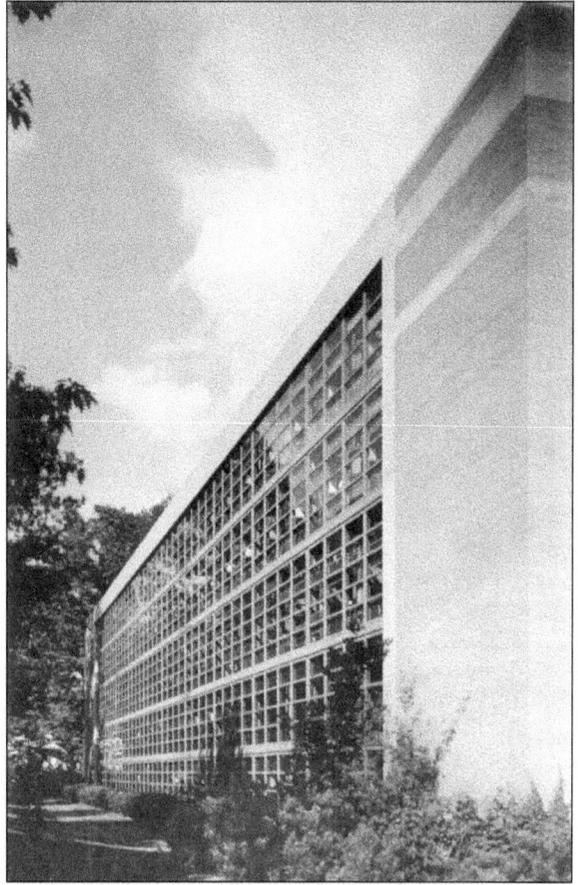

Flanking the library to the east is the former New Education Building, also completed in 1940. It is now known as the Burrowes Building in honor of Thomas H. Burrowes, who was president of the college from 1868 to 1871. As its original name implies, the Burrowes Building was planned to hold the College of Education, now located in the Chambers Building. Today, Burrowes houses the College of Liberal Arts.

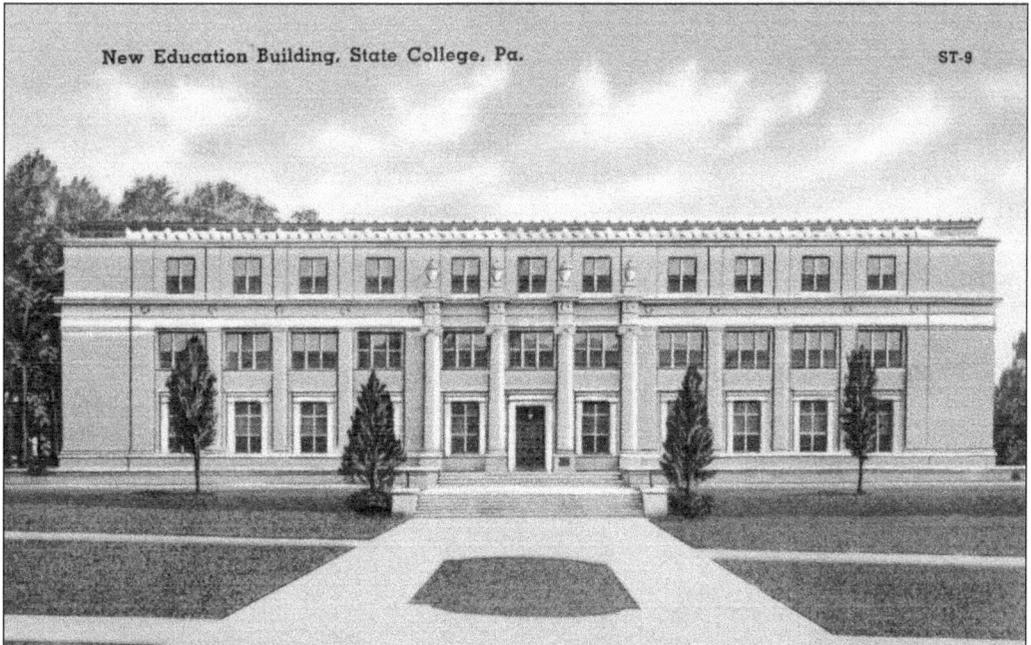

New Education Building, State College, Pa. ST-9

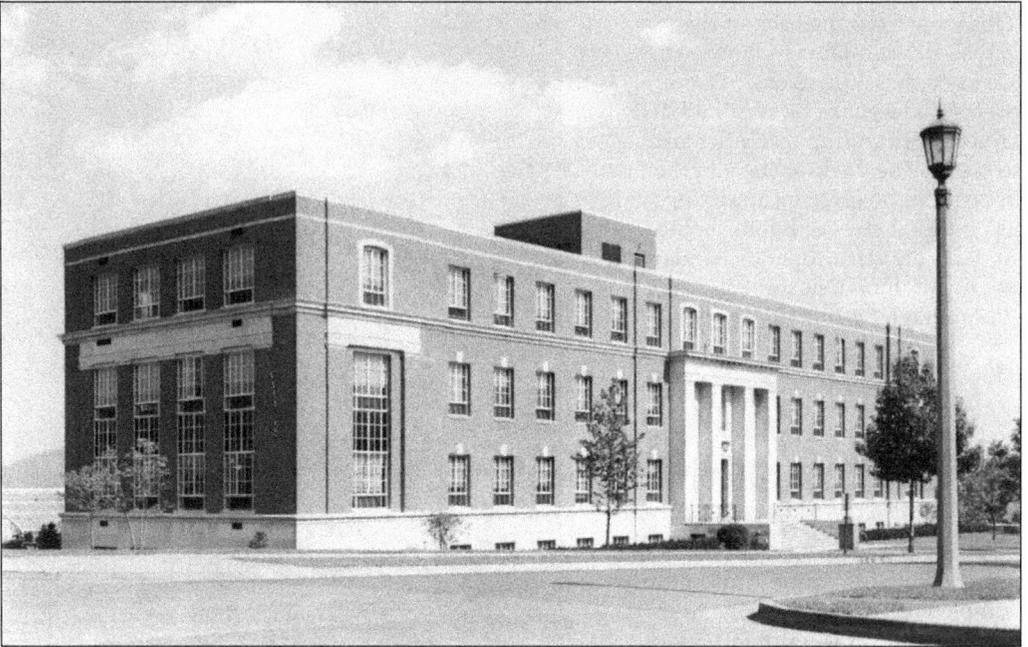

The Plant Industries Building, now known as the Tyson Building, is located at the corner of Shortlidge and Curtin Roads, next to Eisenhower Auditorium and across from the Pavilion Theatre. The building was constructed in 1949 and later dedicated to Chester J. Tyson, a member of the board of trustees from 1912 to 1938. (Photograph by Richard C. Miller.)

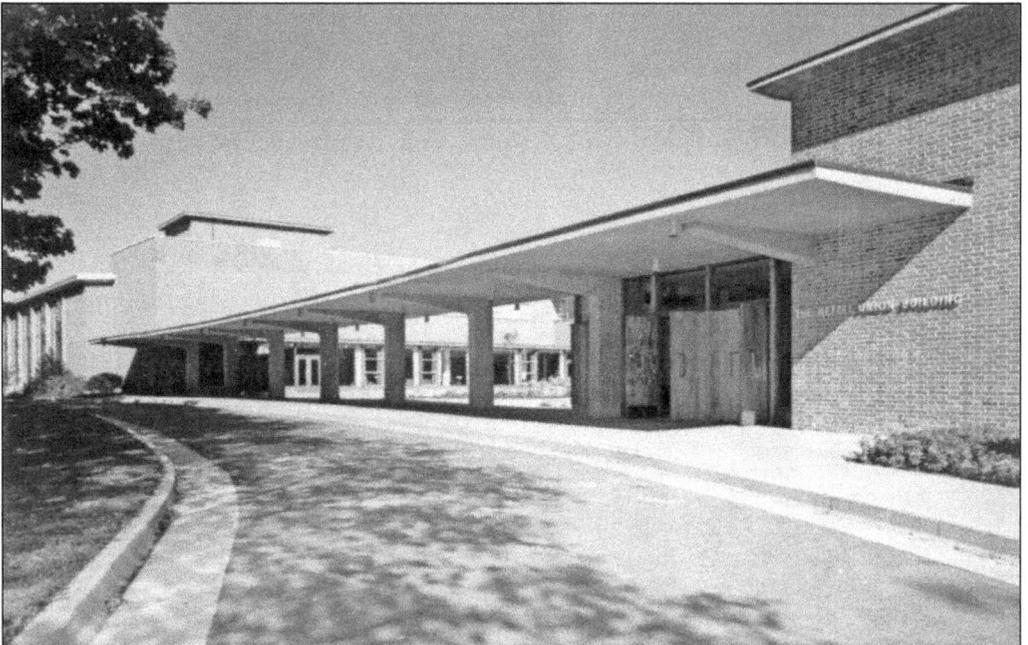

The Hetzel Union Building (HUB) was constructed in 1953 and officially opened in 1955. The HUB has been a meeting place for students and activities since its creation. Housing food vendors, televisions, game rooms, and auditoriums, the HUB might be one of the most visited buildings in the life of a Penn State student. (Photograph by Richard C. Miller.)

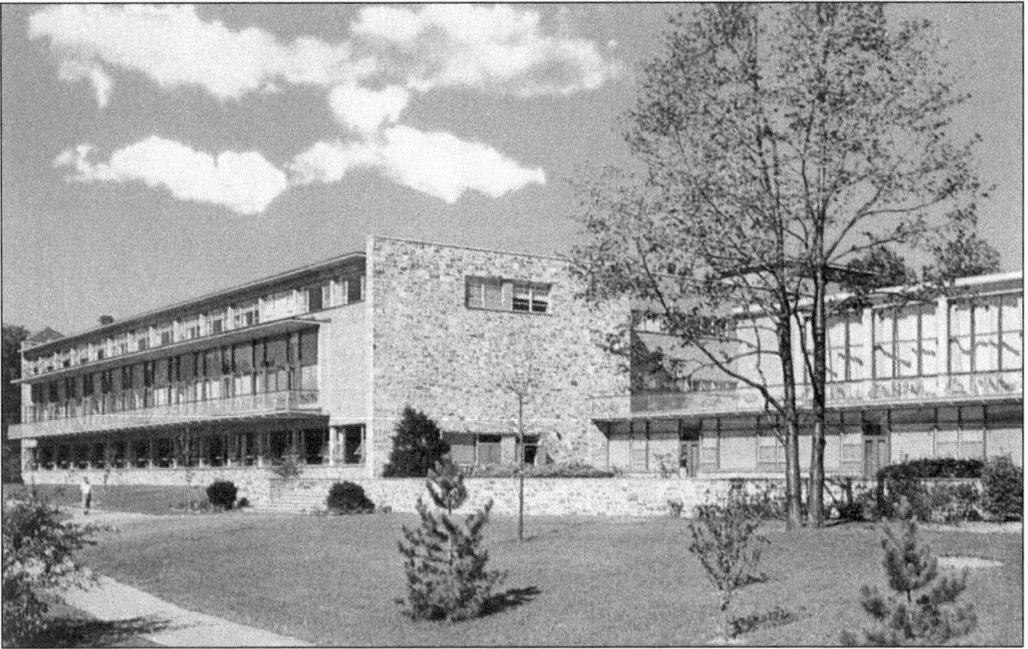

The HUB has undergone many renovations since 1955. This view shows the back of the HUB before 1999, when a terrace was constructed to offer students an outdoor dining area. The building was named after Ralph Hetzel, who was president of the college from 1927 to 1947. (Photograph by Bill Coleman.)

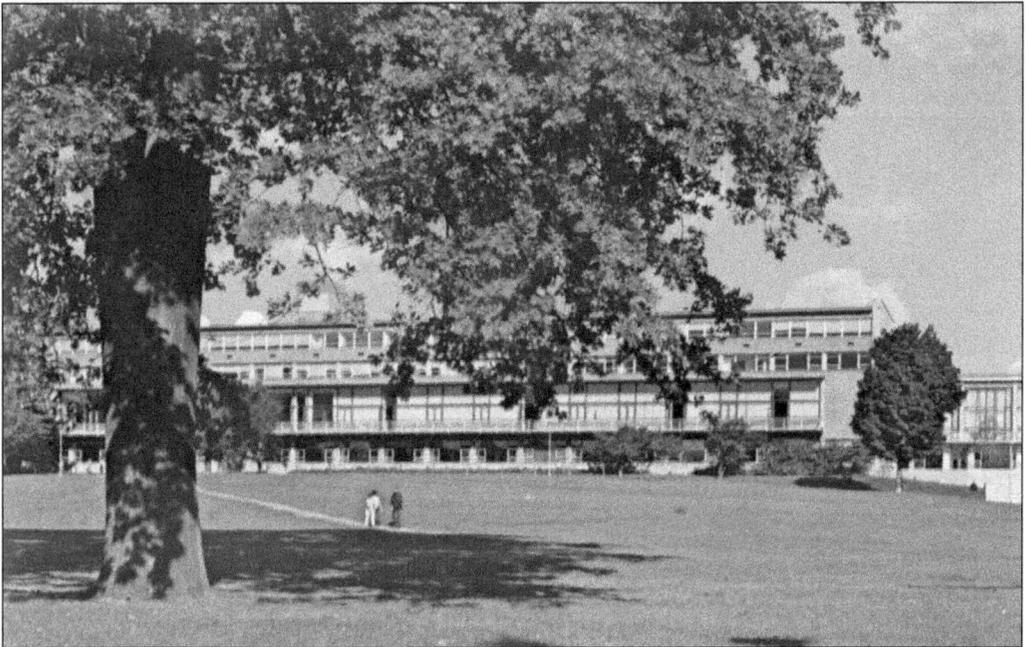

The expansive lawn behind the HUB has seen many games of Frisbee, football, and even tag. Students use this area as they please for recreation and relaxation. It is not uncommon to see students set up a towel to sunbathe or to see a nighttime movie shown in the open air. Outdoor concerts have also been performed here. (Photograph by Richard C. Miller.)

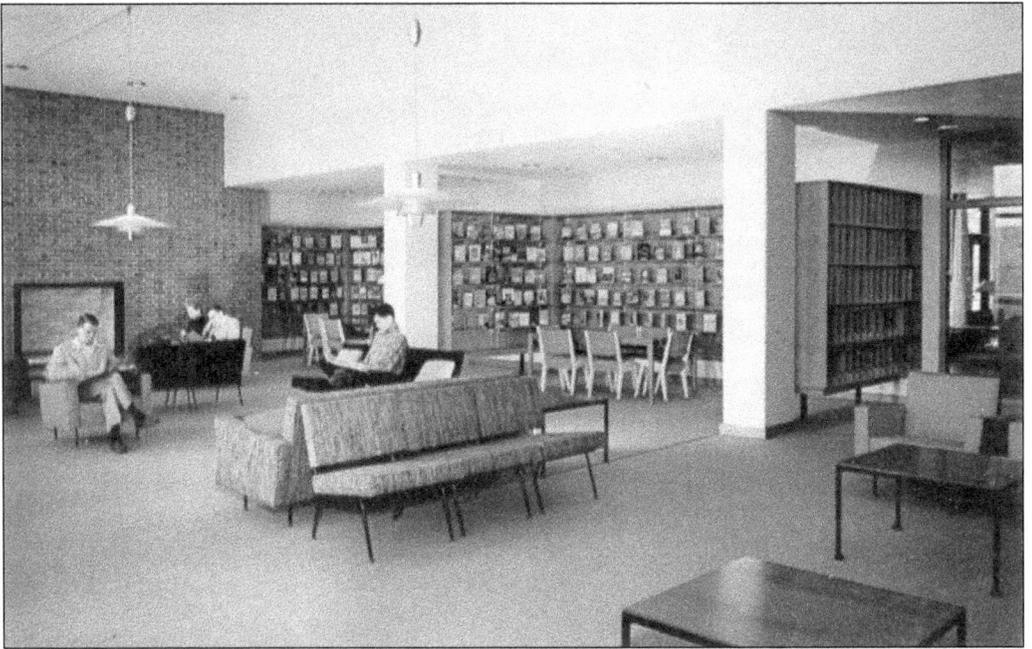

The interior of the HUB has transformed over time. A number of fast-food restaurants have opened on the lower level, along with a revamped student bookstore. In 1997, the HUB building was renamed the HUB–Robeson Center in honor of Paul Robeson, a performer and activist who was not a Penn State graduate but who had visited campus often. The Paul Robeson Cultural Center is also housed in the HUB. These views show the HUB in the 1950s and 1960s. Though the decor has changed with the decades, the original intent remains the same. The HUB-Robeson Center is a place where students can gather to relax, read a book, do some homework, watch television, or grab a bite to eat. (Photographs by Bill Coleman.)

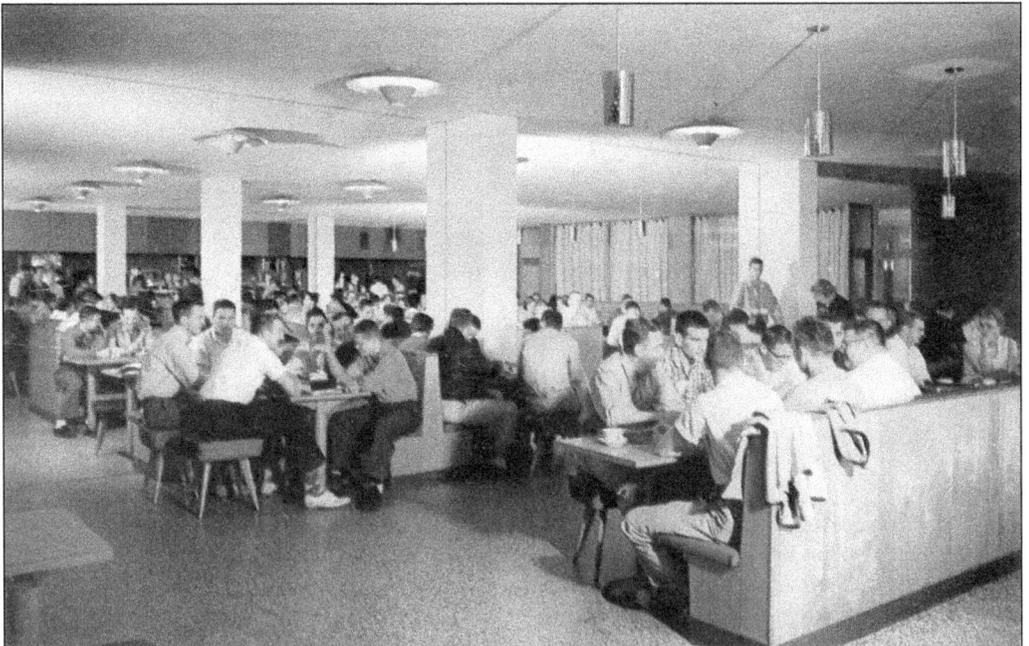

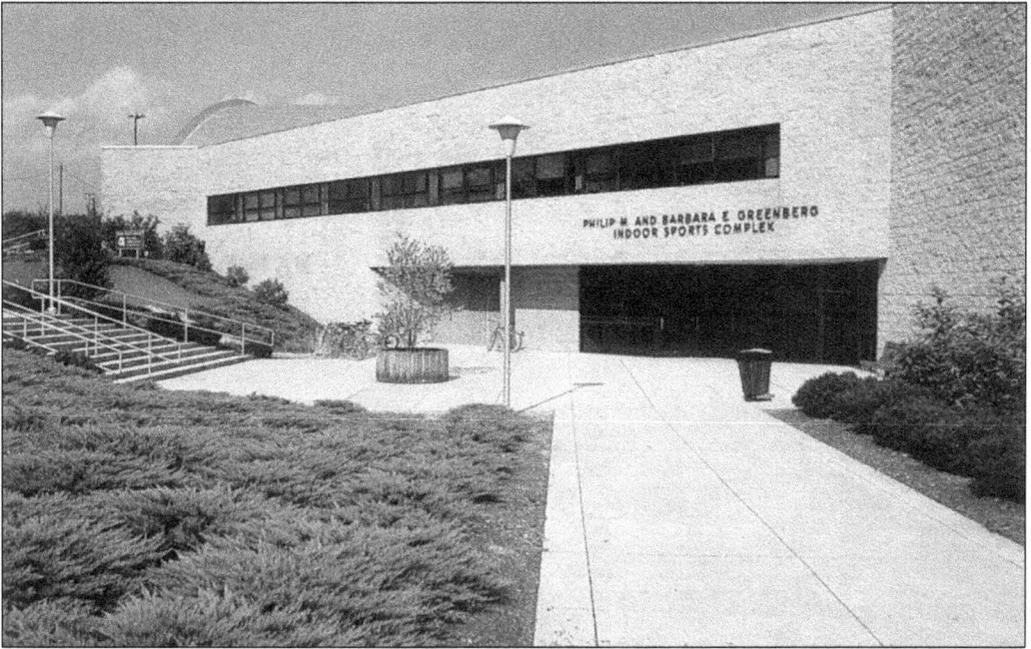

The Philip M. and Barbara E. Greenberg Indoor Sports Complex was officially named in 1982, but the building has its origins as the Ice Pavilion, which was constructed between 1954 and 1955. Before the Pegula Ice Arena, students and ice hockey clubs would skate at this year-round rink with a seating capacity of 1,100. (Photograph by Richard C. Miller.)

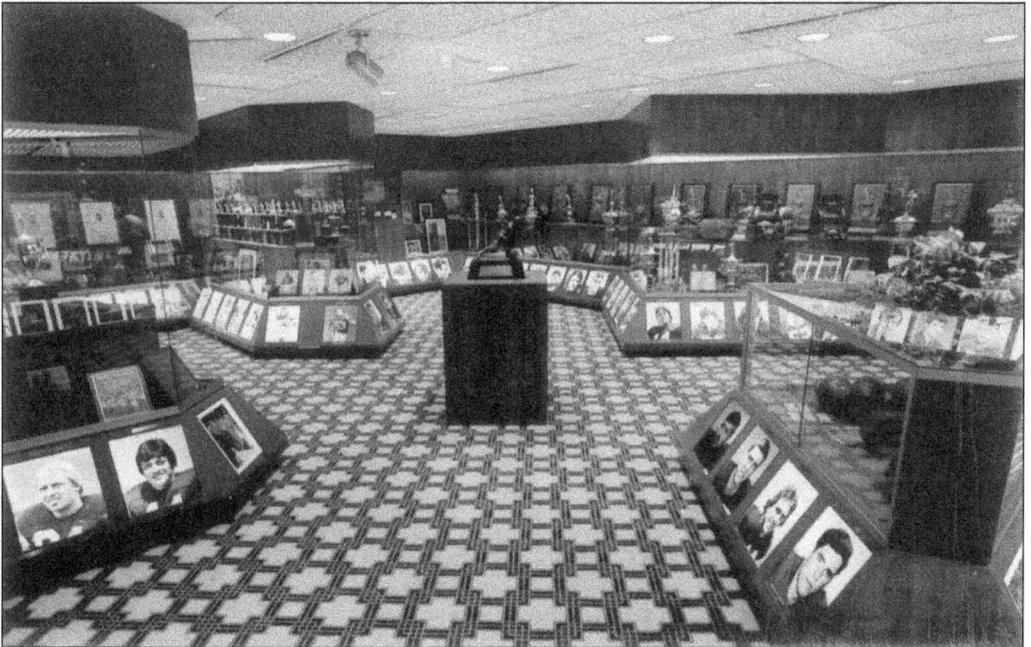

Penn State's Football Hall of Fame was housed inside the Greenberg Indoor Sports Complex. The museum contained football memorabilia, including John Cappelletti's Heisman Trophy, which is pictured in the center. All the items were moved to the southwest corner of Beaver Stadium, where the All-Sports Museum opened in 2002.

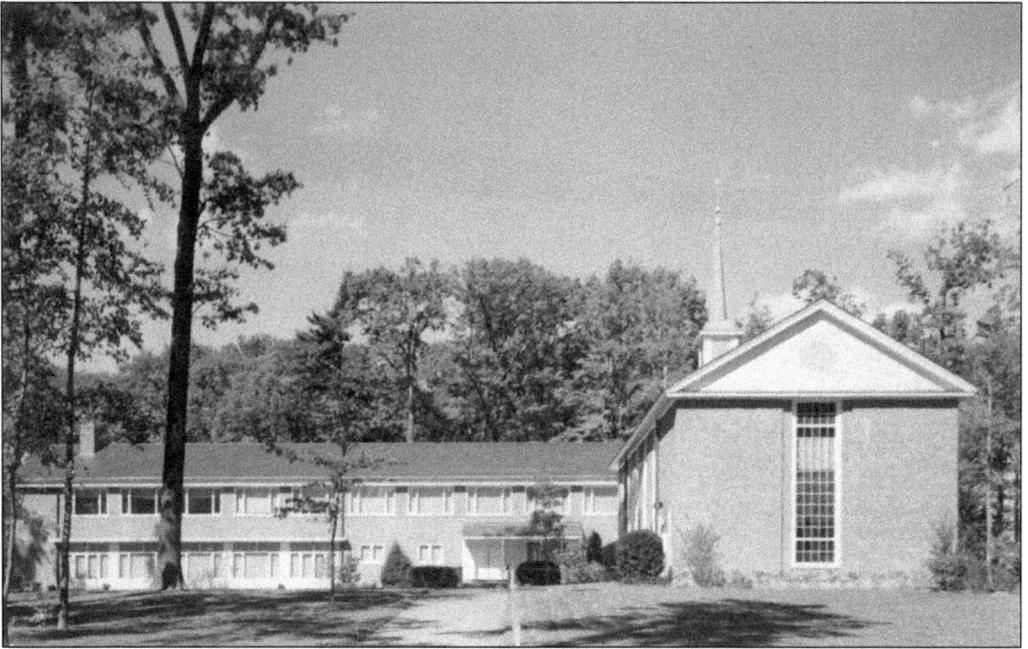

The Helen Eakin Eisenhower Chapel, built between 1955 and 1956, is an all-faith chapel named after the wife of then university president Milton S. Eisenhower, who was the brother of then president of the United States Dwight "Ike" Eisenhower. Helen Eisenhower passed away two years before the completion of the chapel. The Pasquerilla Spiritual Center was added in 2003. (Photograph by Richard C. Miller.)

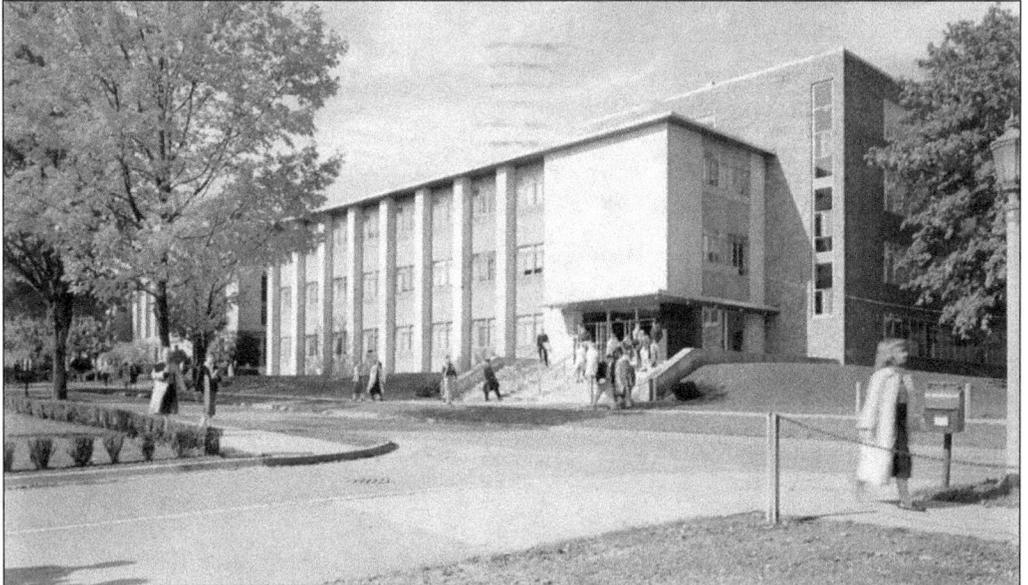

The Bouke Building is located next to Osmond Laboratory, across the street from the HUB. Constructed between 1955 and 1956, the building was named after Oswald Frederick Boucke, who was head of the Department of Economics from 1909 to 1935. The Bouke Building contains office space for various organizations, such as student affairs, affirmative action, and global studies. (Photograph by Bill Coleman.)

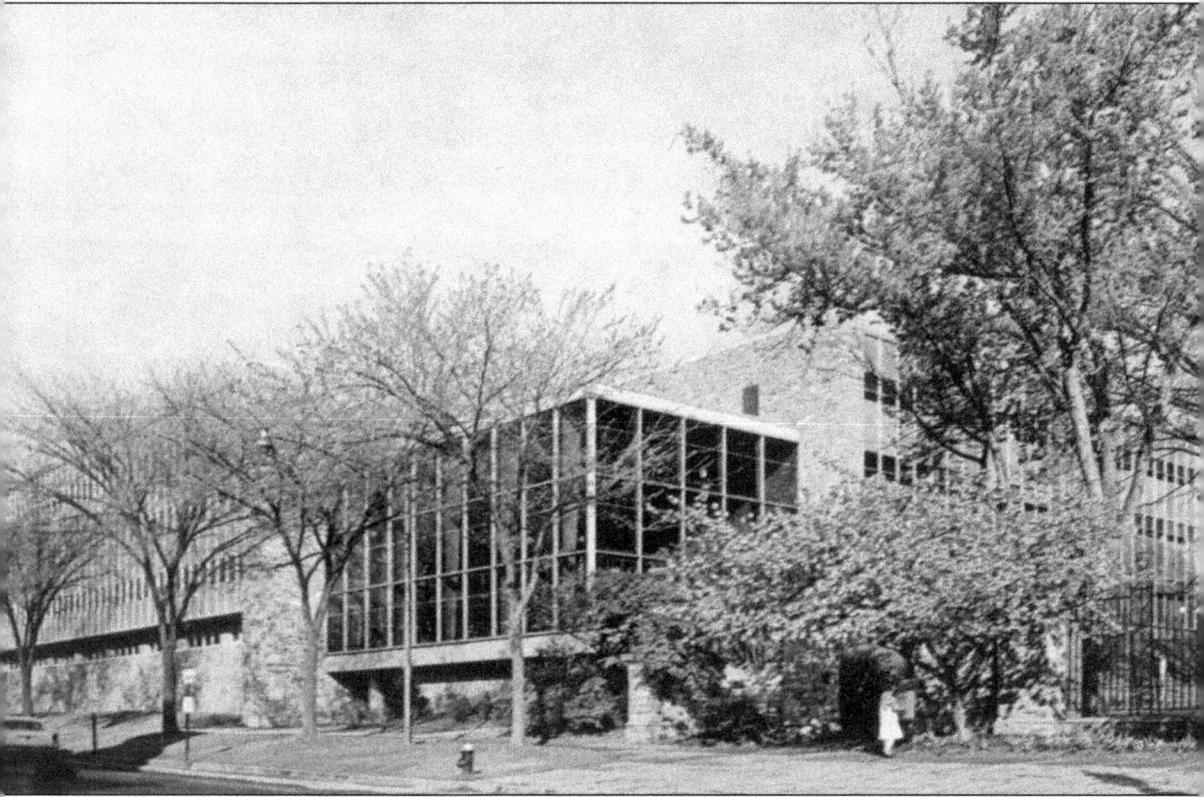

Harry Parker Hammond was dean of the College of Engineering from 1937 to 1951. To honor his work for the university, the building that houses classrooms and laboratories for the College of Engineering would take his name. The Hammond Building, constructed from 1958 to 1960, is situated at the corner of the main entranceway to the university, seen to the lower right. In the center is the main entrance to the Hammond Building, and to the right is the beginning of the Sackett Building. To make way for the new building, the Petroleum Refining Laboratory was removed. The additions to the Sackett Building were erected at about the same time, and both the Hammond and Sackett Buildings are accessible from this entranceway. (Photograph by Richard C. Miller.)

The Henderson South Building is located at the Pugh Street entranceway. This building was erected in 1960 to add more classrooms and office space for the growing College of Home Economics. Since then, the College of Home Economics has changed to the College of Human Development and now the College of Health and Human Development. Henderson and Henderson South are now part of the Henderson Complex. (Photograph by Richard C. Miller.)

Almost every Penn State student has had at least one class in the Forum, located near the Palmer Museum of Art and the Theatre Building. This multipurpose building, constructed from 1962 to 1965, has a circular configuration with numerous lecture halls, each of which can contain up to 400 students. (Photograph by Richard C. Miller.)

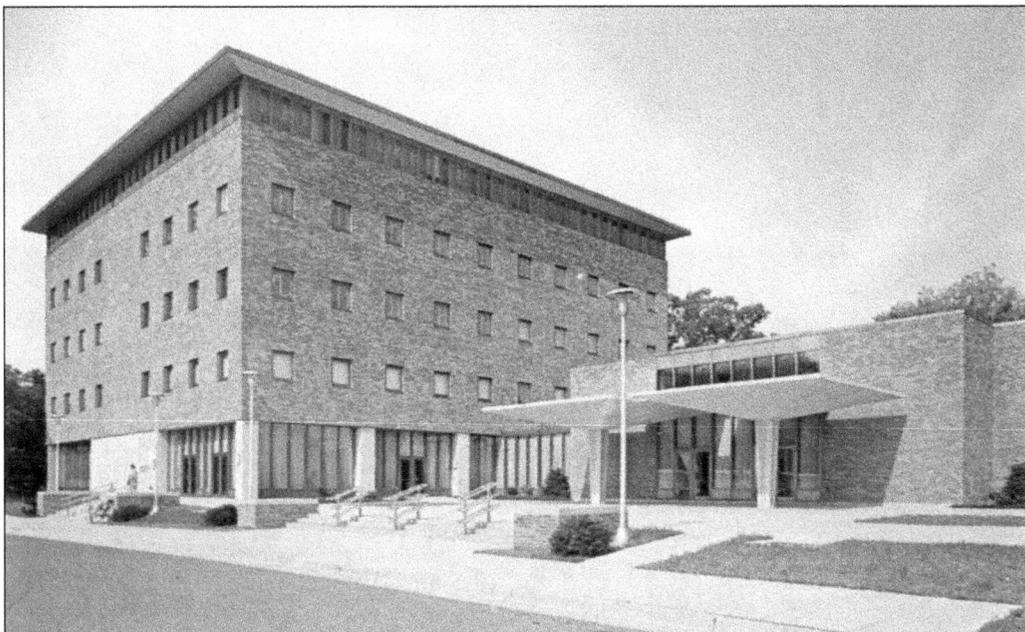

The J. Orvis Keller Building, constructed from 1963 to 1965, is located near the Nittany Parking Deck. It is used as a conference center and as the headquarters of the continuing education program. The building's namesake, J. Orvis Keller, was a 1914 graduate and staff member from 1916 to 1953. Keller was in charge of the continuing education program from 1934 to 1953. (Photograph by Richard C. Miller.)

In 1965, Penn State's Festival Theatre was held in the newly constructed Arts Building, located between the Forum and the Music Buildings. The 385-seat theater would become known as Pennsylvania Centre Stage in 1985. The building was renovated in 2009 and is now known as the Theatre Building. (Photograph by Richard C. Miller.)

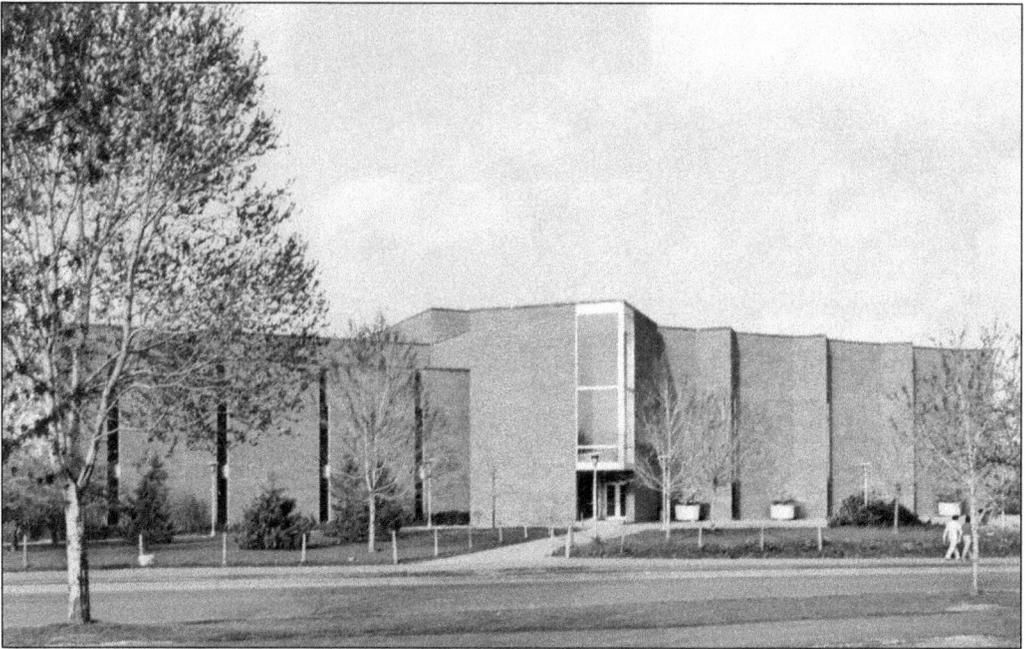

The McCoy Natatorium, constructed from 1965 to 1967, was named after Ernest B. McCoy, who was the dean of the College of Health, Physical Education, and Recreation from 1952 to 1970. The building contains three pools for swimming and diving lessons and competitions, as well as classrooms and office space. (Photograph by Richard C. Miller.)

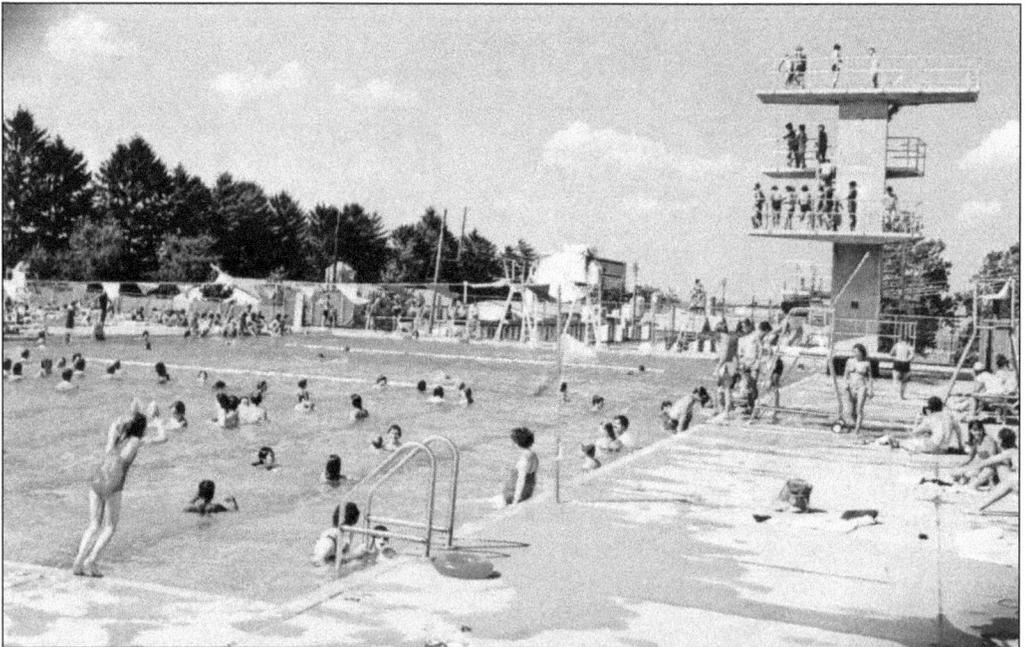

Penn State's outdoor pool is directly adjacent to the McCoy Natatorium. The Olympic-size pool (50 meters by 25 meters) is available to the student body and staff, who can purchase one-day recreational passes or annual memberships. The pool is also open to local residents. (Photograph by Richard C. Miller.)

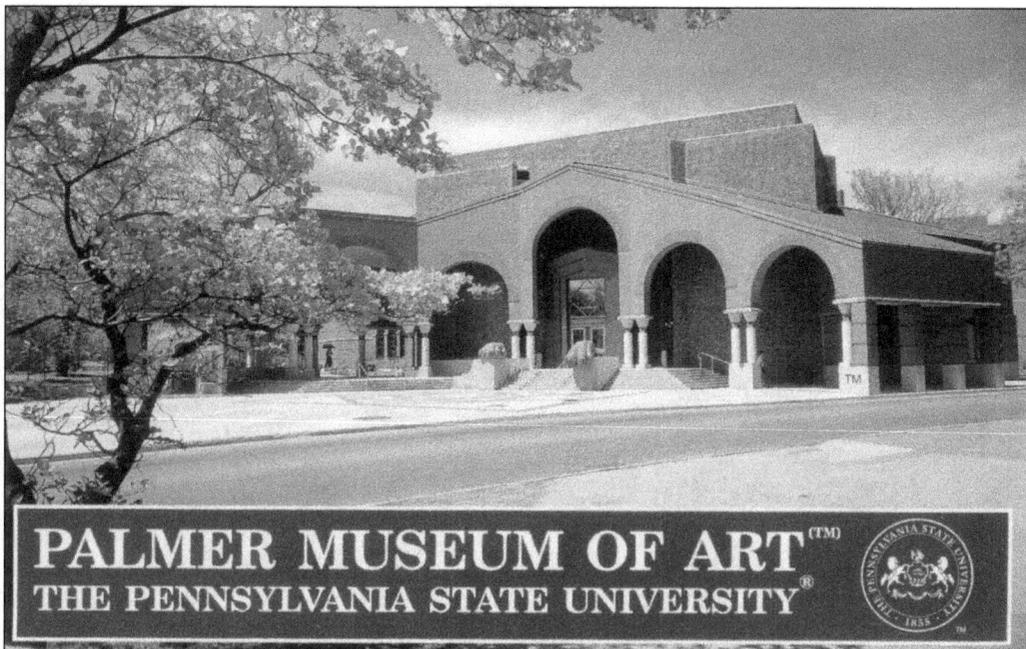

The Palmer Museum of Art, constructed from 1967 to 1972, houses paintings and sculptures from around the world. A new entranceway was built in the early 1990s. With this addition came the two huge lion paws, which command much more attention than the previous entrance. (Photograph by C.G. Wagner Jr.)

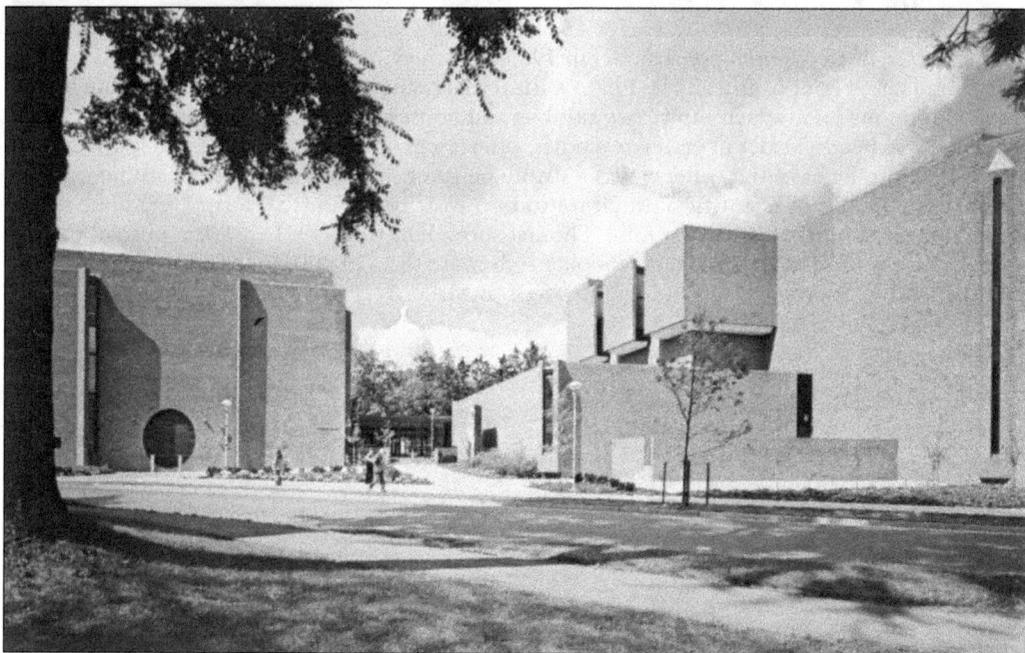

This side view of the Palmer Museum shows the blocky structure of the building prior to the new entranceway addition. To the right is the Visual Arts Building, which was constructed in 1971 to house the Edwin W. Zoller Gallery. The water tower seen above the trees in the distance was demolished in 2015. (Photograph by Richard C. Miller.)

The Kern Graduate Center, constructed in 1969, is named after Frank D. Kern, who was dean of the graduate school from 1922 to 1950. Within this home of the Penn State Graduate School is the Commons area, which showcases exhibits and houses Otto's Café, a popular eatery. Penn State has long been a leader in graduate studies, offering graduate-level courses since 1863. Evan Pugh, then president of the college, was a strong believer in post-baccalaureate studies, and he awarded the master of scientific agriculture to two worthy students. A formal graduate school was not created until 1922, when John Thomas, president from 1921 to 1925, pushed to have one established. Today, the graduate school enrolls more than 10,000 students a year across more than 160 different programs. (Photograph by Bron Miller.)

Across the street from the McAllister Building are the Chandlee and Davey Laboratories. Occupied in 1966, Chandlee Laboratory (left) was named after Grover Chandlee, who was head of the Department of Chemistry from 1919 to 1949. Constructed from 1969 to 1972, Davey Laboratory (right) was named after Wheeler P. Davey, who was a professor of physics and chemistry from 1926 to 1949. (Photograph by Richard C. Miller.)

Eisenhower Auditorium was named in honor of Milton S. Eisenhower, president of the university from 1950 to 1956. He was also the brother of Dwight D. Eisenhower, who was president of the United States from 1953 to 1961. The 2,600-seat auditorium was built in 1974 and was dedicated to Eisenhower in 1977. (Photograph by Bron Miller.)

The Intramural Building, completed in 1975, is one of three facilities used for physical education. The other two are Rec Hall, built in 1929, and the Mary Beaver White Building, built in 1938. At Penn State, every student is required to have credits in health and physical activity. Such classes offered at the Intramural Building include archery, fitness and games, and jogging, as well as other heart-healthy exercises. A recent renovation to the building in 2014 boasts an expanded fitness center, a new entranceway, and several multipurpose rooms. Students can borrow sports equipment, such as volleyballs and soccer balls, for use within the building, which is open every day until midnight. Adjacent to the freshmen dormitories of East Halls, its location is about a block away from Beaver Stadium and across the street from the Shields Building in the northeast corner of campus. (Photograph by Bron Miller.)

Three

SOMETHING OTHER THAN STUDYING

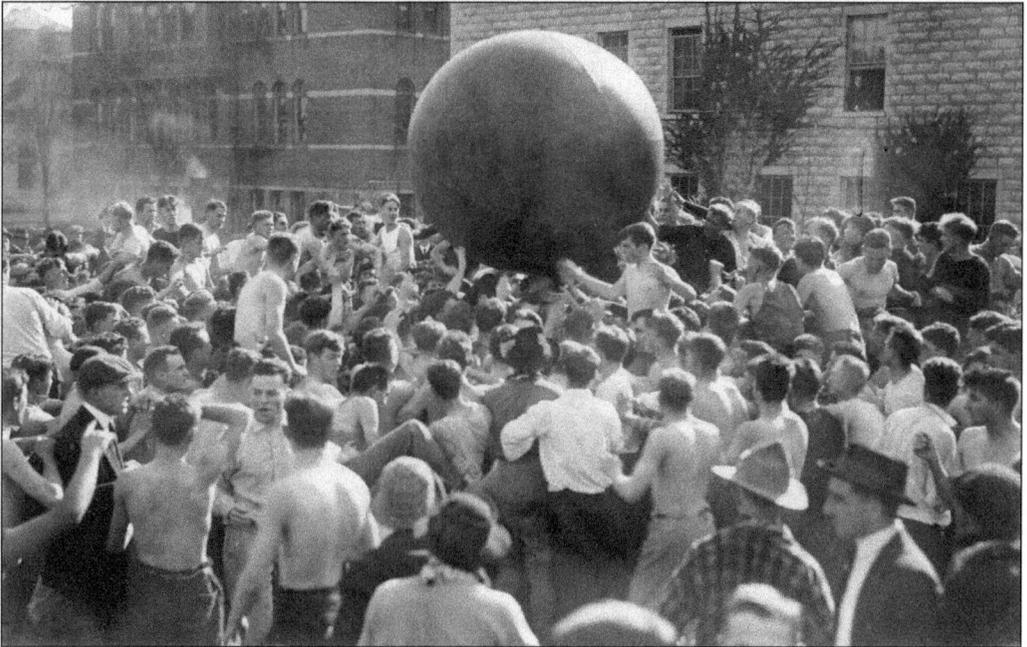

This scene depicts a pushball scrap between the sophomore and freshmen classes. Scraps between classes were common at the time, and pushing a large ball toward one end of a field or the other seemed to be one of the less dangerous of the scraps. In his message, the sender of this postcard refers to himself as a "top man" in the scrap and claims there were "about 1,000 fellows" involved. This card was postmarked on November 2, 1914.

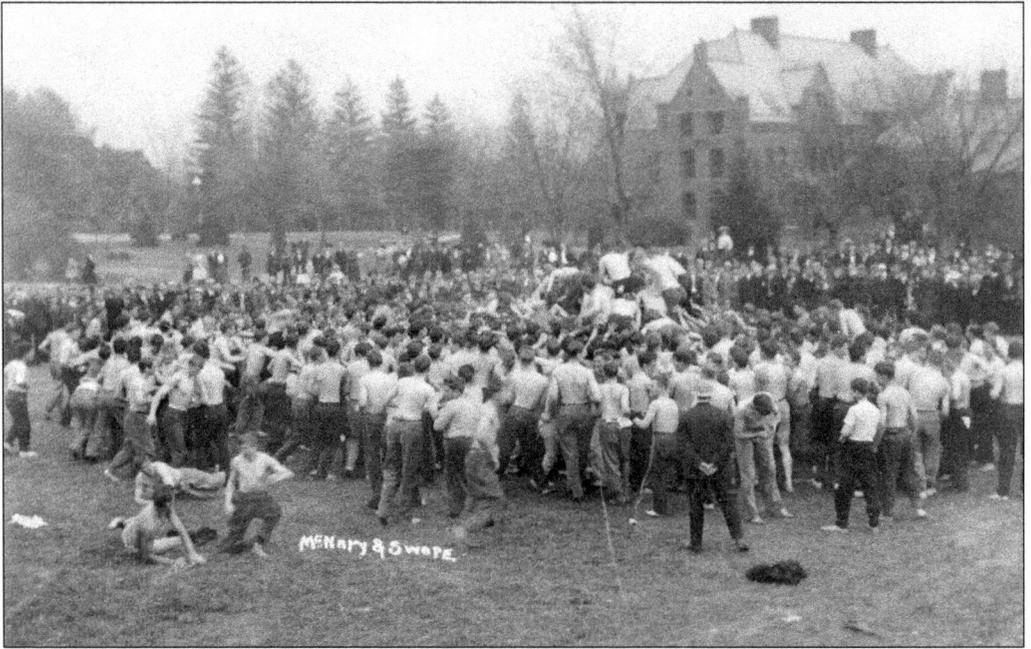

Pushball scraps were still going strong in 1915. The locations of these scraps were numerous, since there was a lot of open space on campus in the early 1900s. This scrap occurred by the Old Engineering Building. The main road lined with elm trees is visible toward the back left.

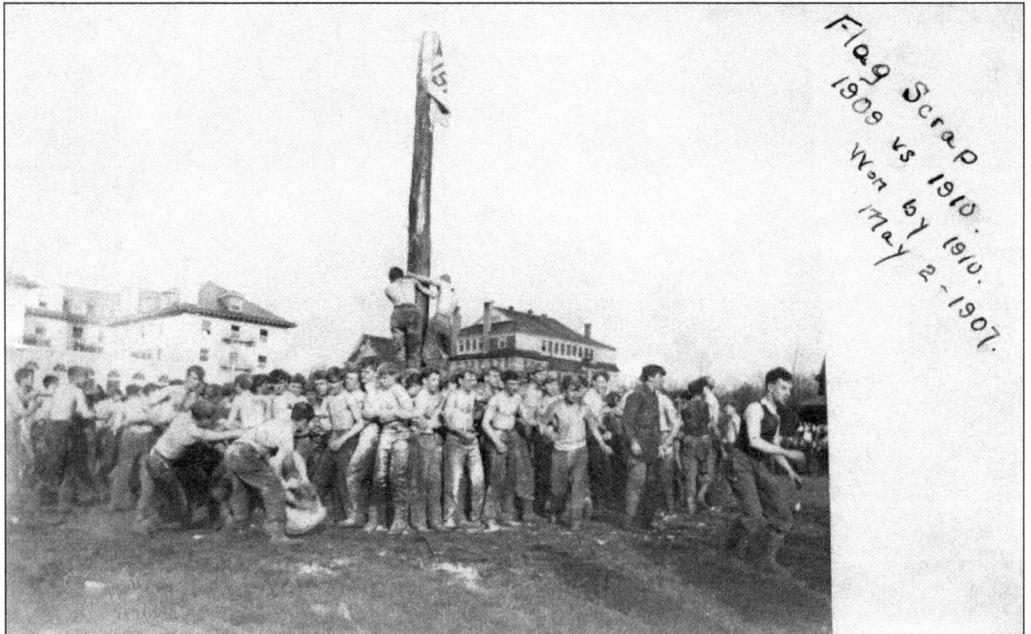

Another type of competition from the early days was the flag scrap, in which students had to climb the pole of the opposing class and retrieve their flag. This real-photo postcard shows the class of 1910 defeating the class of 1909 on May 2, 1907. The building pictured in the center of this scene appears to be the old Chemistry and Physics Building, while the building to the left looks like the back of McAllister Hall.

74

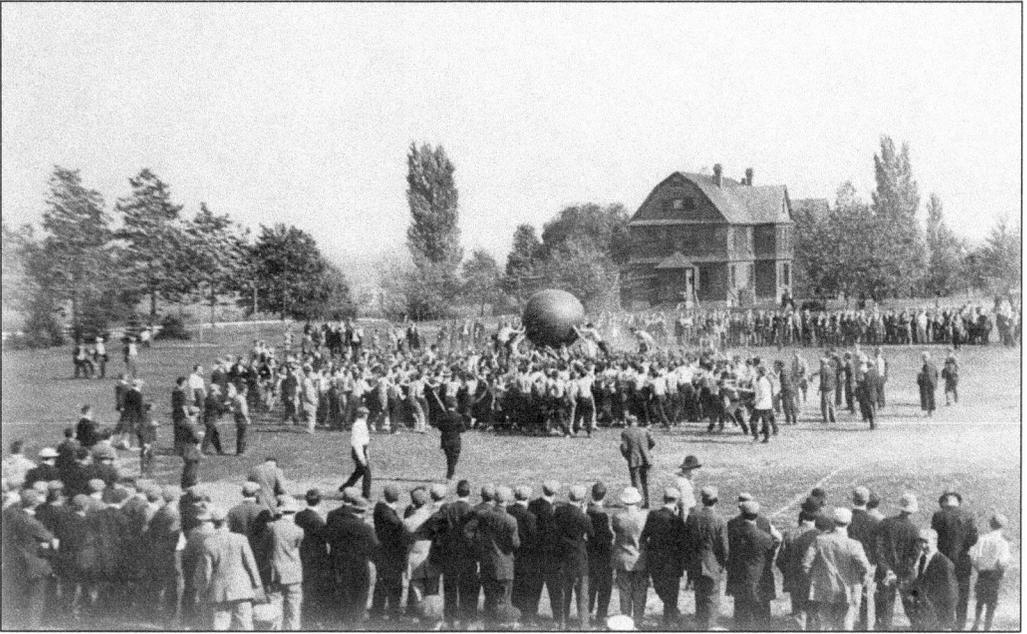

These postcards show a pushball scrap on Beaver Field. At the time, Beaver Field was located much closer to Old Main, near what is now a parking area for Pond and Osmond Laboratories. Beaver Field remained there until 1909, when it was moved to the northwest corner of campus, approximately where the Nittany Parking Deck is today. Note the cottages at the edge of the field that were used for housing faculty. The cottage seen in both images looks to be Maple Cottage, which was demolished in 1953. The second cottage is hard to identify because of the lighting, but it is probably Pine Cottage.

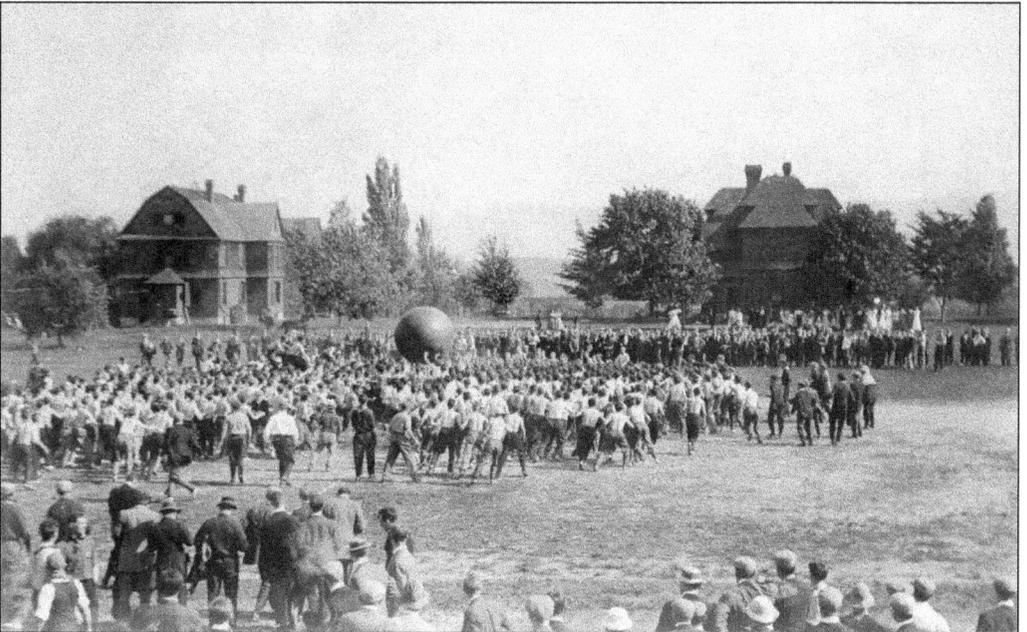

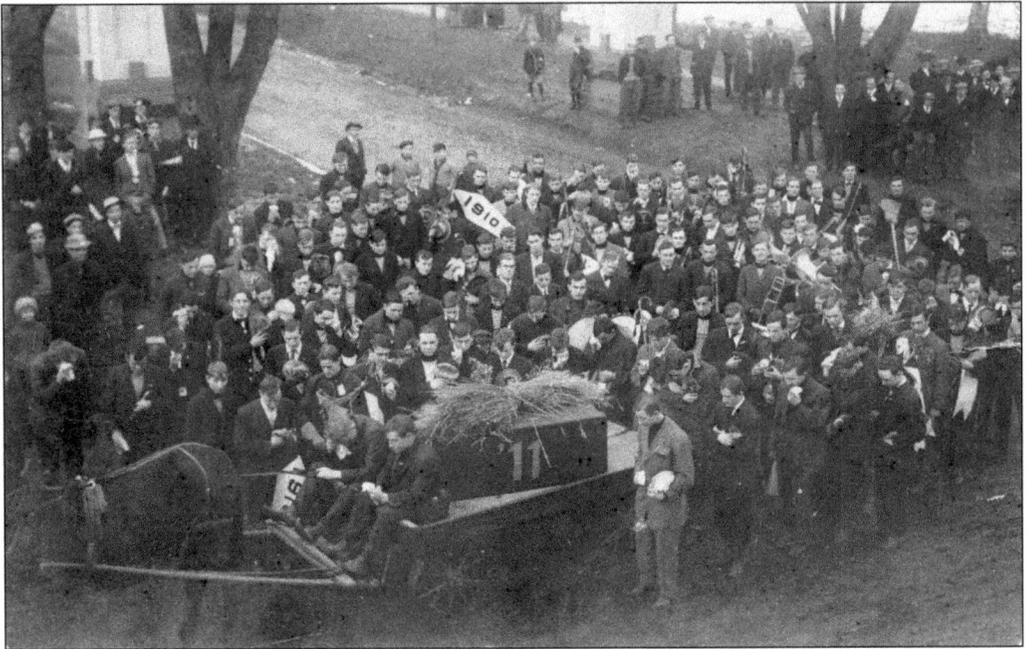

In this real-photo postcard, the class of 1910 is holding a mock funeral for the class of 1911 (notice the '11 on the casket) outside the main entrance to Penn State. Perhaps the class of 1910 defeated the class of 1911 in some of the scraps at the time. Members of the Cadet Band can be seen following the casket.

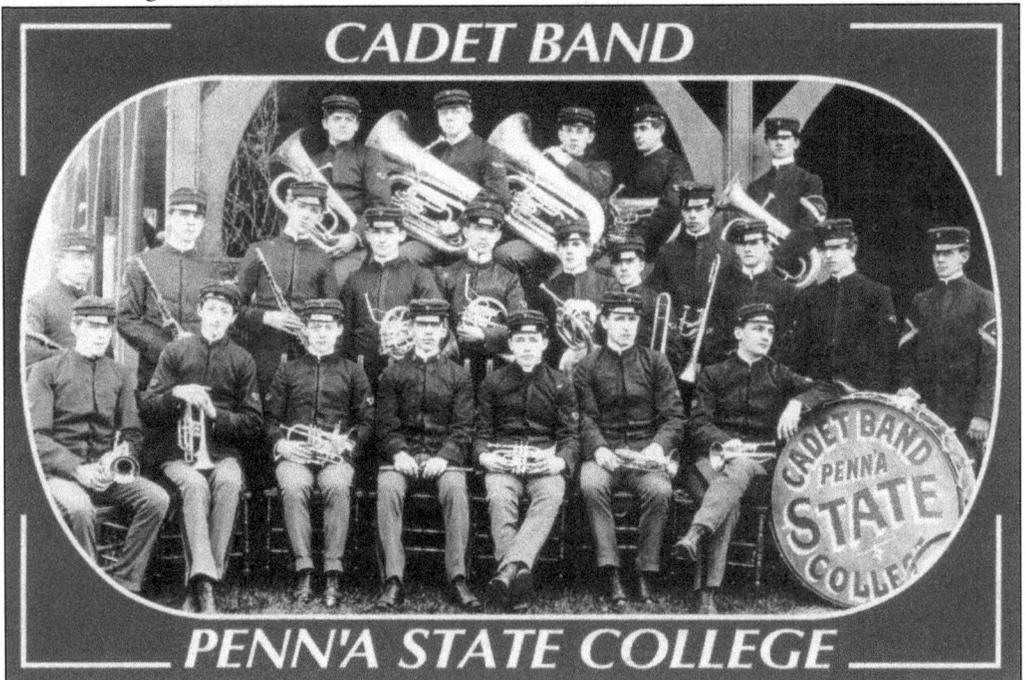

The Penn State Blue Band can trace its origins to 1899 with the formation of the Cadet Band. This postcard shows the 1901 Cadet Band. The organization would not be known as the Blue Band until 1923, when a small portion of the gray uniforms were replaced with blue ones.

76

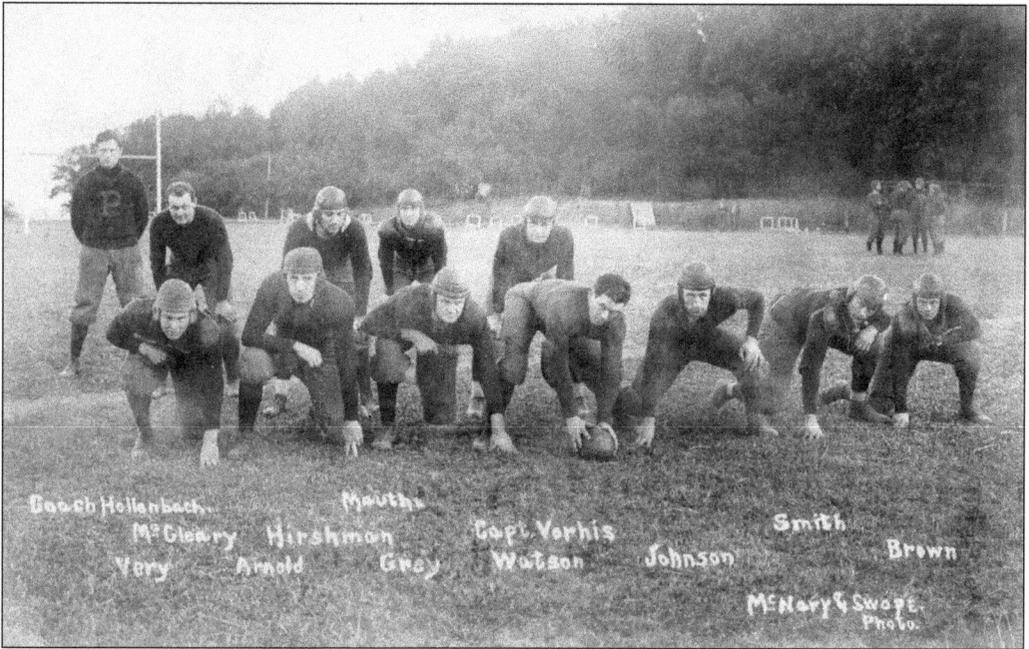

Coach Hollenbach. Mauthe
McCleary Hirshman Capt. Vorhis Smith
Very Arnold Grey Watson Johnson Brown
McNary & Swope.
Photo.

Before James Franklin, Bill O'Brien, Joe Paterno, Rip Engle, Joe Bedenk, Bob Higgins, and Hugo Bezdek, there was Bill Hollenback. This card shows the undefeated 1909 football team, which was the first to play at the new Beaver Field in the northwest section of campus. The 1911 and 1912 teams were also undefeated under Coach Hollenback.

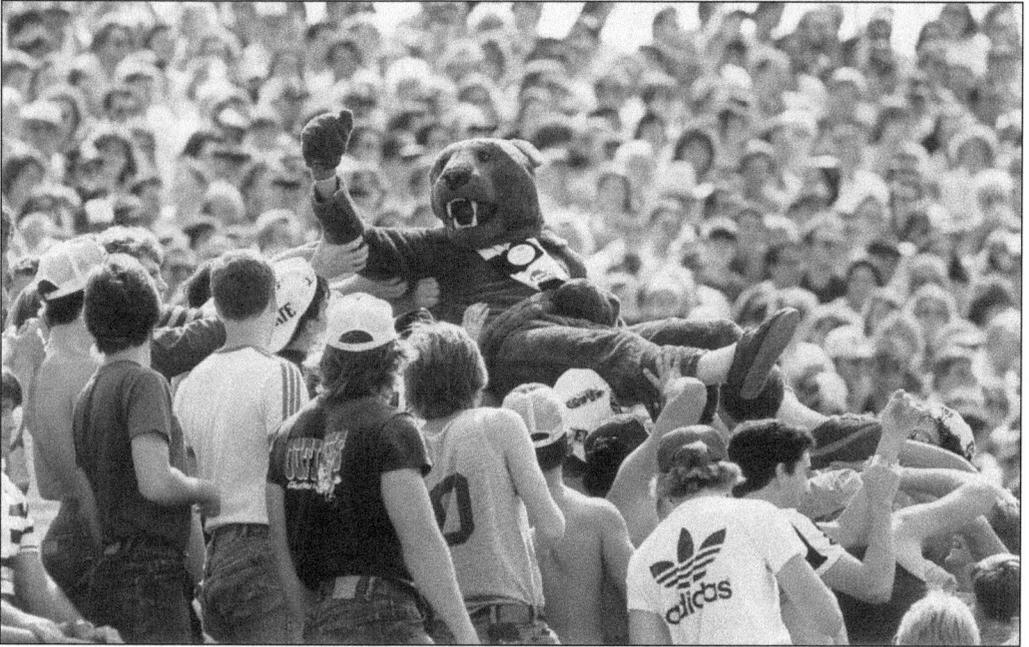

In the past, the Nittany Lion mascot would crowd surf during a game in whatever section of the stadium cheered, "We want the Lion!" the loudest. This tradition seems to have gone by the wayside since the enclosure of the stadium with the north and south decks and the addition of the suites to the east side.

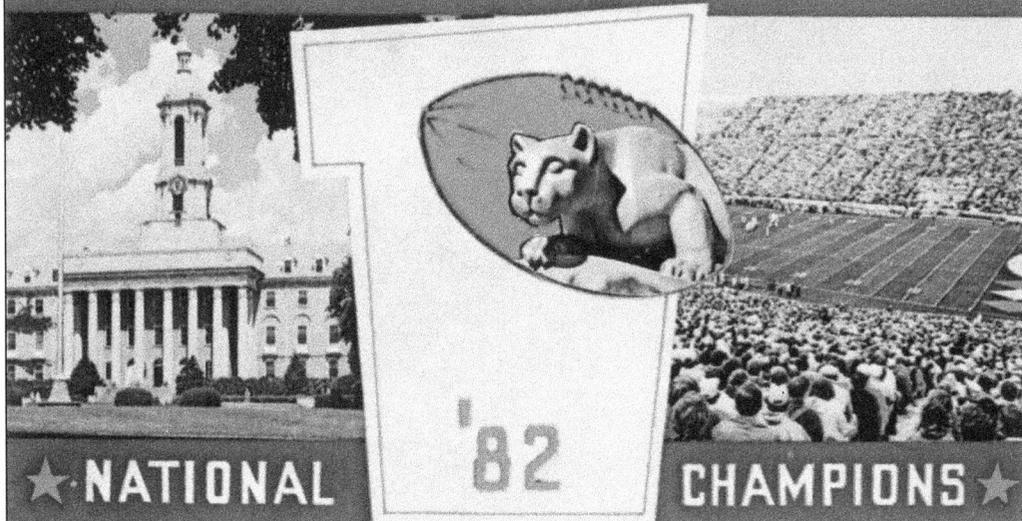

NATIONAL '82 CHAMPIONS

In the long history of Penn State football, the team has taken home only two national championship titles, in 1982 and 1986. Penn State was awarded the 1982 national championship after defeating the University of Georgia by a score of 27–23 in the 1983 Sugar Bowl. Penn State would win the national championship just four years later when the University of Miami was defeated 14–10 in the 1987 Fiesta Bowl. Many believe the 1969 team deserved the national championship, but after going undefeated, the Nittany Lions were overtaken when none other than Pres. Richard Nixon proclaimed the undefeated Texas Longhorns as the national champions. Penn State would be "robbed" once again in 1994, when an undefeated Nebraska Cornhuskers team was crowned national champions instead of the undefeated Nittany Lions.

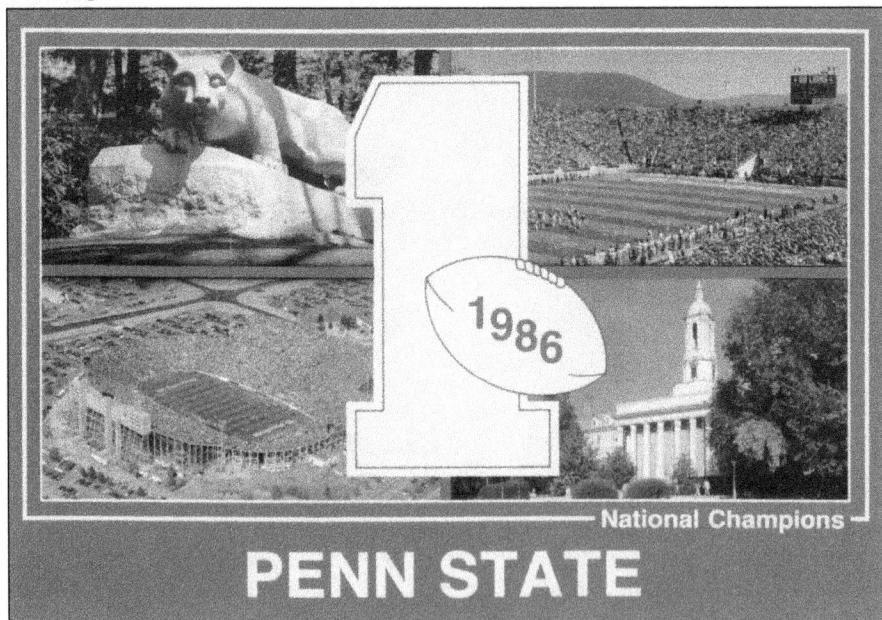

National Champions
PENN STATE

Joe Paterno was head coach of the Penn State Nittany Lions football team from 1966 to 2011. The team's record during his tenure as coach was 409-136-3, boasting multiple undefeated seasons, two national championships, and only five losing seasons. Paterno passed away from lung cancer on January 22, 2012.

The Paterno statue was erected on the east side of Beaver Stadium in 2001 to commemorate his status as the Division 1-A all-time victories leader. To the right of the statue is the inscription: "They ask me what I'd like written about me when I'm gone. I hope they write I made Penn State a better place, not just that I was a good football coach." (Photograph by Bron Miller.)

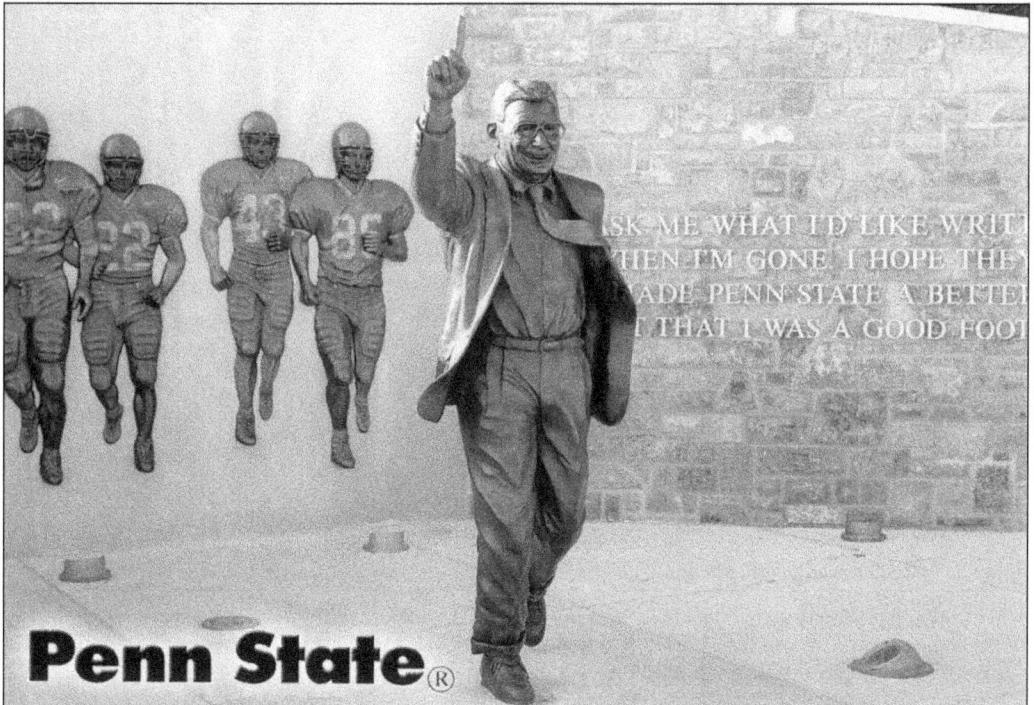

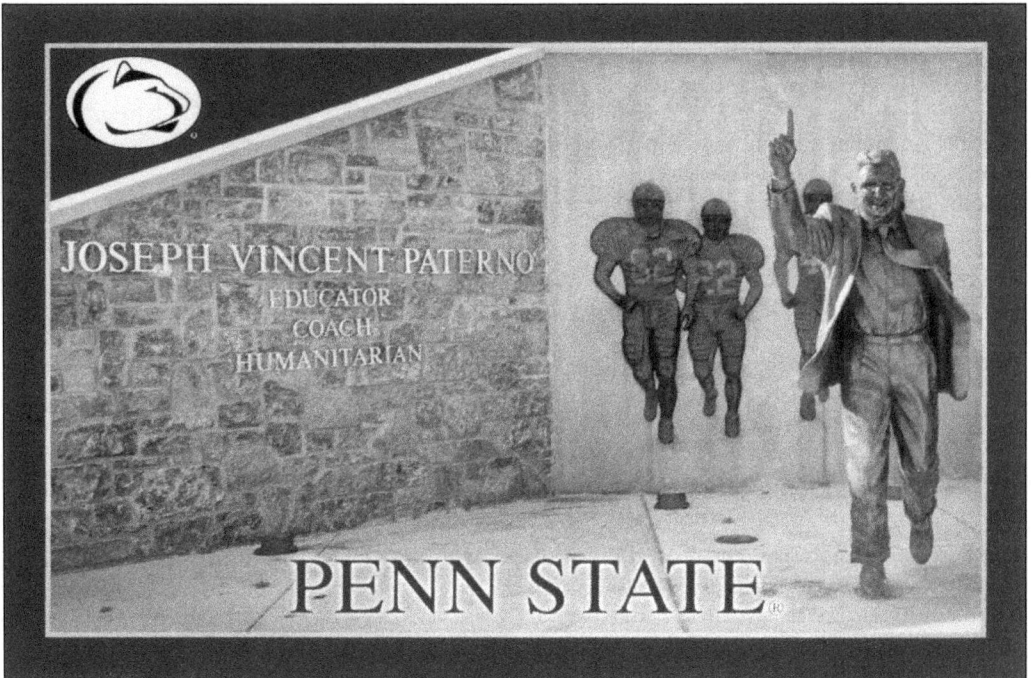

On July 22, 2012, the Paterno statue was removed and placed in a secure location in light of the Jerry Sandusky scandal. Then president Rodney Erickson stated, "Coach Paterno's statue has become a source of division and an obstacle to healing in our university and beyond." Many alumni and supporters believe the statue will be reerected sometime soon. (Photograph by C.G. Wagner Jr.)

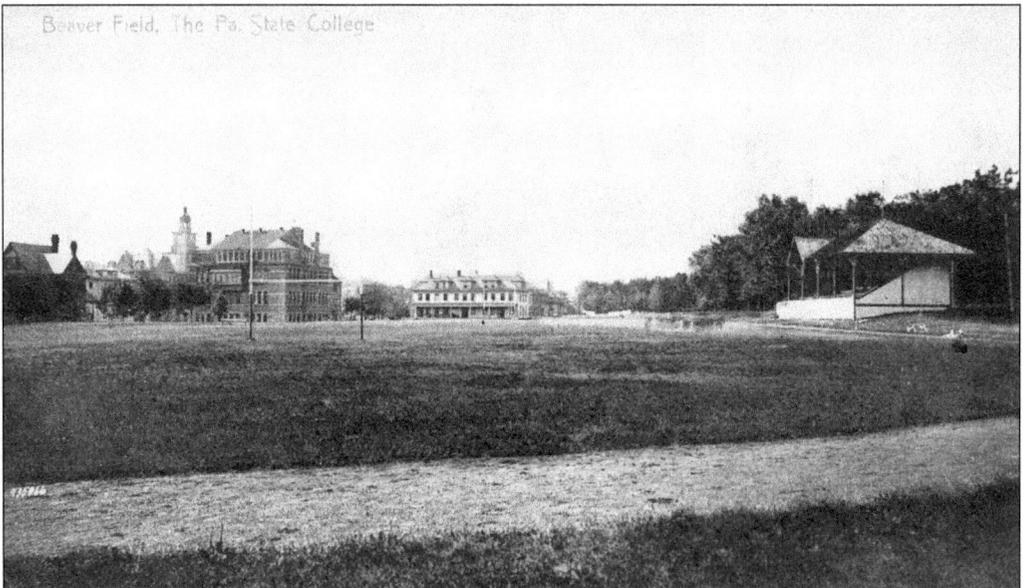

Originally, football games were played on the lawn in front of Old Main. Beaver Field, pictured here, was established in 1893 with a grandstand that could seat 500 spectators. The field would remain behind the Chemistry and Physics Building (the current site of Osmond and Davey Laboratories) until 1909. (CPCCCHS.)

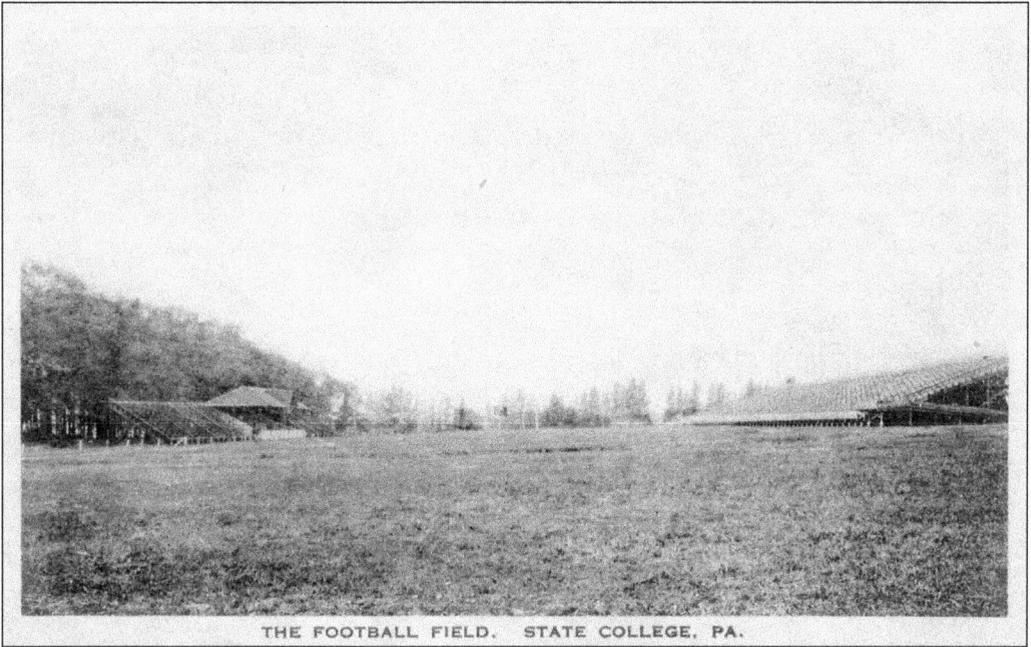

THE FOOTBALL FIELD. STATE COLLEGE, PA.

In 1909, Beaver Field was moved to the northwest corner of campus, approximately where the Nittany Parking Deck is today. The field was named after Gen. James Beaver, a Civil War veteran who was also governor of Pennsylvania (1887–1891), a member of the board of trustees (1873–1882 and 1897–1914), and acting president of the college (1906–1908). (CPCCCHS.)

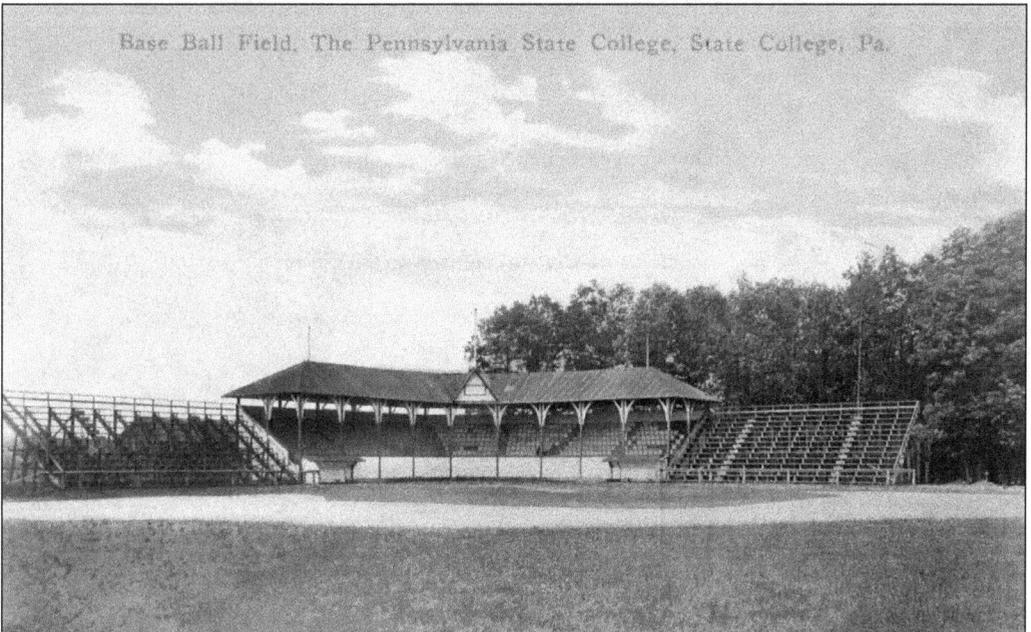

Base Ball Field, The Pennsylvania State College, State College, Pa.

At the time, Beaver Field denoted both the football field and the baseball field, both of which were located in the northwest corner of campus. The original intent was to have most of the sports venues situated in that area. Rec Hall was constructed as the basketball arena in 1929, followed by the Nittany Lion Inn in 1931, so visitors had a place to eat and sleep. (CPCCCHS.)

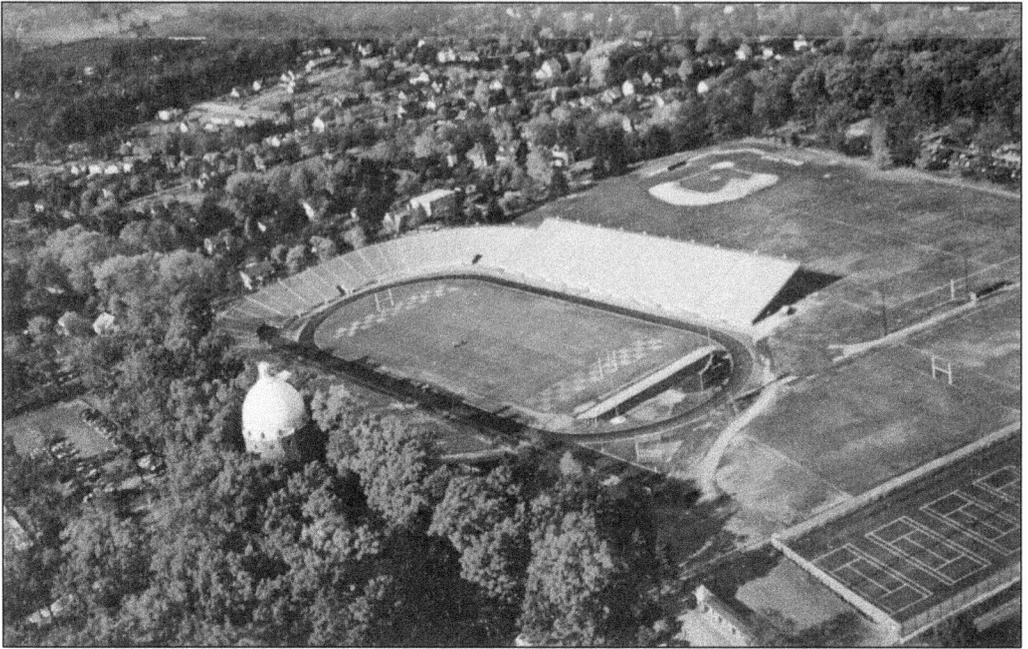

Beaver Field was located in the northwest corner of campus and configured into a horseshoe for the 1949 football season. It would remain in this location until 1960, when the 30,000-seat structure was torn down and relocated to its present location on the east side of campus with additional seating. Notice the baseball field, along with tennis courts in front of the field.

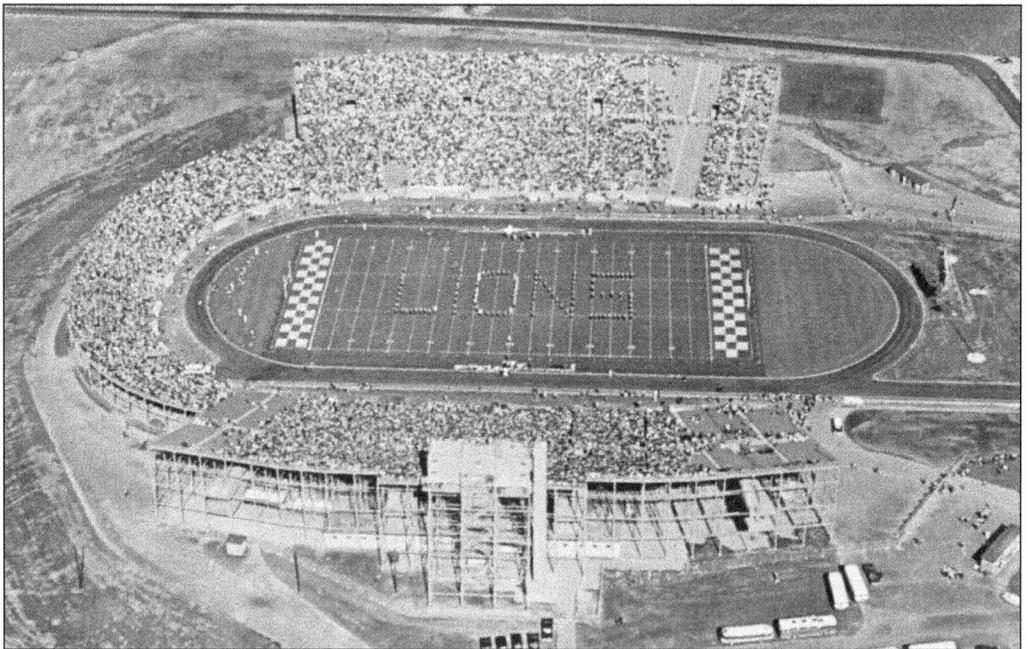

The horseshoe-shaped stadium is pictured here in its new location. On the field, the Blue Band is seen in a formation spelling out the word "LIONS." Notice the empty block of seats to the left, near the 15-yard line. This area was reserved for the Blue Band in the 1960s. The seating of the band has moved often during its long history. (Photograph by Richard C. Miller.)

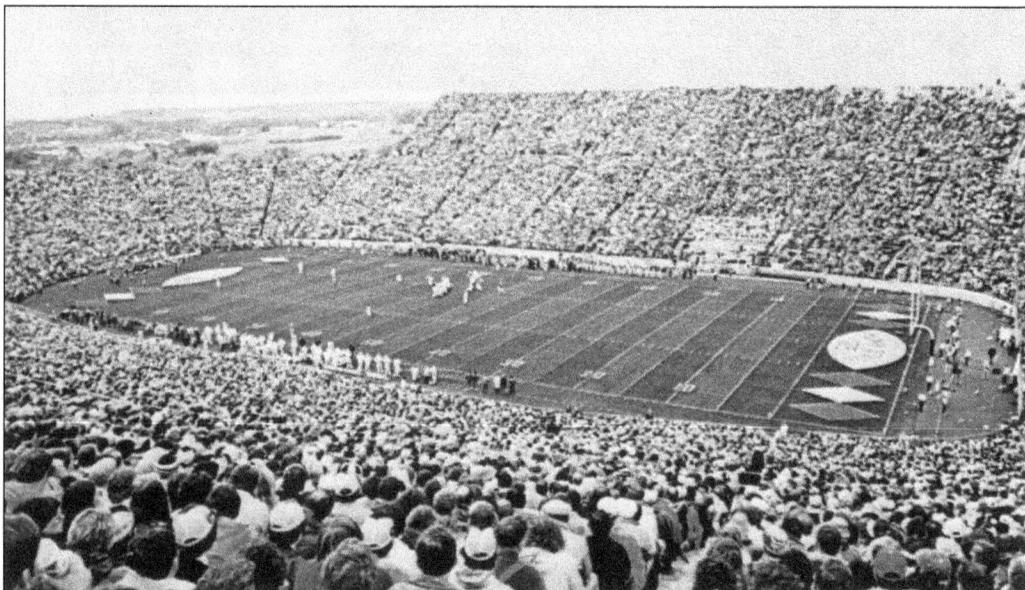

The stadium continued to grow as the south end zone was enclosed. The horseshoe was no longer, and the stadium was now a bowl. Notice the track around the field is also missing, which dates this card to after 1978. At this point, the Blue Band is seated at the 30-yard line, near the south end zone. (Photograph by Robert L. Goerder.)

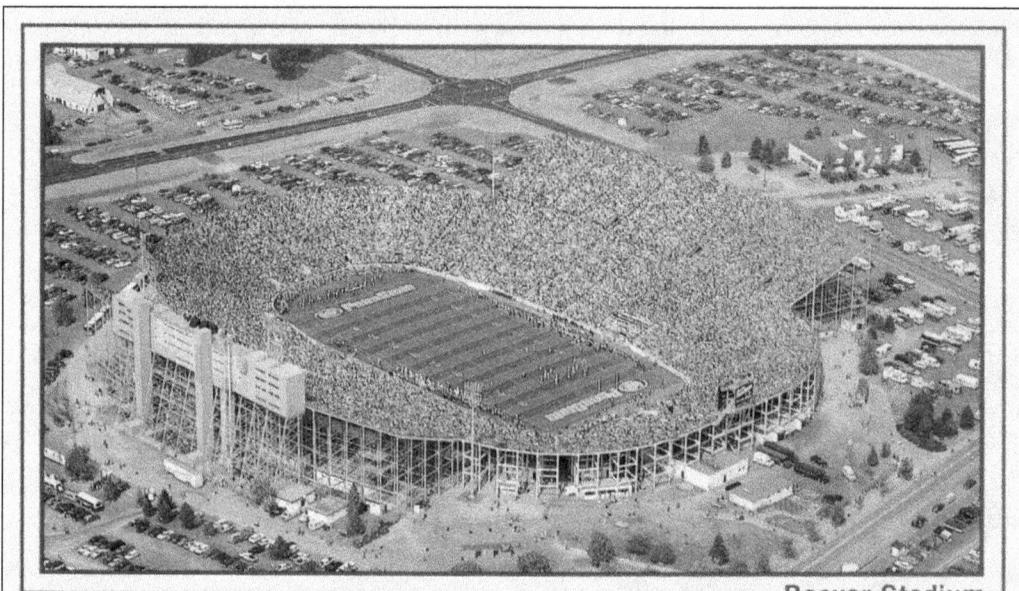

Beaver Stadium

PENN STATE

Beaver Stadium's first night game was held on September 6, 1985, when Penn State defeated Temple 45-14 en route to an undefeated regular season. The stadium lights had been installed by the time this photograph was taken in 1984, but the ramps to the upper levels would not be in place until the following year. (Photograph by Bron Miller.)

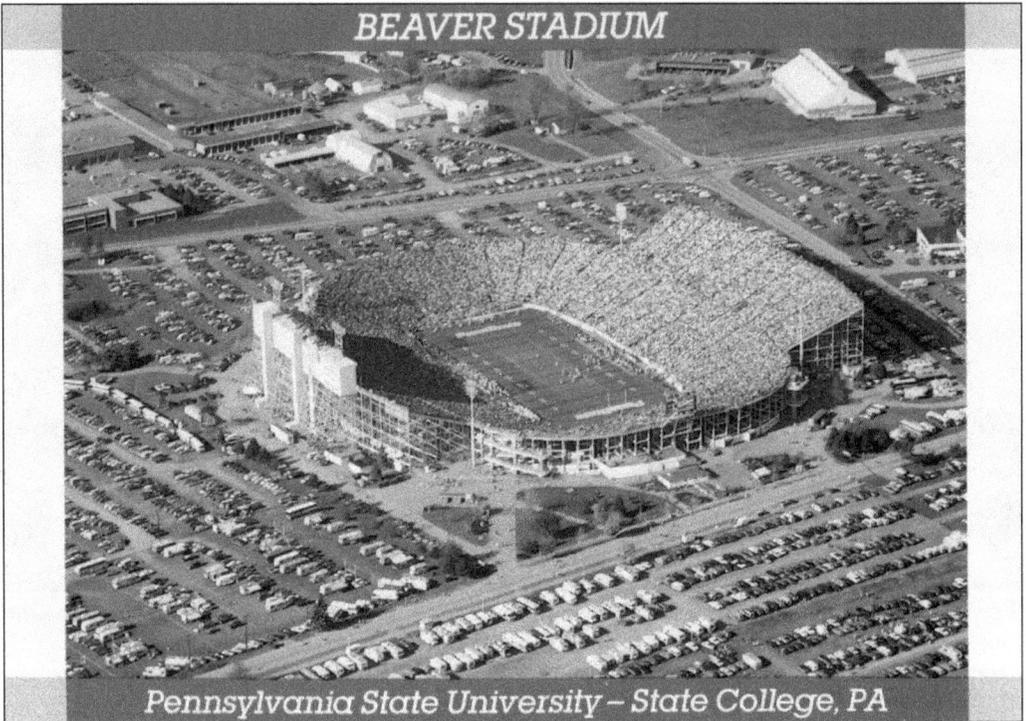

BEAVER STADIUM

Pennsylvania State University – State College, PA

This northward view is very similar to the previous one, except now the pedestrian ramps have been installed in the corners of the stadium for easier access to the upper levels. The ramps were constructed in 1985. This postcard is from the 1985 or 1986 season, since the Blue Band is still seated at the 30-yard line. (Photograph by Ralph Menne.)

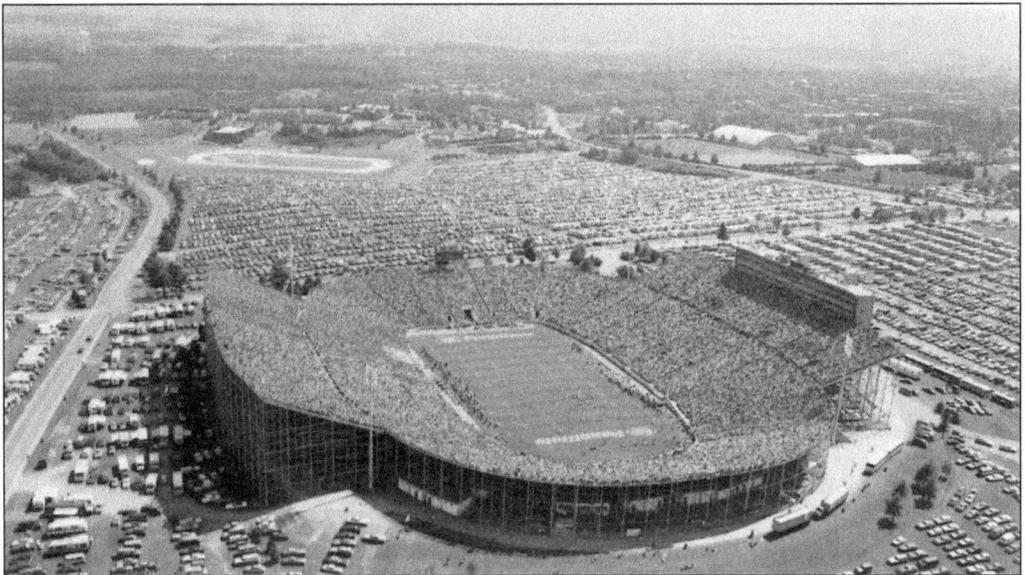

In this view looking south, the Blue Band is about to take the field for the halftime show in the mid-1980s (probably 1984). Notice the empty block of seats by the 30-yard line and the line of musicians by each sideline. Missing from view is the Bryce Jordan Center, which would be constructed across the street from the stadium from 1993 to 1995.

84

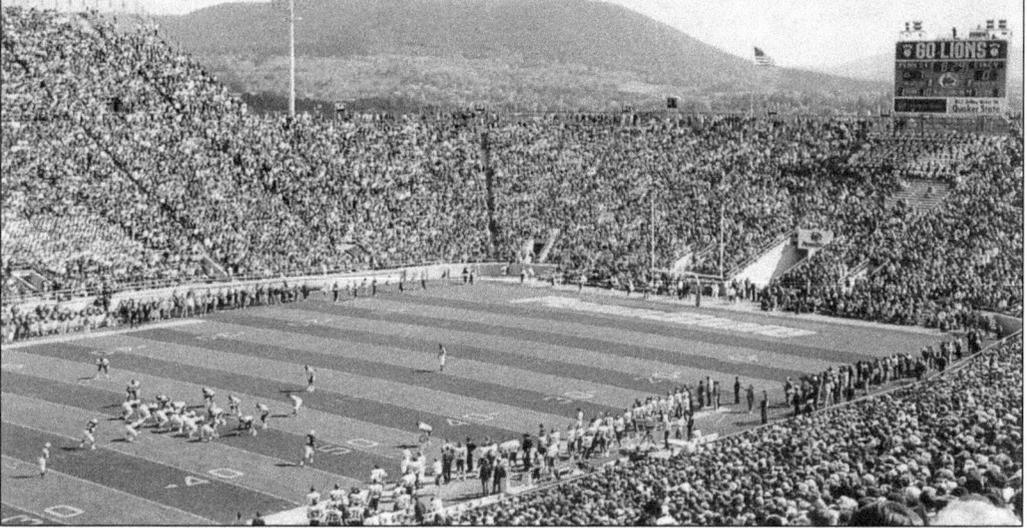

This postcard shows Beaver Stadium as it appeared in the late 1980s through the 1990s. The unobscured view of Mount Nittany predates construction of the south deck, and the Blue Band is seated underneath the scoreboard. The lack of a Lion Ambassadors S-Zone dates this image prior to 1998. (Photograph by Robert L. Goerder.)

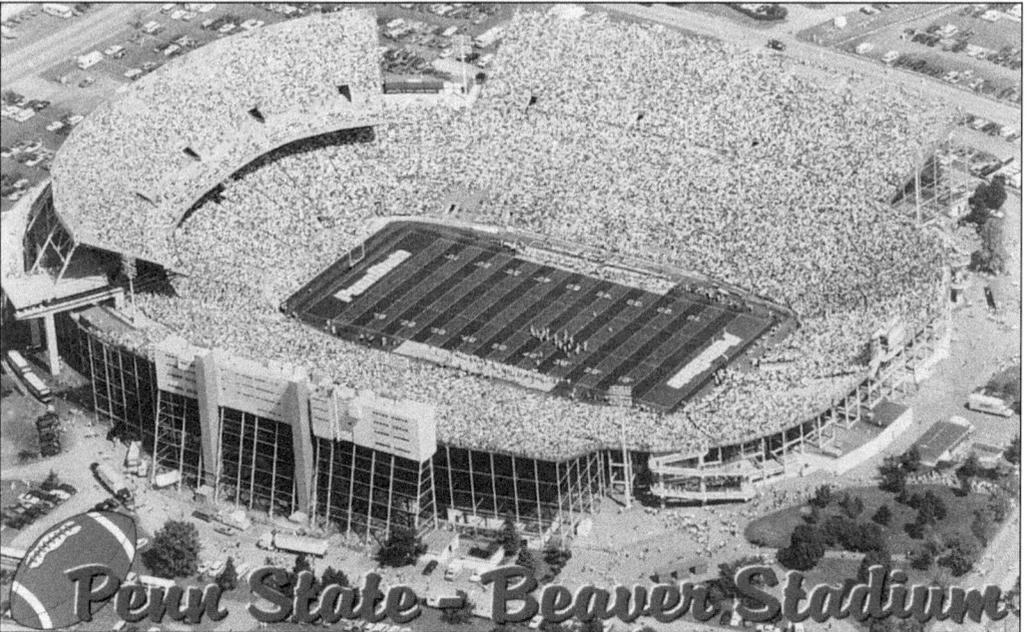

In 1991, an upper deck was added to the north end zone, increasing the seating capacity by about 10,000 to almost 94,000. It was thought that spectators in the seats under the deck would dislike the new addition, but in reality, those seats are the most sought after since the deck protects this area from the sun, as well as from rain and snow. (Photograph by Steve Manuel.)

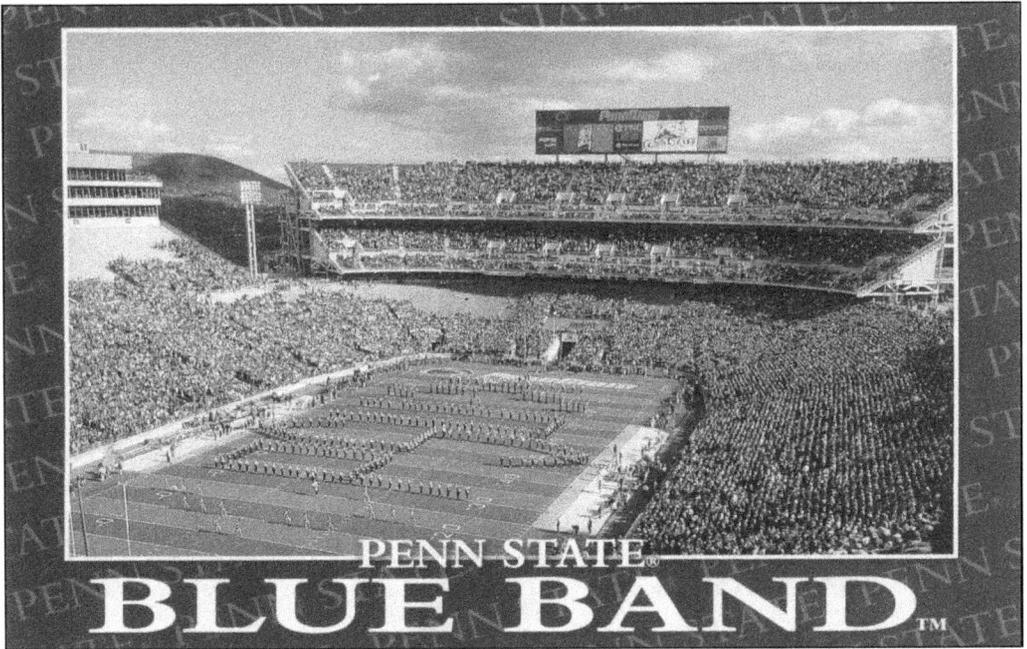

A controversial expansion of Beaver Stadium occurred in 2002. Along with the addition of skyboxes to the east side of the stadium, a double upper deck was added to the south end zone, blocking the view of Mount Nittany. At the time, there were many complaints about obstructing the view, but the new double deck added approximately 13,000 seats. (Photograph by Bron Miller.)

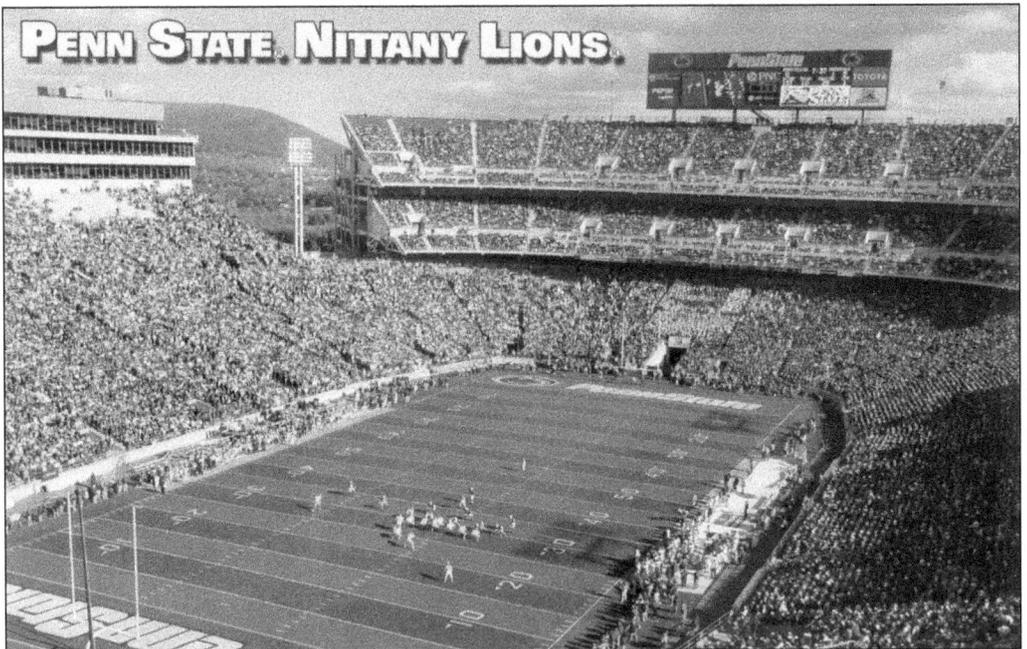

With the construction of the south upper deck, the Blue Band was moved to a lower section closer to the tunnel entrance because of the sound reverberating back at them from under the deck. Part of the S-Zone can be seen as well, but the new deck also proved problematic in blocking the view of this section. (Photograph by Bron Miller.)

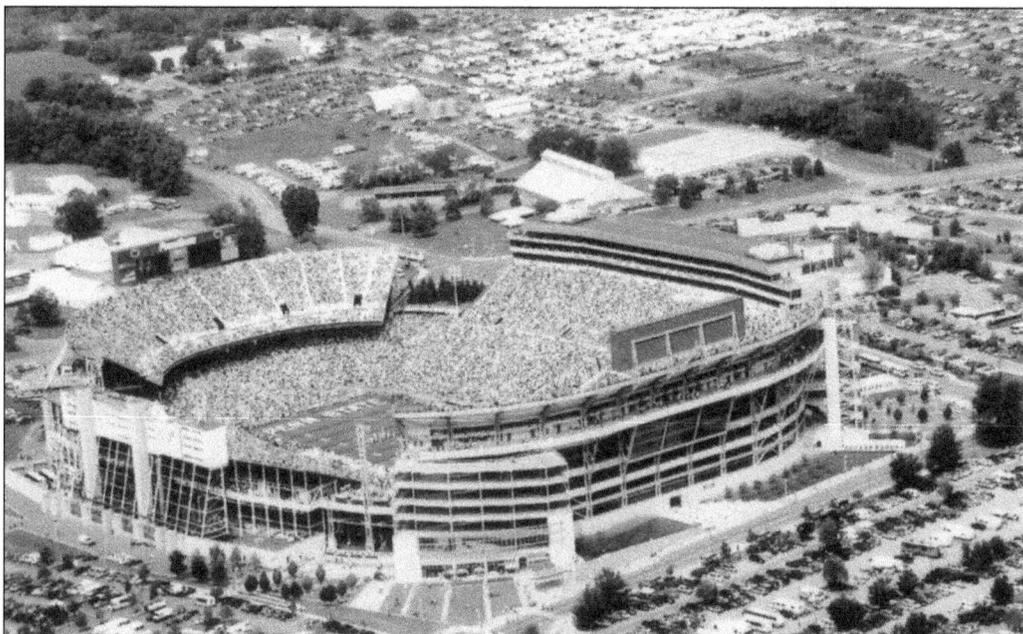

Currently, Beaver Stadium is the second-largest stadium in America, behind Michigan Stadium by about 3,000 seats. The Blue Band now occupies the southeast corner of the stadium, and the S–Zone has been moved to the band's former location above the tunnel entrance in the south end zone.

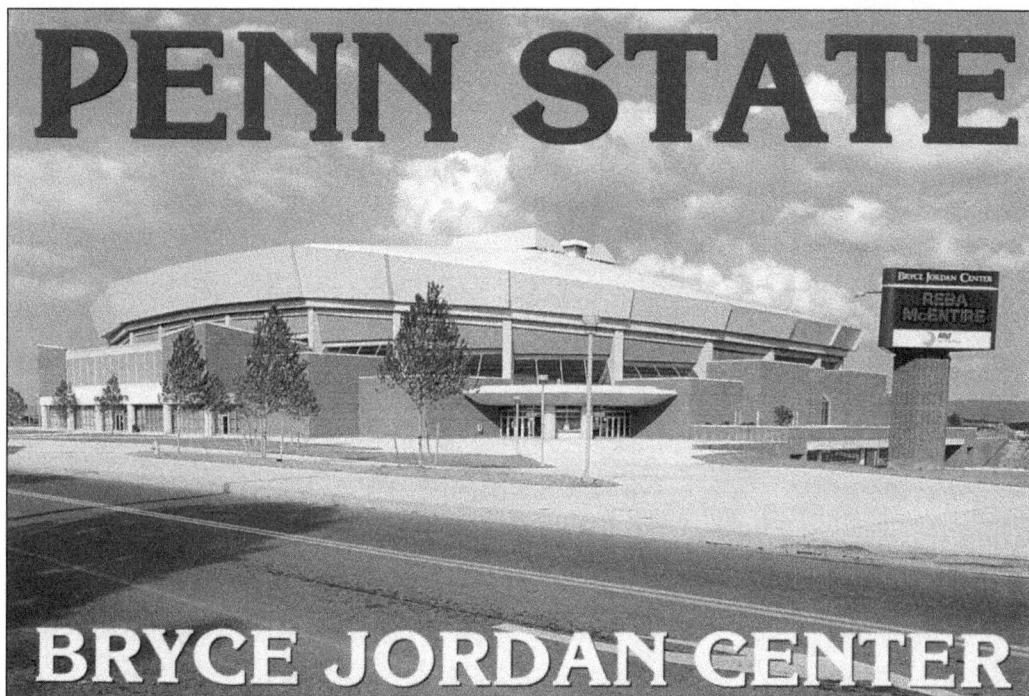

The Bryce Jordan Center, with a seating capacity of close to 16,000, was completed at a cost of $53 million in 1995. The arena was named after Penn State's 14th president, who served from 1983 to 1990. It is ironic that a Penn State sporting arena is named after a president, while part of the library is named after a sporting figure. (Photograph by Bron Miller.)

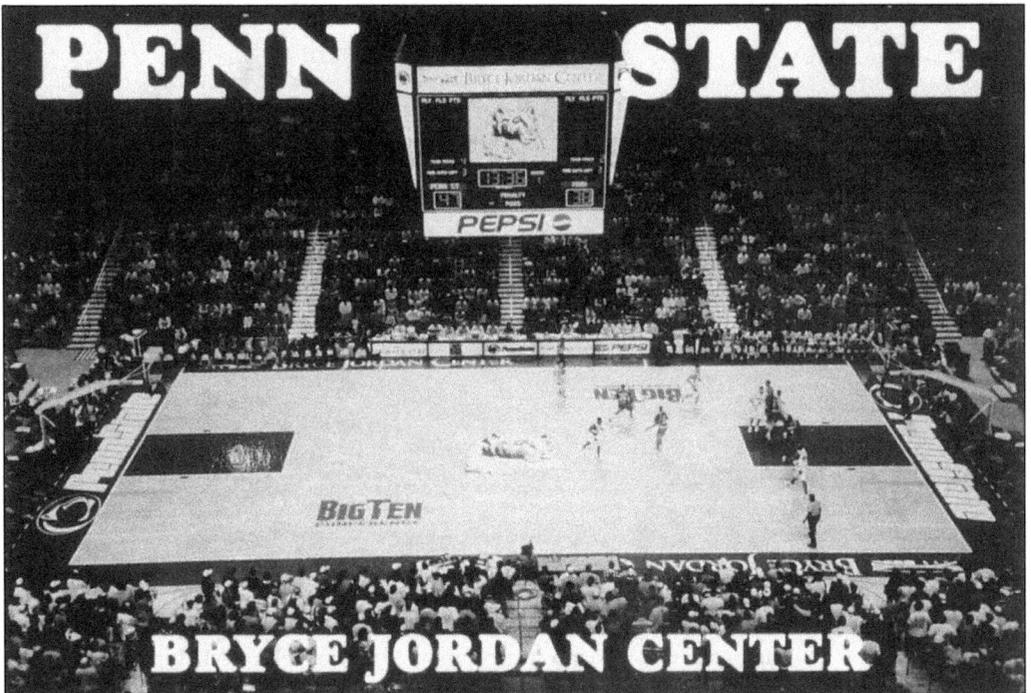

The Bryce Jordan Center is home to both the men's and women's basketball teams, as well as the wrestling team when it is not competing at Rec Hall. It is also host to THON, the largest student-run philanthropy in the world. As the largest concert hall between Philadelphia and Pittsburgh, the BJC is a preferred venue for many entertainers. (Photograph by Robert L. Goerder.)

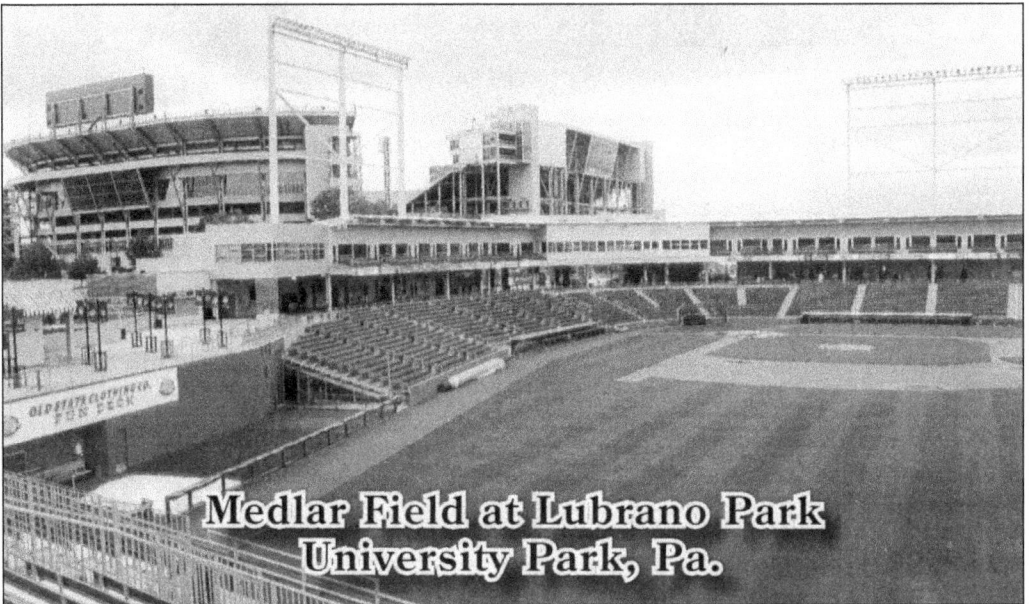

Medler Field at Lubrano Park is home to the Nittany Lions baseball team and the State College Spikes minor league team. The 5,406-seat ballpark was built across the road from Beaver Stadium in 2006. It is named after Chuck Medler, Penn State baseball coach from 1963 to 1981, and Anthony Lubrano (class of 1982), who funded its construction. (Photograph by Richard Arthur.)

Four

A Place to Sleep

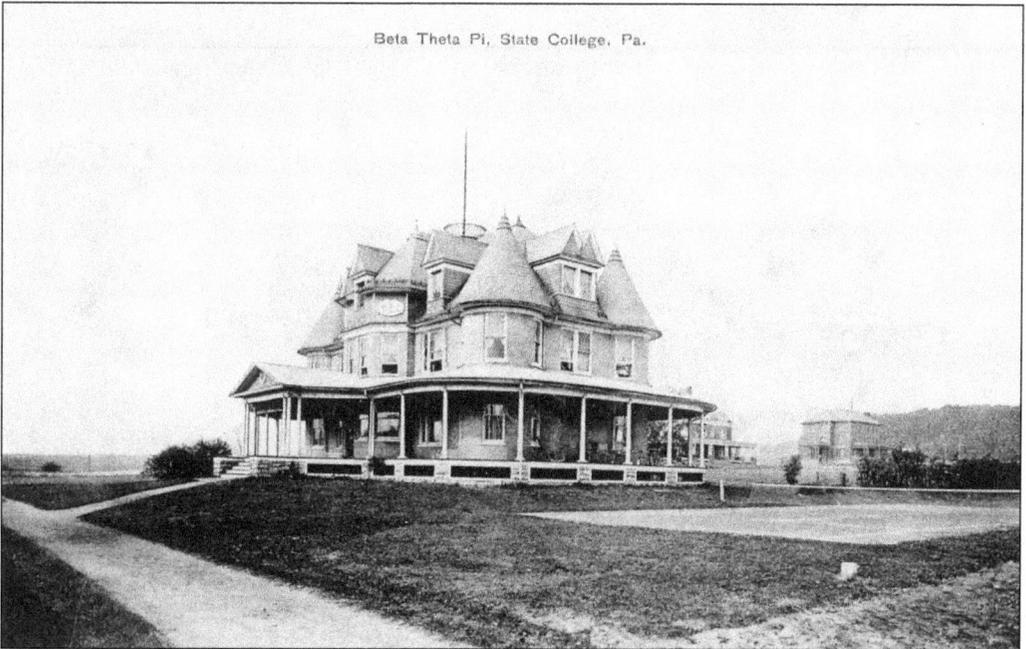

Beta Theta Pi, State College, Pa.

Beta Theta Pi, chartered at Penn State in 1888, was one of the few fraternities located on campus. This card shows the second house of the Alpha Upsilon Chapter, which was destroyed to make way for the Deike Building. Disbanded in 2008 due to alcohol violations, the fraternity reopened its doors in 2010, promising to realign its values with the national motto: "building men of principal for a principled life." (CPCCCHS.)

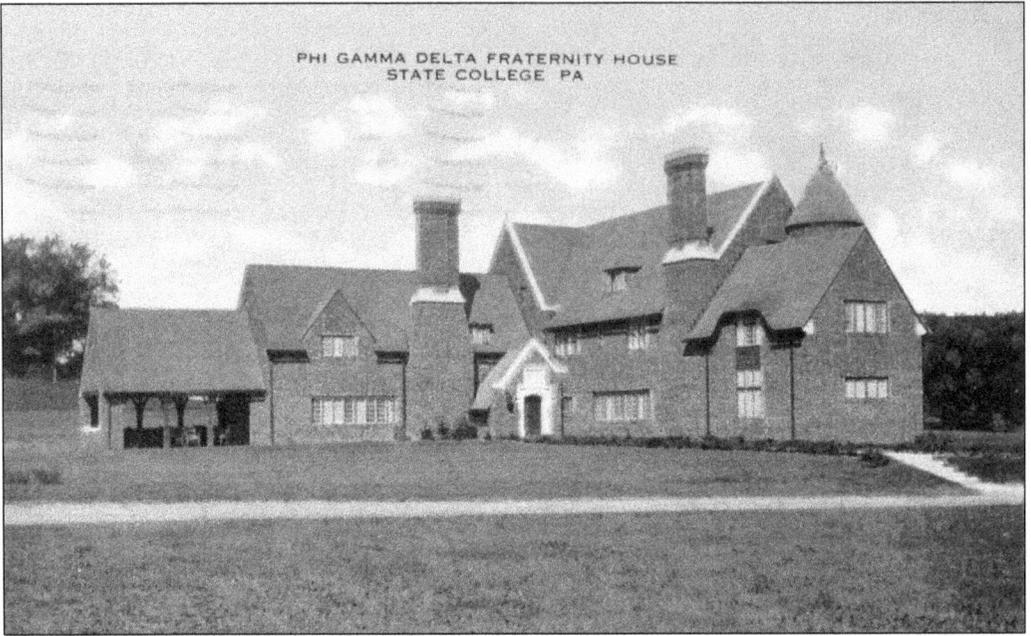

PHI GAMMA DELTA FRATERNITY HOUSE
STATE COLLEGE PA

Phi Gamma Delta, or "FIJI," is one of only four fraternity houses still remaining on campus. Though the Gamma Phi Chapter was chartered at Penn State in 1888, the fraternity did not take possession of this house at the corner of Pollock Road and North Burrowes Street until 1916.

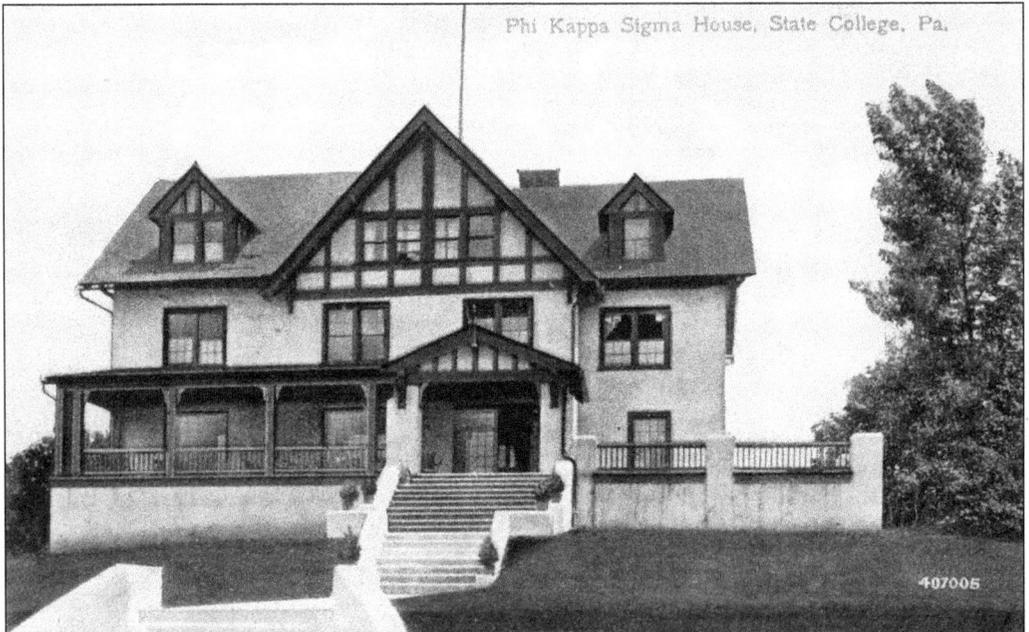

Phi Kappa Sigma House, State College, Pa.

The "Skull House" of Phi Kappa Sigma is located at 234 Beaver Avenue in State College. The national fraternity was founded at the University of Pennsylvania in 1850, while the Psi Chapter was established at Penn State in 1890. The fraternity's vision is: "We will strive for lifelong growth and development of the fraternity and its members." (CPCCCHS.)

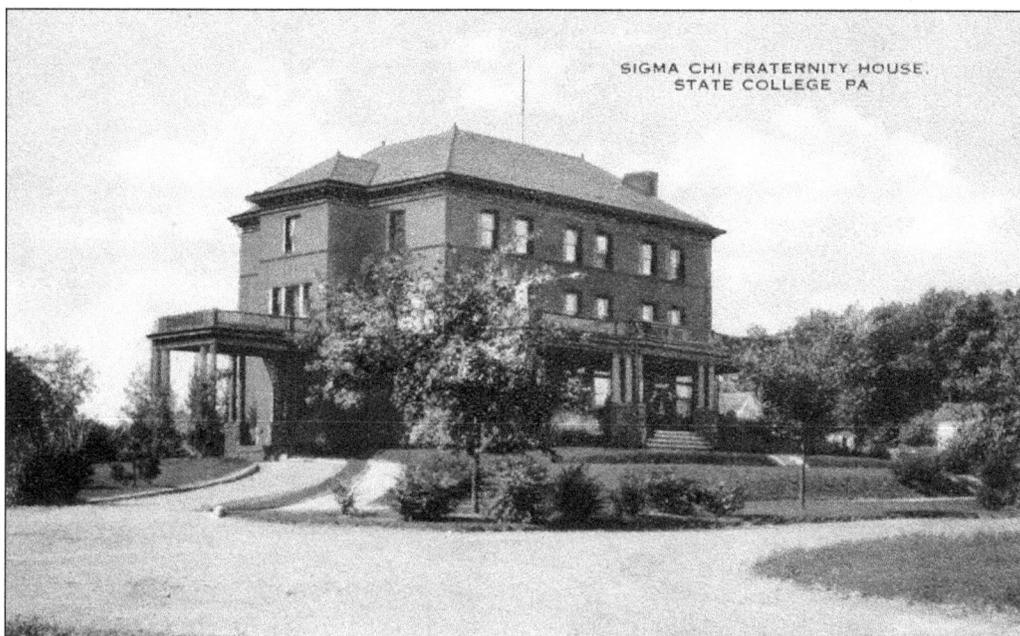

Sigma Chi is one of the oldest fraternities at Penn State, having been chartered in 1891. The fraternity's first house was located on South Allen Street, but when a fire destroyed it, a new house was built on campus near West Halls between 1905 and 1906. The Alpha Chi Chapter moved back into town at the corner of Prospect and Garner Streets in 1928. (CPCCCHS.)

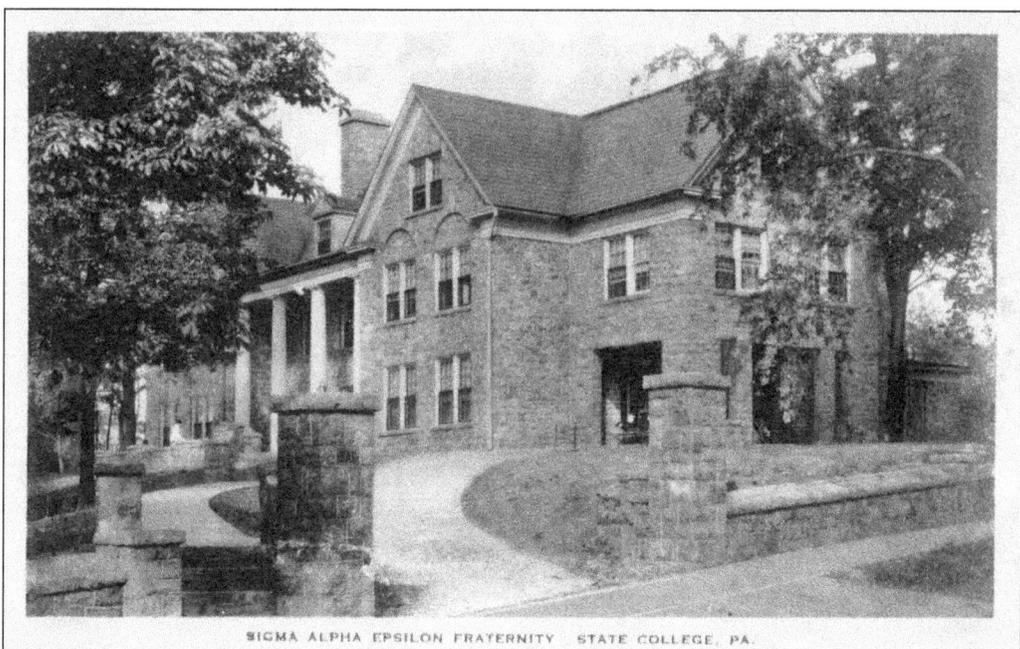

The Pennsylvania Alpha Zeta Chapter of Sigma Alpha Epsilon was chartered at Penn State in 1892. The "True Gentlemen" of Sigma Alpha Epsilon are still housed in this Colonial Revival residence at 200 East Beaver Avenue in State College. This view of the fraternity's house is dated between 1915 and 1930.

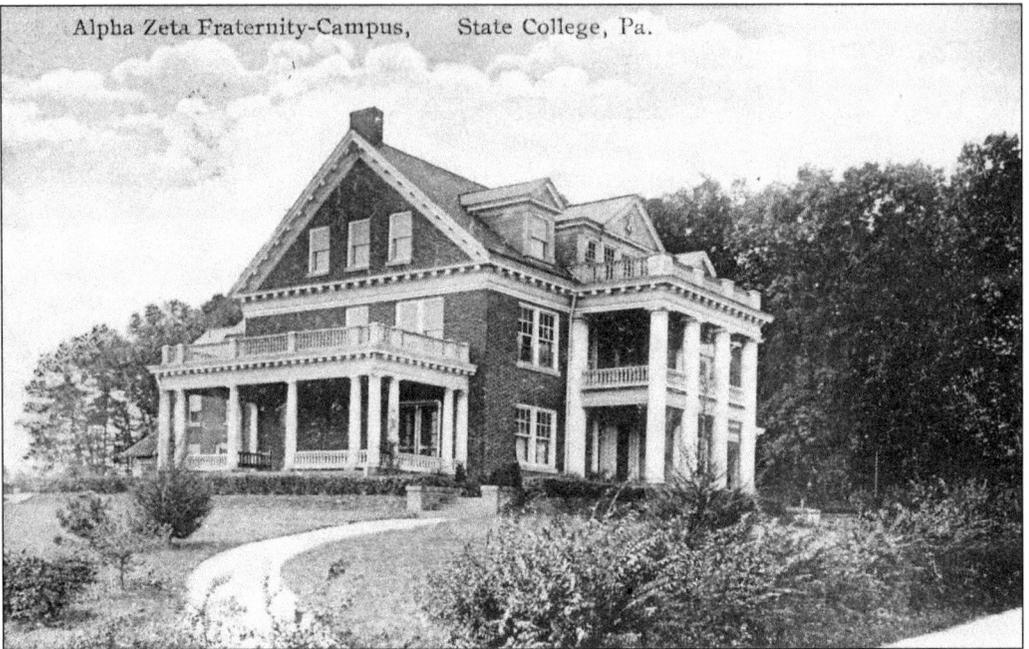

Alpha Zeta Fraternity-Campus, State College, Pa.

Alpha Zeta is a national professional fraternity for both male and female agricultural students. The Morrill Chapter was chartered at Penn State in 1898, and the house was completed in 1916. Located near West Halls and Rec Hall, it is one of four fraternity houses still on campus. (CPCCCHS.)

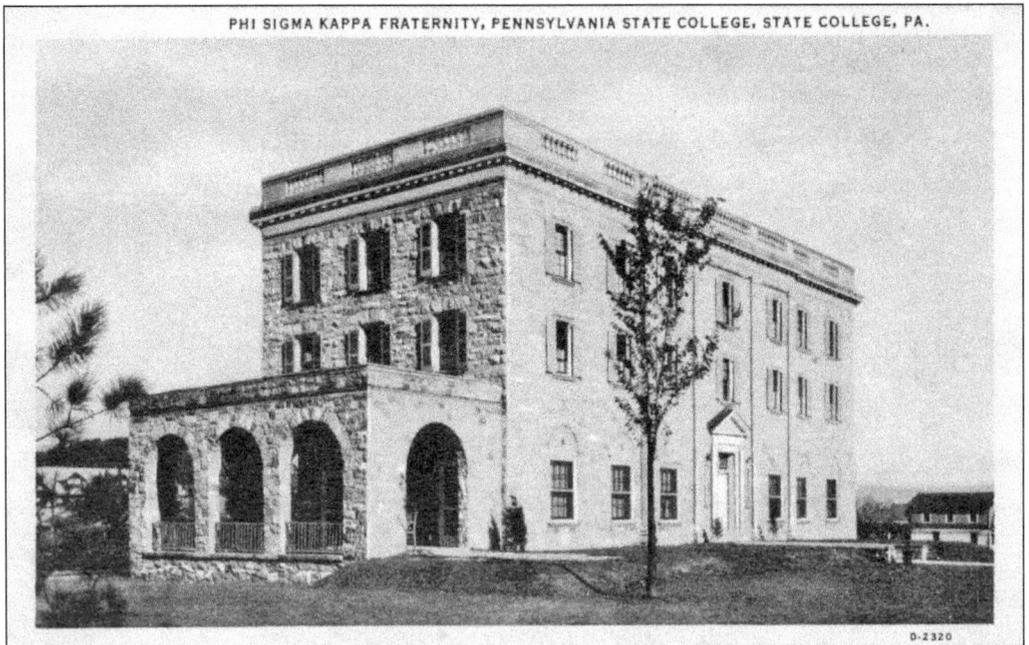

PHI SIGMA KAPPA FRATERNITY, PENNSYLVANIA STATE COLLEGE, STATE COLLEGE, PA.

Chartered at Penn State in 1899, the Kappa Chapter of Phi Sigma Kappa remains active at 501 South Atherton Street in State College. The house has not had many revisions in its long history. This postcard has a white border and a divided back, which means it was produced sometime between 1915 and 1930.

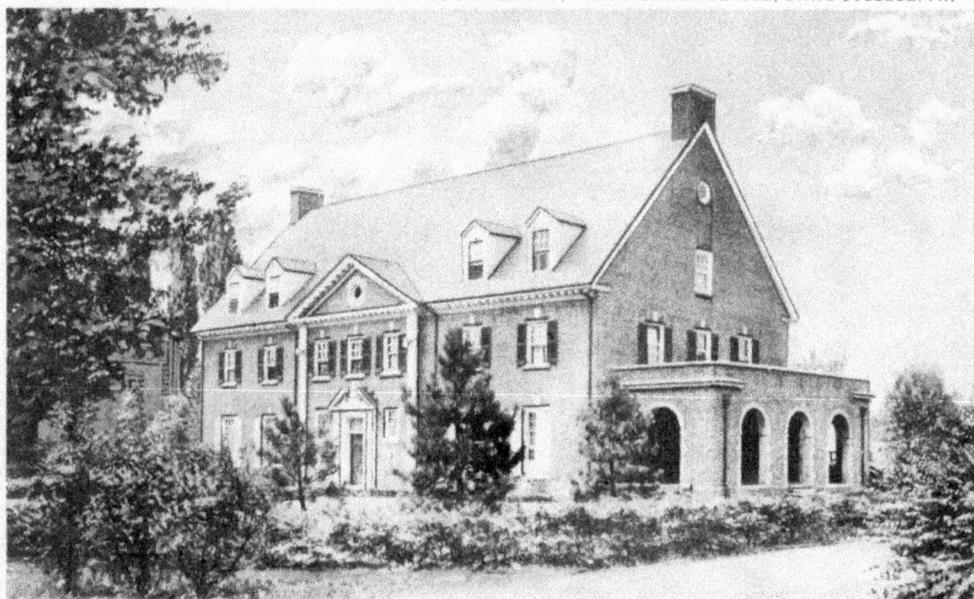

D-790

Originally known as a University Club, the members of this organization were granted a charter from Sigma Nu in 1908, and the Delta Delta Chapter was born. The current house is located on campus, next to the Alpha Zeta house and the entranceway to the Information Sciences and Technology Building. (CPCCCHS.)

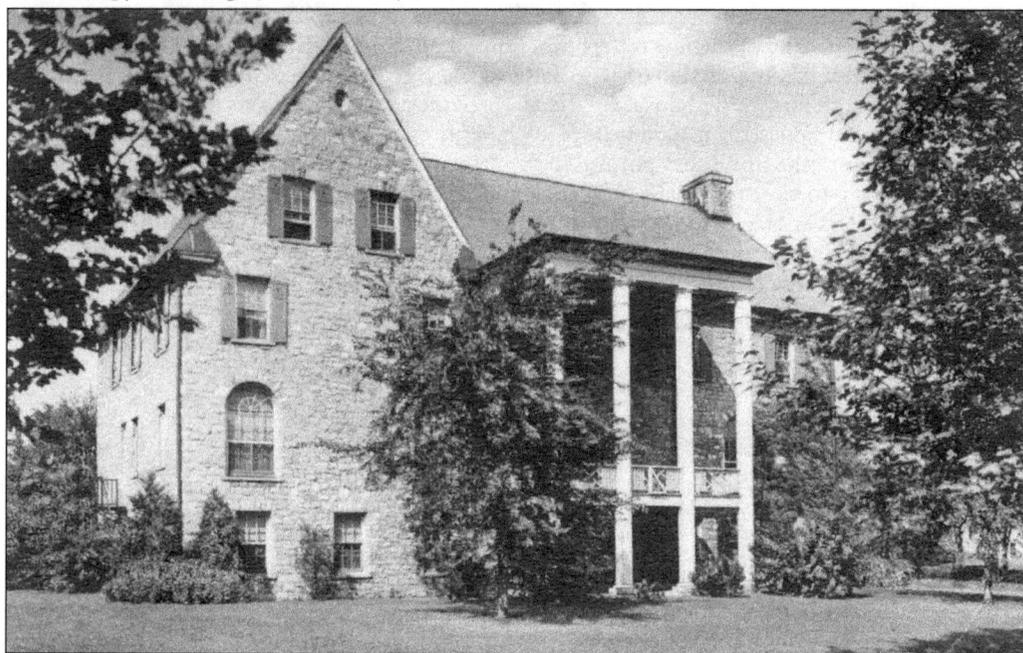

The Penn State Chapter of ACACIA was chartered in 1909. This postcard from 1942 depicts the fraternity's house at the corner of Foster Avenue and Locust Lane as it appeared at that time. Since then, it has undergone renovations in 1963 and in 2015, when a new main entrance to the club room was completed.

PHI DELTA THETA FRATERNITY STATE COLLEGE, PA.

Phi Delta Theta was one of the few fraternities housed on campus. Built in 1909, the fraternity's house was located at the intersection of Pollock Road and Burrowes Street. Because of its proximity to Beaver Field at the time, the house was used to provide accommodations for the football team during preseason practice from 1953 to 1961. When the fraternity was disbanded in 2007 due to drinking violations, the university purchased the property and demolished the building in 2010. The entranceway to the Information Science and Technology (IST) Building was expanded in almost the exact spot where the fraternity stood. The IST Building was constructed from 2001 to 2003 and houses the Department of Computer Science and the School of Information Sciences and Technology.

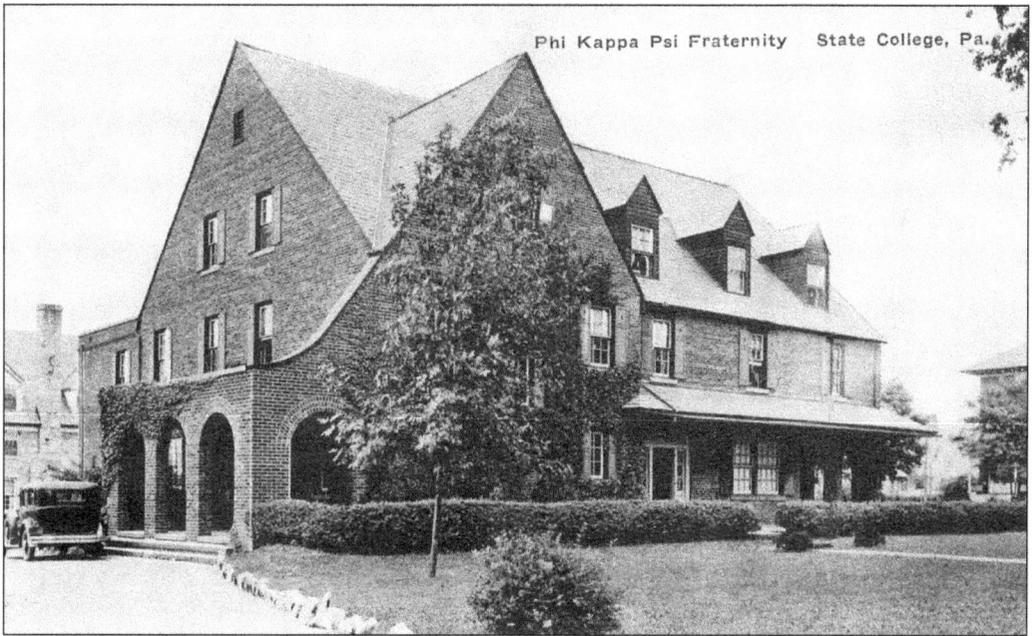

Another longtime fraternity of Penn State is Phi Kappa Psi, or Phi Psi. The Lambda Chapter celebrated its 100th anniversary in 2012, making it one of the oldest at Penn State. The fraternity's house is located at 403 Locust Lane in State College. (CPCCCHS.)

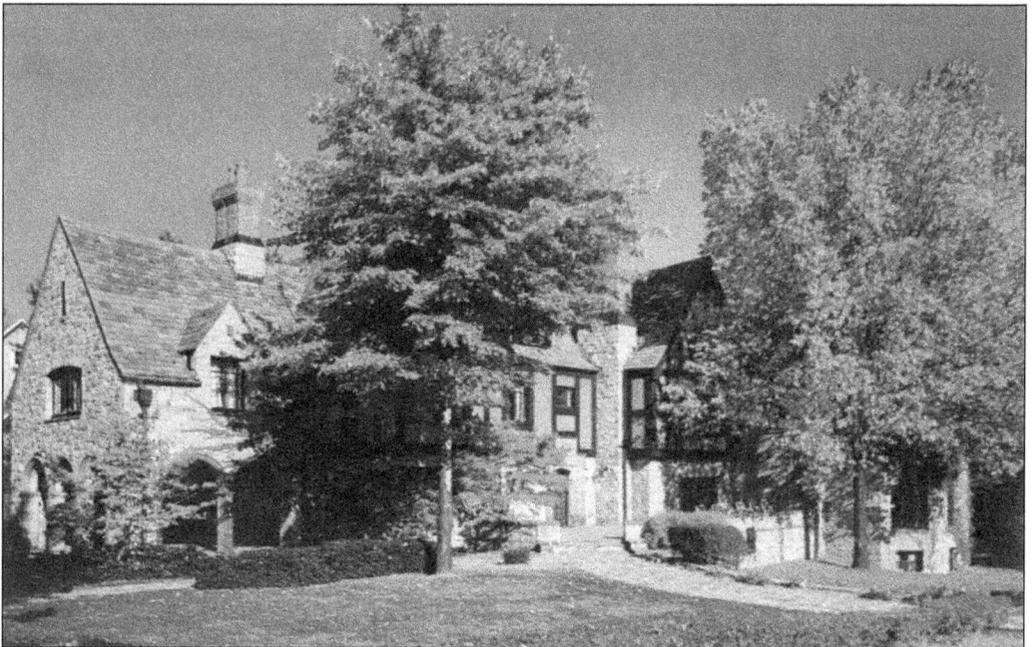

The Theta Chapter of Sigma Pi was chartered at Penn State on October 26, 1912. Located at 303 Fraternity Row in State College, this residence was voted the eighth best fraternity house in the country in 2013. The fraternity is annually involved in THON and the Greek Sing. (Photograph by Richard C. Miller.)

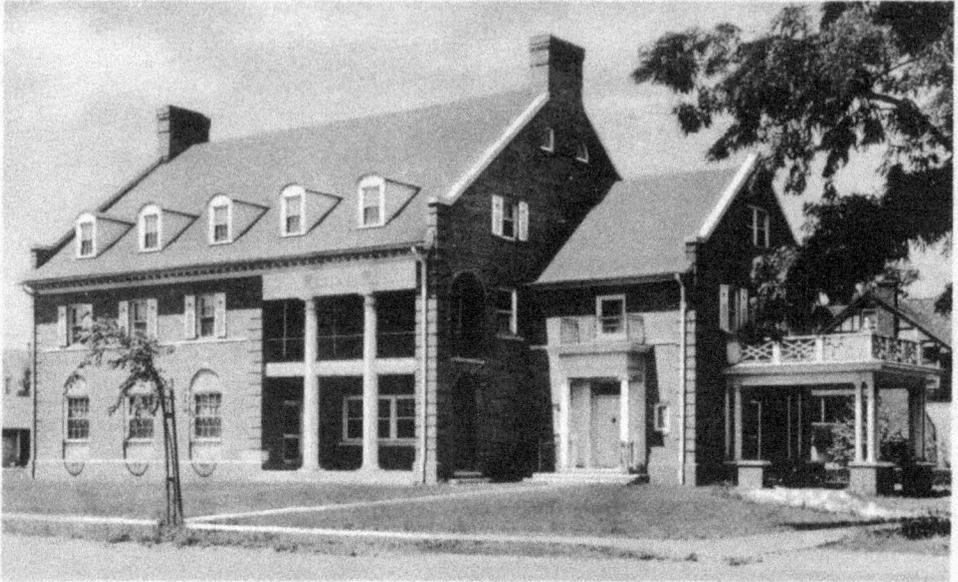

The Beta Chapter of Beta Sigma Rho was chartered at Penn State in 1913. In 1972, Beta Sigma Rho merged into Pi Lambda Phi, but the Penn State chapter refused to follow suit and thus was renamed Beta Sigma Beta. The Beta Sigs are still housed at 255 East Fairmount Avenue in State College.

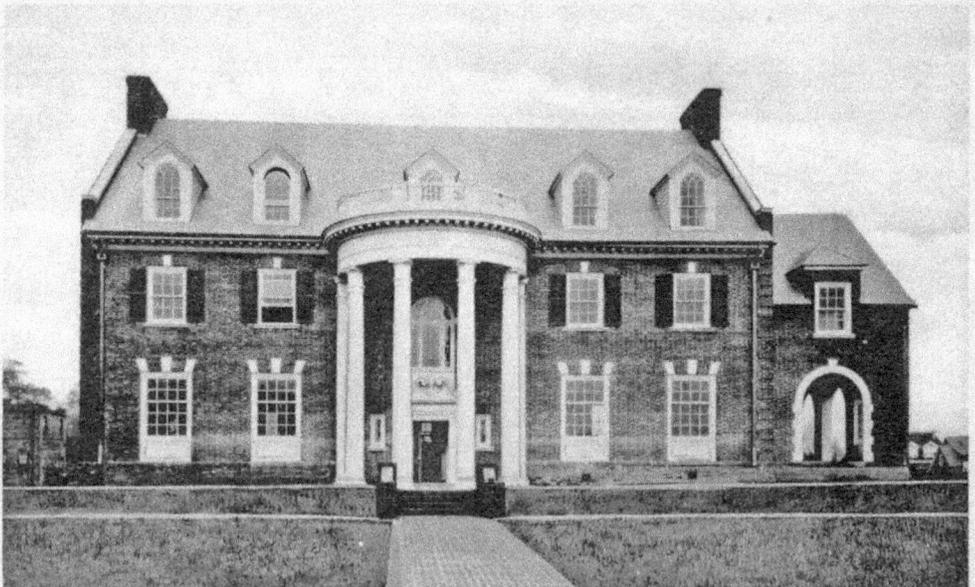

The Gamma Omega Chapter of Alpha Tau Omega, "America's leadership development fraternity," was chartered at Penn State in 1914. The fraternity's house is located at 321 East Fairmount Avenue in State College, between Clover Alley and Fraternity Row.

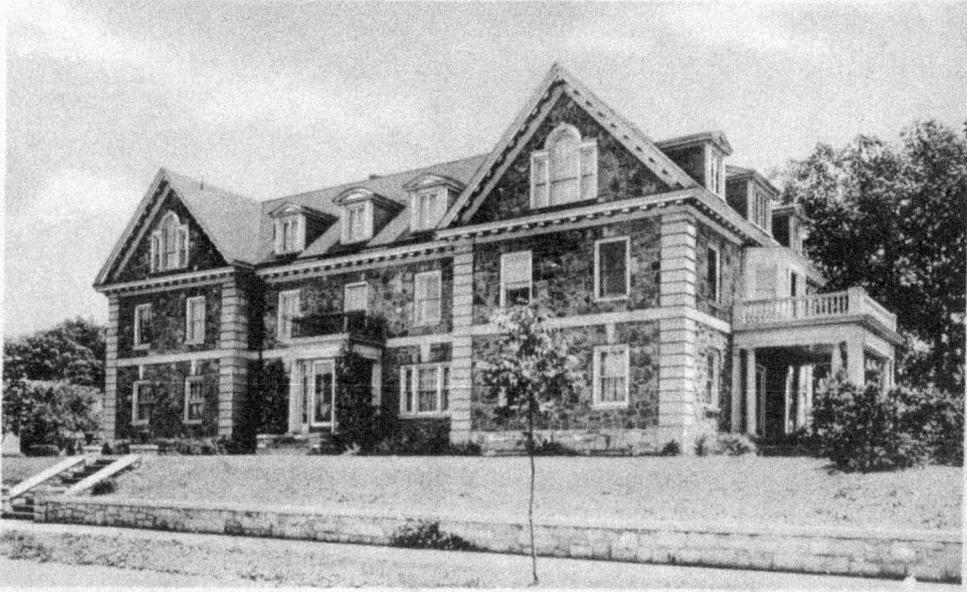

The Upsilon Chapter of Alpha Sigma Phi was chartered at Penn State in 1918. This chapter regained its charter in 2006 after some "risk management violations." Each year, the fraternity supports THON and hosts the Mash Bash, a Thanksgiving-themed eating contest. The Alpha Sigma Phi house is located at 328 East Fairmount Avenue in State College.

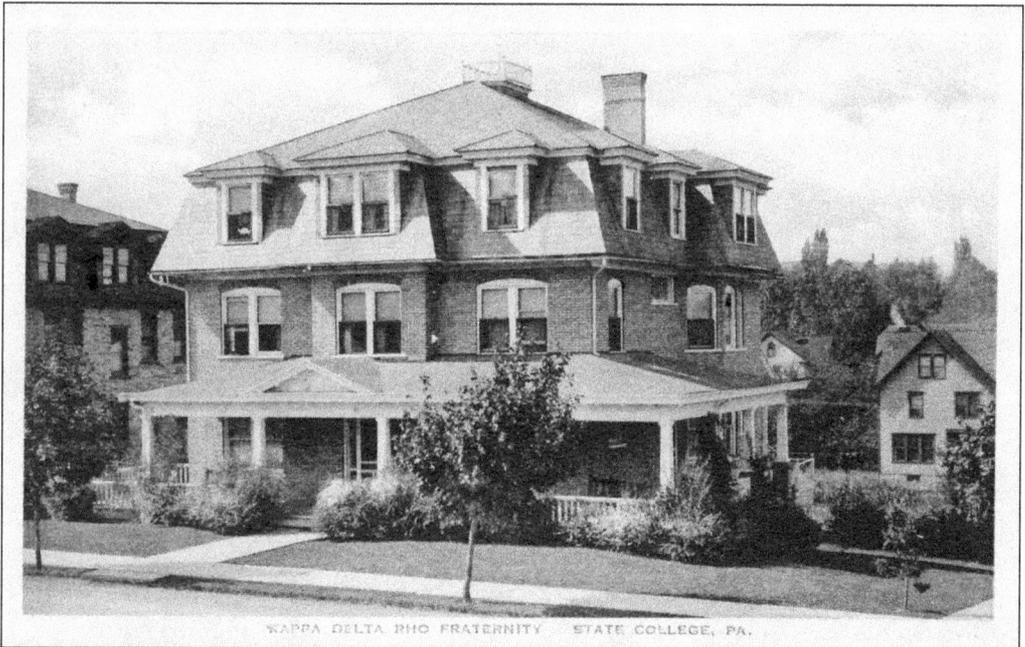

The Zeta Chapter of Kappa Delta Rho was chartered at Penn State in 1920. The fraternity's current house at 420 East Prospect Avenue looks nothing like the one depicted here. This chapter was suspended from 2015 to 2018 for hazing, drug use, and the degradation of women. The motto inscribed in Latin above the doorway of the house is "honor above all." (CPCCCHS.)

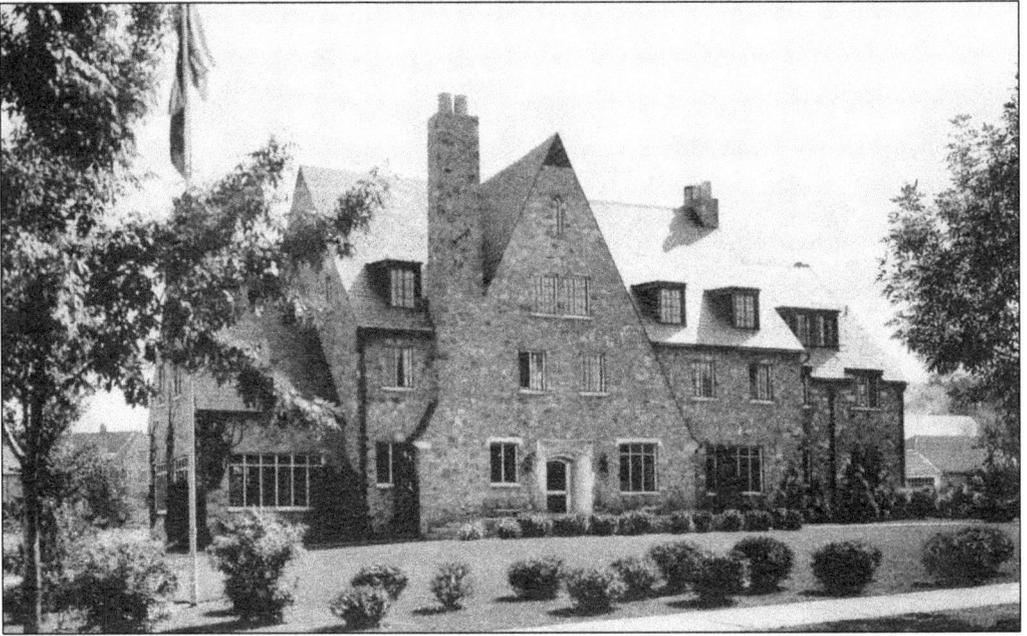

The mission of Tau Kappa Epsilon is to "aid men in their mental, moral, and social development for life." The national fraternity originated at the Illinois Wesleyan University in 1899, and the Pi Chapter was founded at Penn State in 1922. The fraternity's house is located at 346 East Prospect Avenue in State College. (CPCCCHS.)

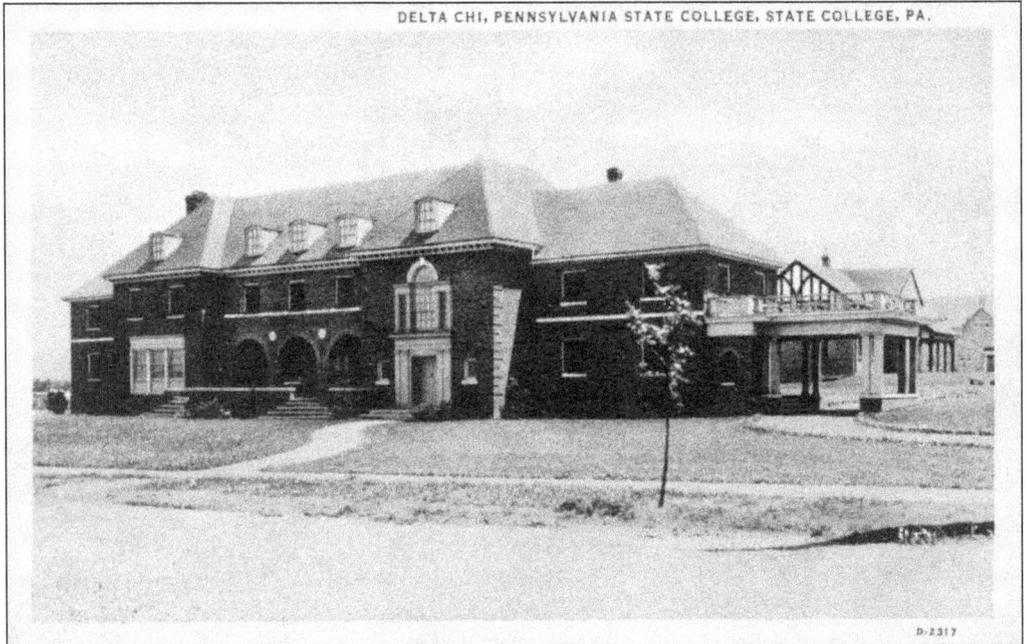

DELTA CHI, PENNSYLVANIA STATE COLLEGE, STATE COLLEGE, PA.

Dr. Marsh White founded the Penn State Chapter of Delta Chi in 1929. Dr. White was the first recipient of a doctoral degree from Penn State in 1926 and was a faculty member for more than 40 years. The fraternity's house is located at 424 East Fairmount Avenue in State College.

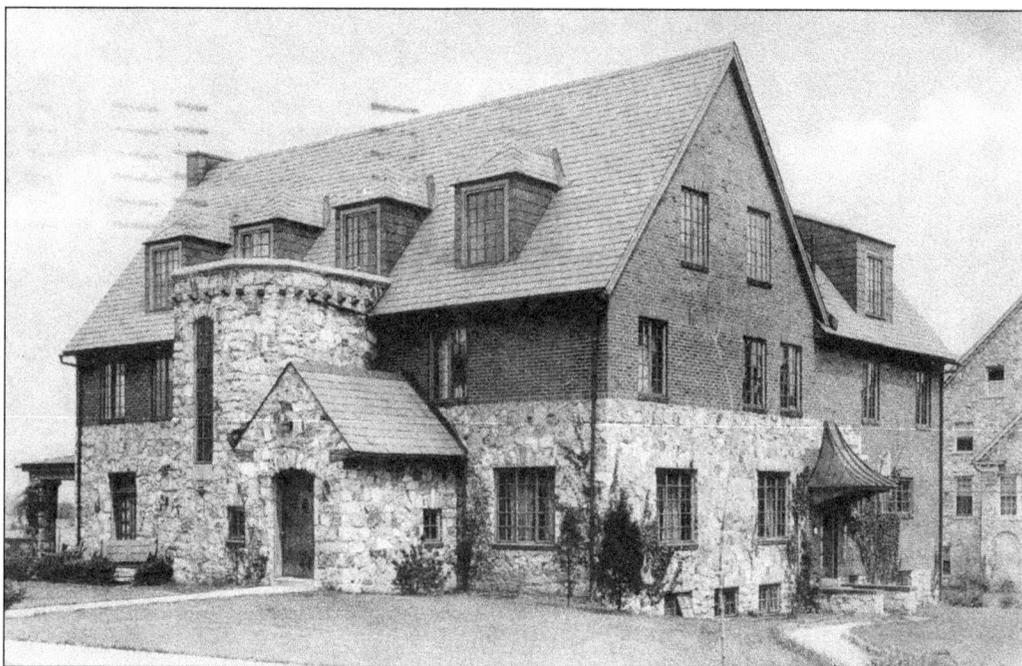

Phi Epsilon Pi, a social Jewish fraternity, is no longer at Penn State. It was absorbed by Zeta Beta Tau, another Jewish fraternity, in 1970. The sender of this postcard states, "We're miles from any big town," but "school is certainly grand." This card was postmarked on September 14, 1942.

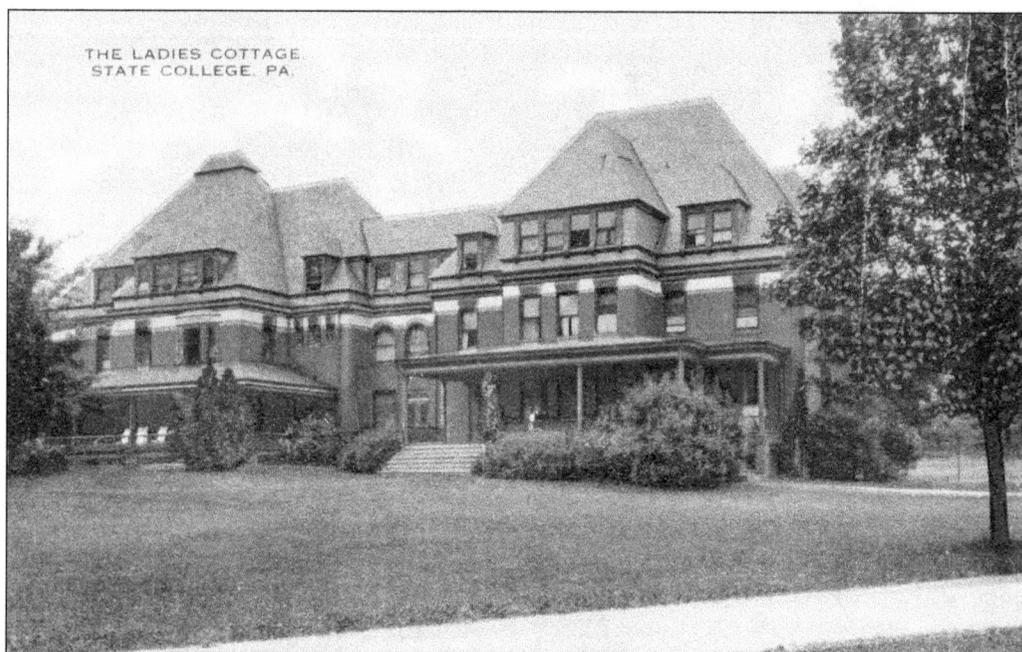

The Ladies Cottage was occupied in 1890 with an announcement from then "lady principal" Harriet McElwain stating that the college was "now able to offer an attractive home to young women who desire to secure the advantages of an advanced college course." The cottage was located just north of Old Main, slightly behind the Botany Building.

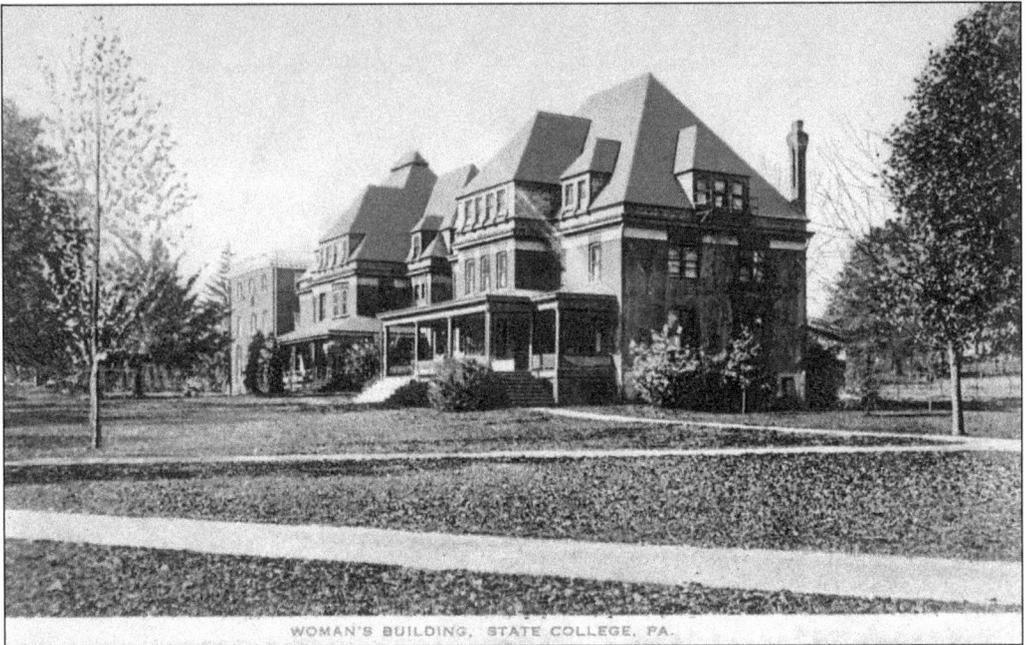

WOMAN'S BUILDING, STATE COLLEGE, PA.

The Ladies Cottage was renamed the Woman's Building in 1908 after an expansion, then renamed Graduate Hall in 1958 when it became housing for graduate students. Lightning struck the building in 1961, causing extensive damage. At the time, it was no longer being used as a residence hall but rather as office space, and with some repairs, the building remained in use until it was demolished in 1971.

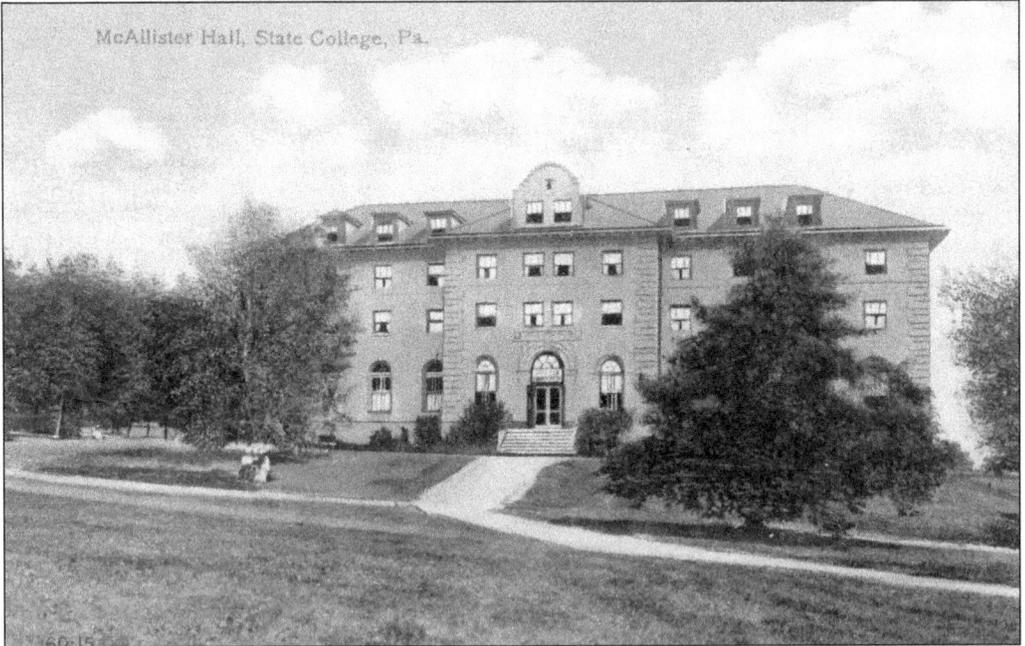

McAllister Hall, State College, Pa.

Built in 1905, McAllister Hall was named after Hugh Nelson McAllister, who was a charter member of the board of trustees from 1855 to 1873. Originally, the building was used as a dormitory that could house up to 150 men. Many students were still living in Old Main at the time.

As a dormitory, McAllister Hall not only housed sleeping rooms but a cafeteria and a lounge area as well. The cafeteria seen here is much more formal than those found in each dormitory area today. The handwritten note states, "The anticipation is said to be better than realization, although I have found no fault." (CPCCCHS.)

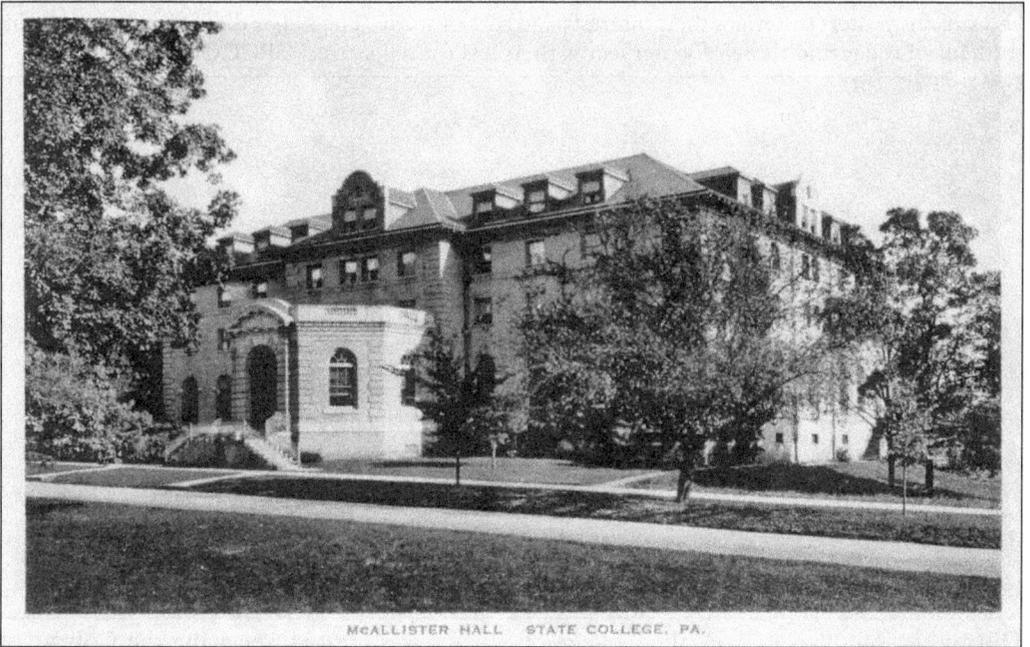

McALLISTER HALL STATE COLLEGE, PA.

To keep pace with the increase of female students, McAllister Hall was renovated and converted into a women's dormitory in 1915, at which time a portico was added to the front of the building for a much grander entranceway. No longer a dormitory, it is now known as the McAllister Building instead of Hall.

101

The interior of a dorm room from 100 years ago is not much different from those of today. The room usually housed two occupants, who would decorate the walls with school pennants and various posters to reflect their interests and school spirit. The major difference between the students of today and those of yesteryear is their less formal attire. (CPCCHS.)

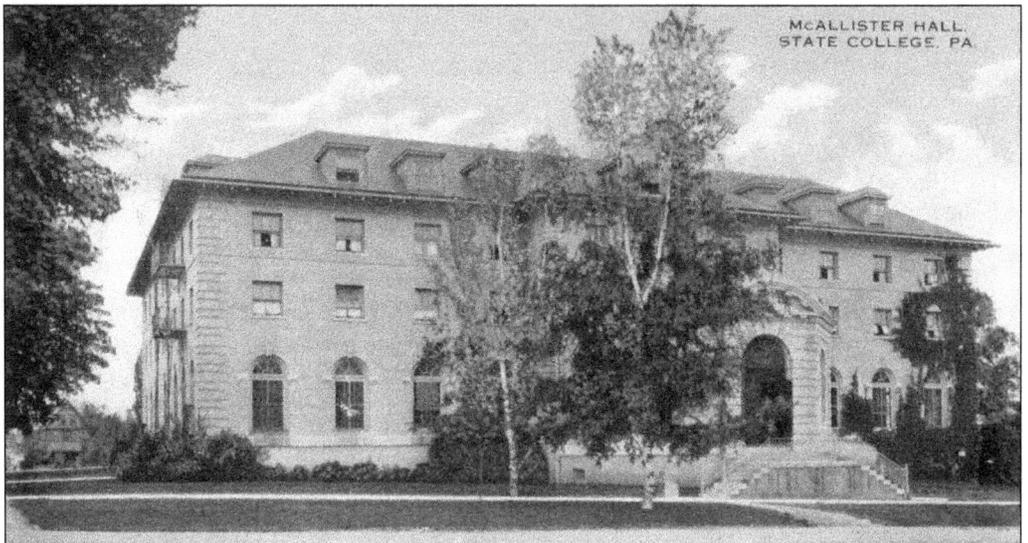

During the summer of 1963, the College of Science was created, replacing the College of Chemistry and Physics, and the Department of Mathematics was transferred from the College of Liberal Arts to this new college. The mathematics department currently resides in the McAllister Building, along with the University Park Post Office, which moved from the Hetzel Union Building in 1983. Another renovation of the building took place in 2005.

According to the 1926 *La Vie* (the Penn State yearbook), a fundraising campaign was started in 1922 with a goal of $2 million. The campaign ended in 1924 with only $1,614,000, which was a large sum at the time but a small disappointment for those involved. The first building created using some of the funds was Varsity Hall (now Irvin Hall), which was the second dormitory of West Halls. When Varsity Hall was dedicated in 1926 (construction began in 1923), Watts Hall had already been erected by 1925 (construction began in 1922). This postcard was written on September 19, 1926, then mailed the following day. At the time, Beaver Field was located across from Varsity Hall, as evidenced in the note from the sender, who was "all settled at Varsity Hall" and "enjoying my work on the football field." He went on to say, "Can't tell yet just how good the freshman team is."

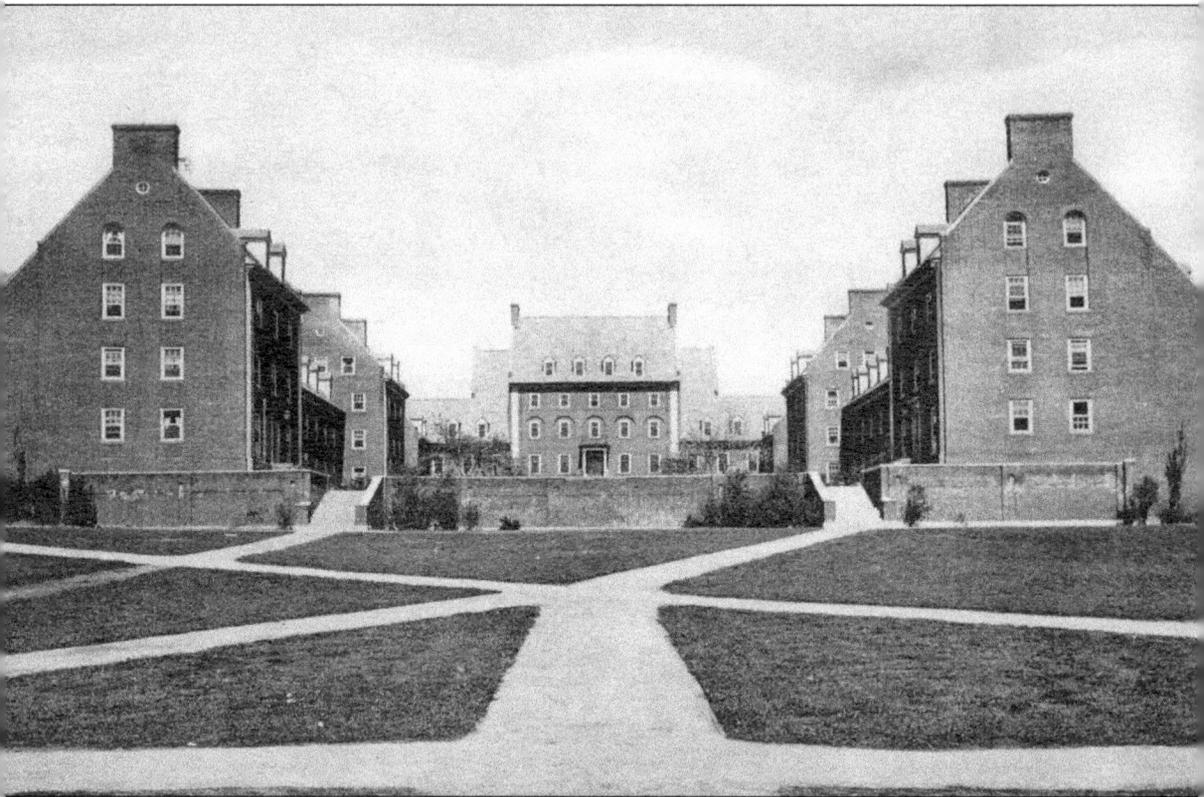

The first students of the school were housed in Old Main. Later, cottages and dormitories were constructed to provide additional accommodations. Built in the 1920s, West Halls was the first of many dedicated dormitory areas established away from the center of campus. This view shows the first three dormitories of West Halls. The back of this card, postmarked on August 15, 1934, denotes the three halls as Watts (left), Varsity (center), and Frear (right). The 1930 *La Vie* mentions the completion of Frear Hall, probably named after William Frear, a professor of agricultural chemistry from 1885 to 1922, prior to the construction of the Frear Building in 1940. As a result, the name of Frear Hall would change to Jordan Hall, and later, Varsity Hall would be renamed Irvin Hall. The cornerstone dates of the three halls are 1922 for Watts, 1923 for Irvin (Varsity), and 1928 for Jordan (Frear).

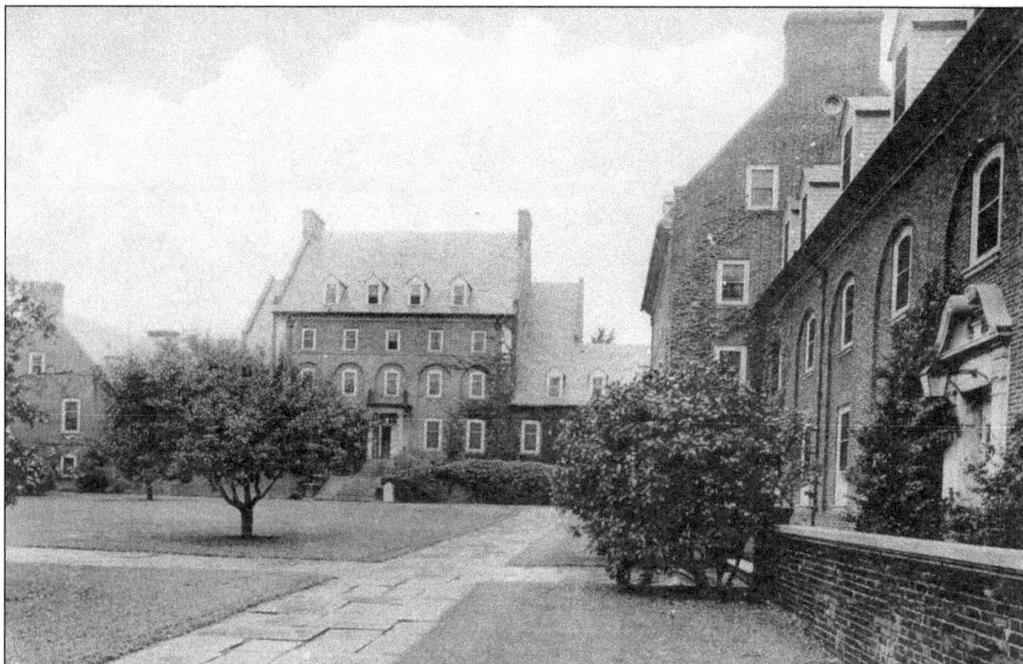

According to the caption printed on the back of this card, it also depicts "Watt-Frear and Varsity Halls." Though not postmarked, it does have a one-cent stamp, which was the cost of sending a postcard from 1928 to 1951. Watts Hall was named after Frederick Watts, who was a member of the board of trustees from 1855 to 1875.

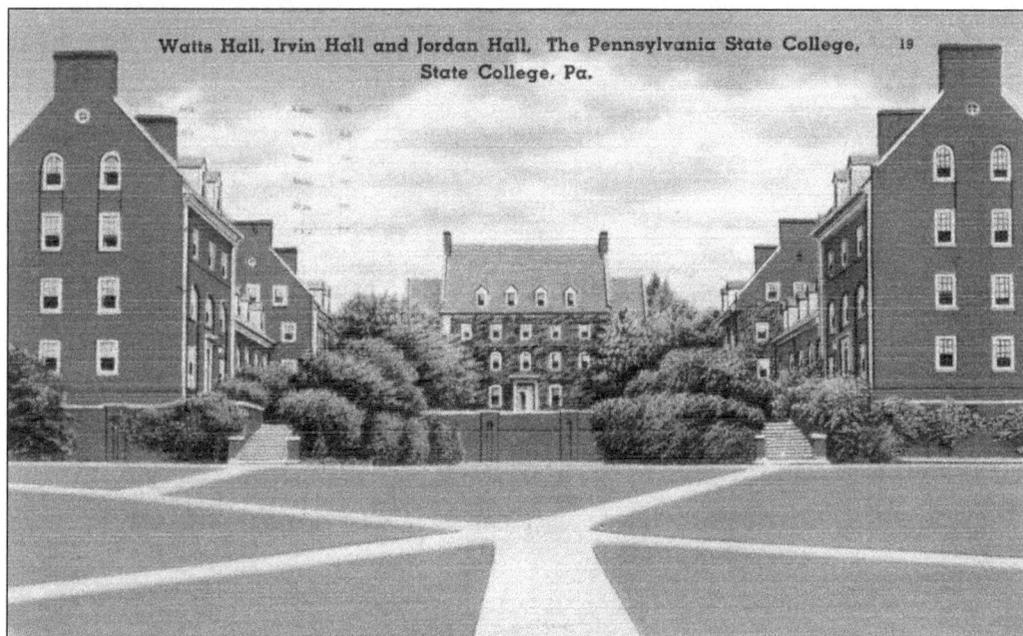

Watts Hall, Irvin Hall and Jordan Hall, The Pennsylvania State College, 19
State College, Pa.

By 1953, the current names of the halls had been established. From left to right are Watts Hall, Irvin Hall, and Jordan Hall. Irvin Hall was named after James Irvin, who donated 200 acres for the construction of the Pennsylvania Farmers' High School, which later became Penn State. He would then sell an additional 200 acres to the school at a very reasonable price.

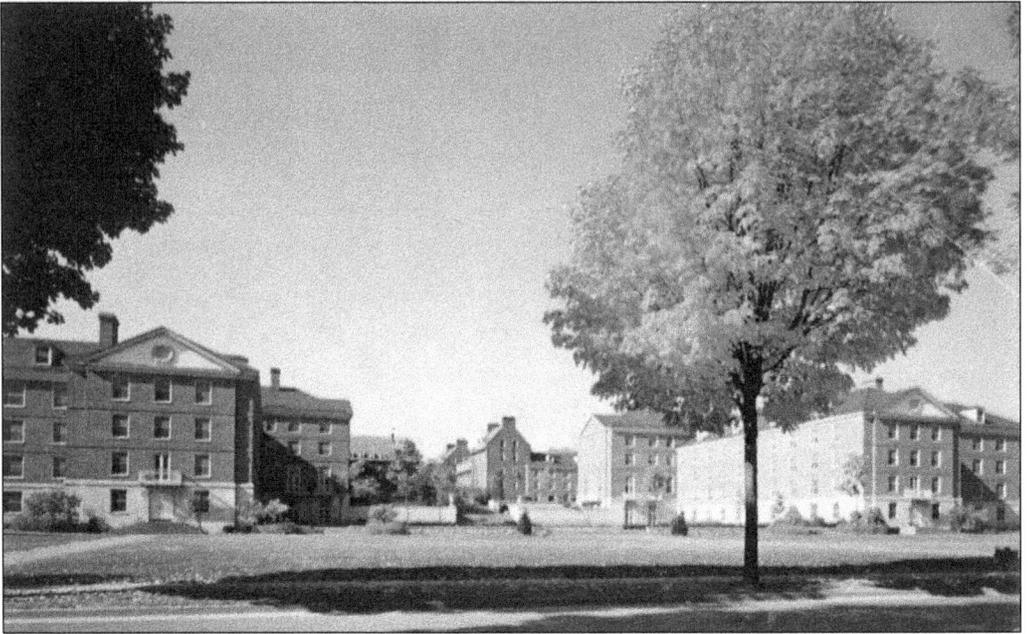

By 1950, West Halls had doubled in size with the construction of McKee Hall, Thompson Hall, and Hamilton Hall, followed by the completion of the Waring Commons Building in 1951. Waring Commons houses the West Food District, along with other facilities such as a computer lab and cultural lounge. Many consider West Halls the most advantageous of all the dormitory areas due to their size and location. Overall, the rooms are larger, and the halls are closer to the library and other academic buildings.

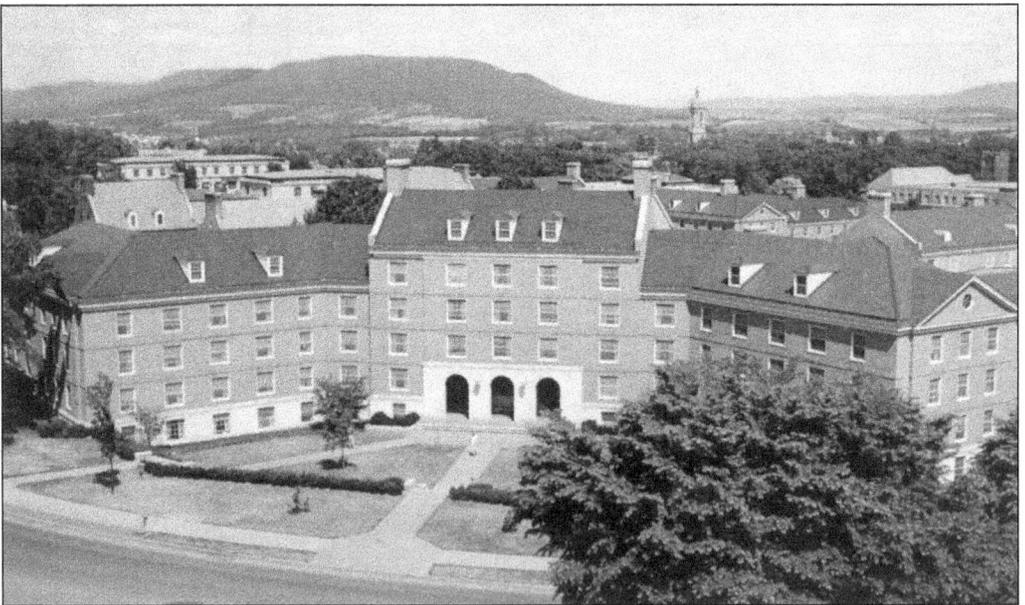

The expanse of West Halls can be seen in this slightly elevated view of McKee Hall. Also present is the very tip of the Old Main bell tower. McKee Hall is located directly across the street from Rec Hall and the Nittany Lion Shrine. The back of the card states that McKee Hall can accommodate 345 men. (Photograph by Bill Coleman.)

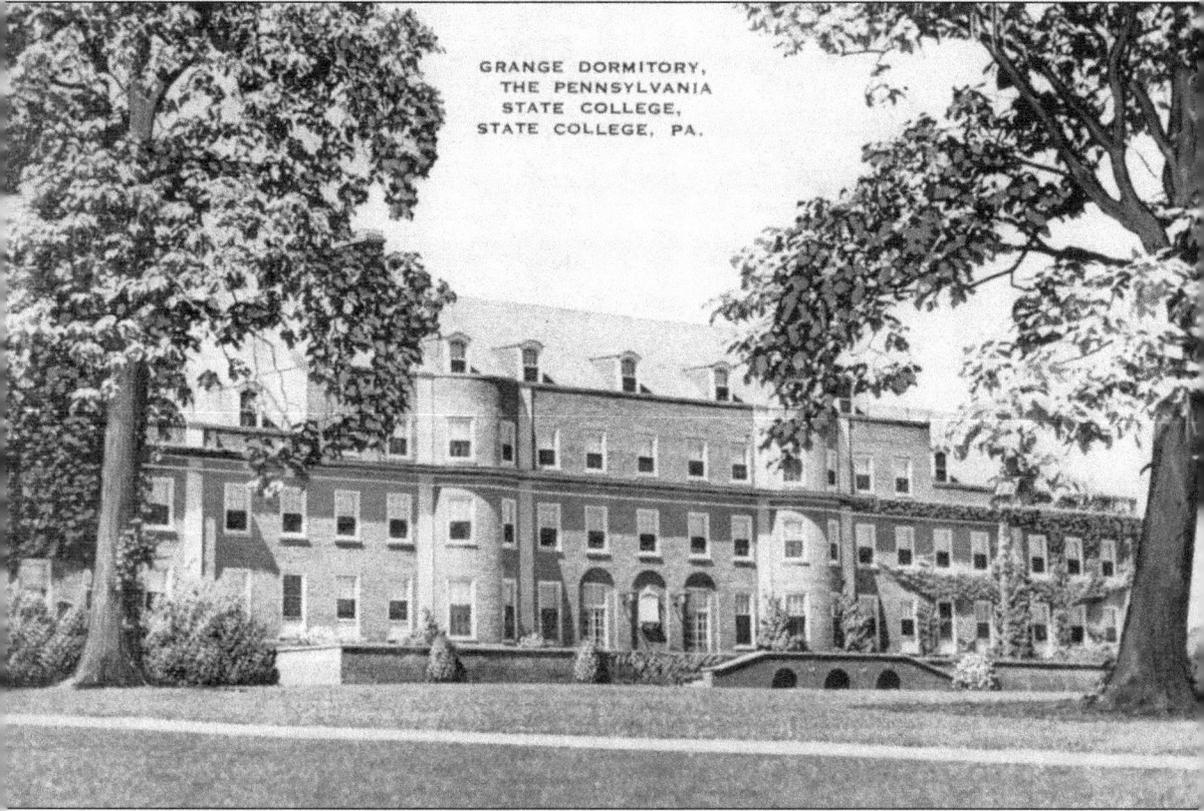

GRANGE DORMITORY,
THE PENNSYLVANIA
STATE COLLEGE,
STATE COLLEGE, PA.

The Grange Hall dormitory was built in 1930 to accommodate the continued influx of female students. Neither the Ladies Cottage nor McAllister Hall could handle all the women attending Penn State at the time, and coed dormitories were still decades away. Some of the older cottages were being used as sorority houses, but more permanent housing was needed. To help fund the construction of the building, the college solicited help from the Pennsylvania State Grange, which donated $100,000 to the project. To procure these funds, the Pennsylvania State Grange asked all its chapters to make a donation; however, most of the money was raised through the statewide sale of Grange cookbooks. By the 1960s, South Halls had been established as the female dormitories, which were completed in 1956, and Grange Hall had become known as the Grange Building, which currently houses a division of the undergraduate studies department.

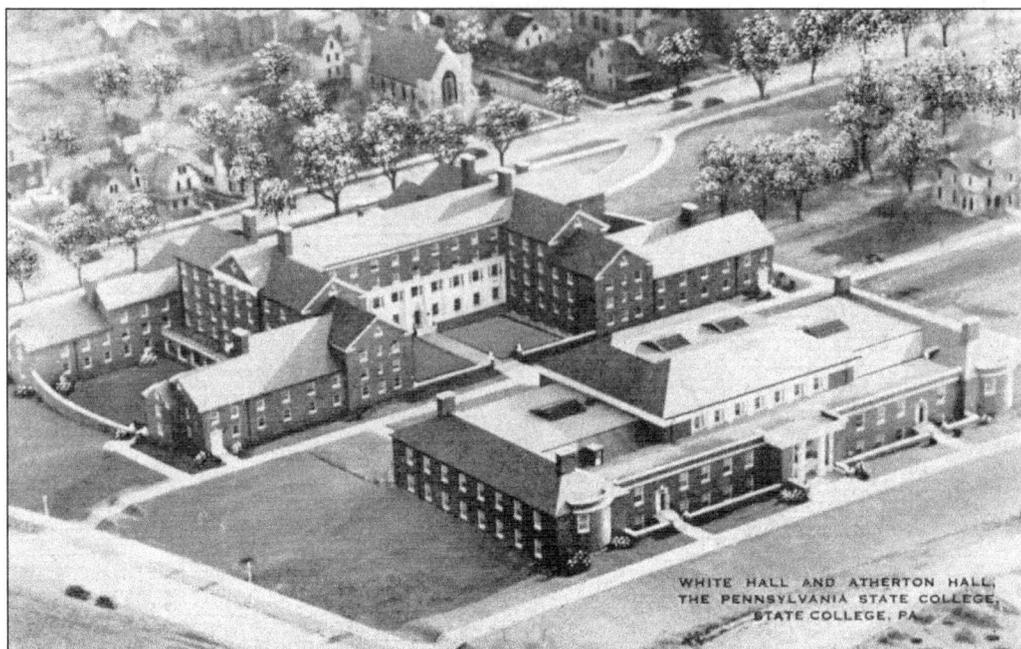

White Hall (foreground) and Atherton Hall are pictured in this view looking south toward town. White Building was named after Mary Beaver White, sister of James A. Beaver (president of Penn State from 1906 to 1908) and wife of Rev. John White (former chaplain of Penn State). Atherton Hall is named after Frances Washburne Atherton, who was the wife of former president George W. Atherton.

The Mary Beaver White Building was constructed from 1937 to 1938. The main purpose of the building was to provide a gymnasium for female students. It is now a coed facility that serves as the headquarters of Penn State fencing and gymnastics. For a few years, Penn State's THON was held here until it outgrew the space and was moved to the Bryce Jordan Center.

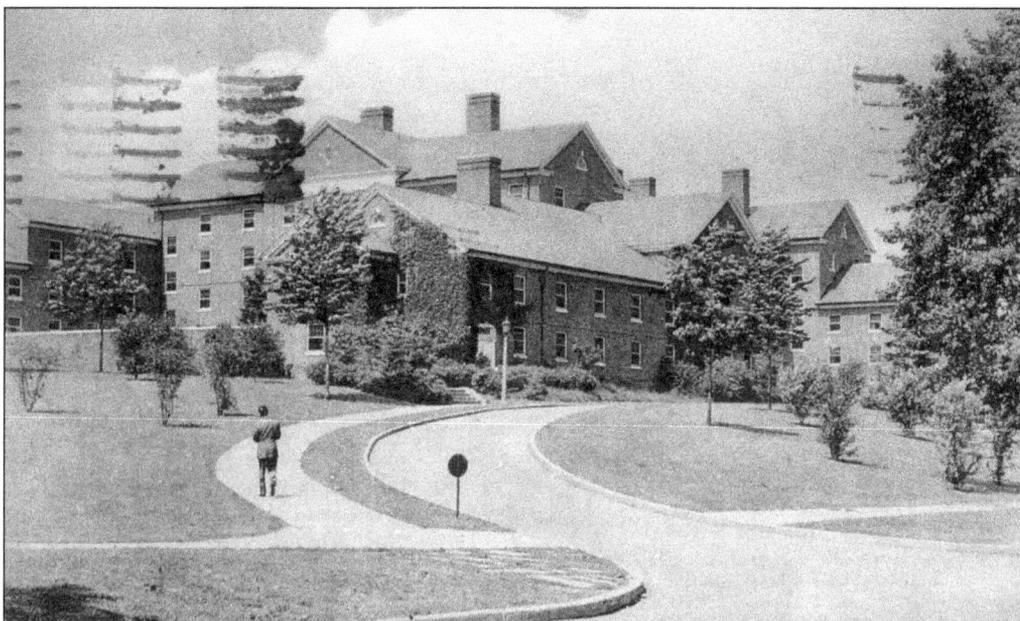

Atherton Hall was another dormitory established for female students. Built in 1939, it was situated next to what was then the women's gymnasium, the Mary Beaver White Building. Atherton Hall became the home of the Honors College in 1984, and the program was renamed the Schreyer Honors College in 1999 with a grant of $30 million from William A. and Joan L. Schreyer.

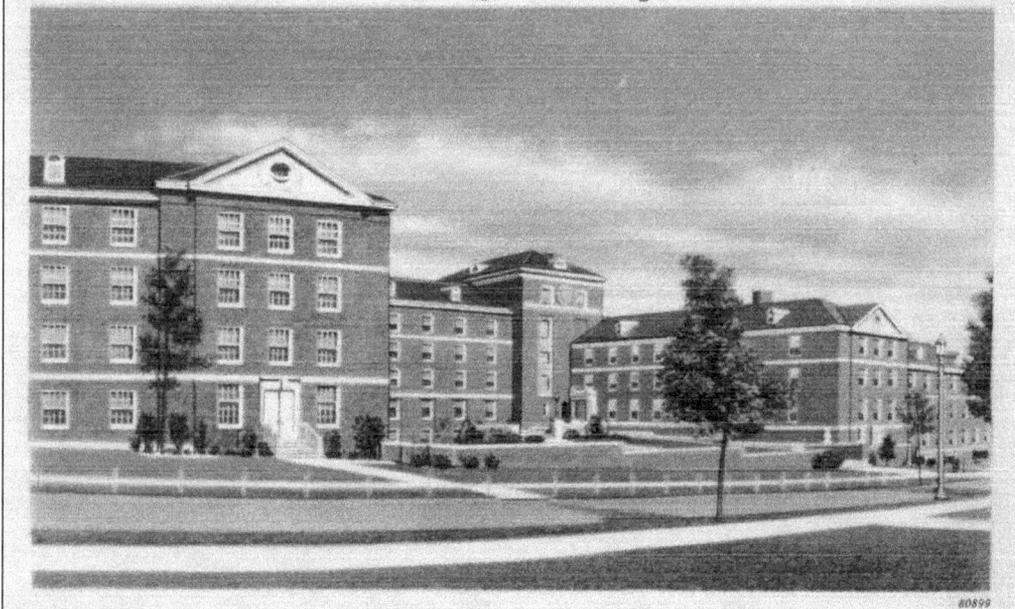

Simmons Hall, Pennsylvania State College, State College, Pa.

Simmons Hall is considered part of the South Halls grouping of dormitories. It is located across Shortlidge Road from the Hub Parking Deck. Built in 1948, the dormitory was named after Dr. Lucretia Van Tuyl Simmons, who earned a master's degree from Penn State and went on to become a member of the faculty, dean of women, and head of the German department from 1919 to 1939. It is now a coed facility that houses Schreyer Honors College students.

Built in 1949, McElwain Hall is the northernmost dormitory of South Halls. Originally established as a dormitory for female students, the building was named after Harriet A. McElwain, who was the only Penn State employee to hold the title of lady principal, from 1883 to 1900.

South Halls is a group of dormitories located on East College Avenue along the border of University Park and State College. This image shows the backs of Hibbs, Stephens, Cooper, and Hoyt, as well as part of the Redifer Commons, all of which were built in 1956. These dormitories house most of the sororities, and each building is named after a famous female faculty member. (Photograph by Richard C. Miller.)

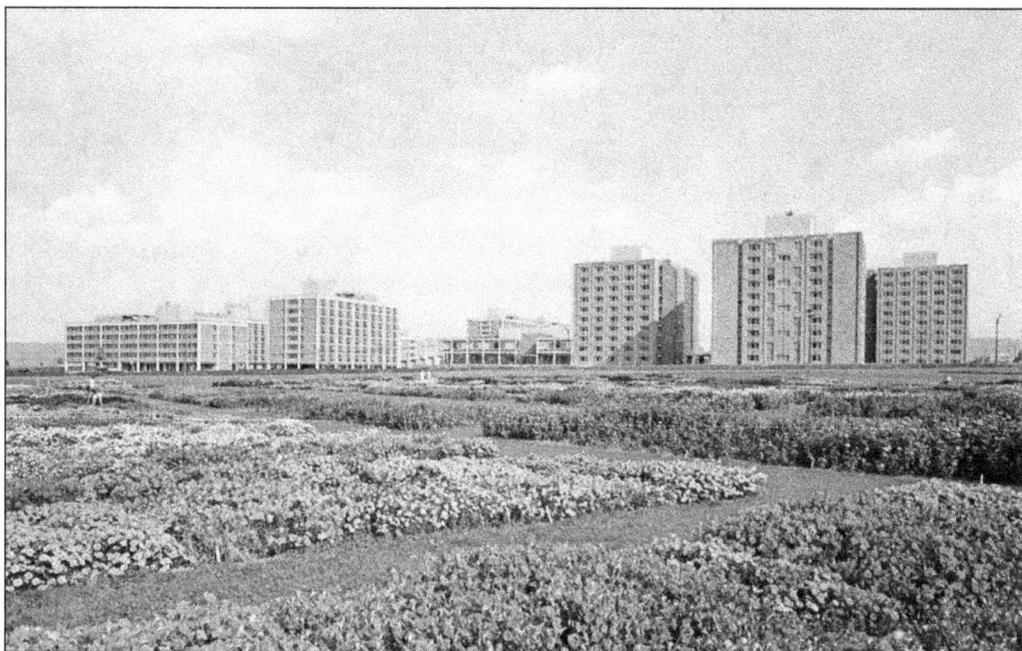

Many students have quipped that East Halls is the closest commonwealth campus to University Park. Despite its distance from many of the academic buildings, East Halls does have certain advantages, the biggest of which is its proximity to Beaver Stadium and the Bryce Jordan Center. The residence halls pictured here are, from left to right, Hastings, Stuart, Brumbaugh, Tener, and Pinchot.

Pictured in this street view from the corner of Park Avenue and Bigler Road are Tener Hall, built in 1964; Pinchot Hall, completed in 1967; and Packer Hall, completed in 1959. Partially blocked by trees, the two-story structure in the center of the image is the Findlay/Johnston Commons Building, which houses a branch of the Penn State Bookstore.

The Penn State Trial Gardens were cultivated on campus beginning in 1933. The first gardens were located next to the Botany Building in the heart of campus. For a while, the gardens found a new home adjacent to East Halls. The different types of flowers and the proximity to East Halls can be determined from this postcard. Consisting of a wide variety of seasonal flowers, the trial gardens have since been moved to Manheim, Pennsylvania. With a generous donation of $10 million from Charles Smith to honor his father, the H.O. Smith Botanic Gardens opened at the Penn State Arboretum in 2009. The arboretum is located approximately one block away from the former trial gardens at East Halls. (Photograph by Richard C. Miller.)

Five

Hanging around Town

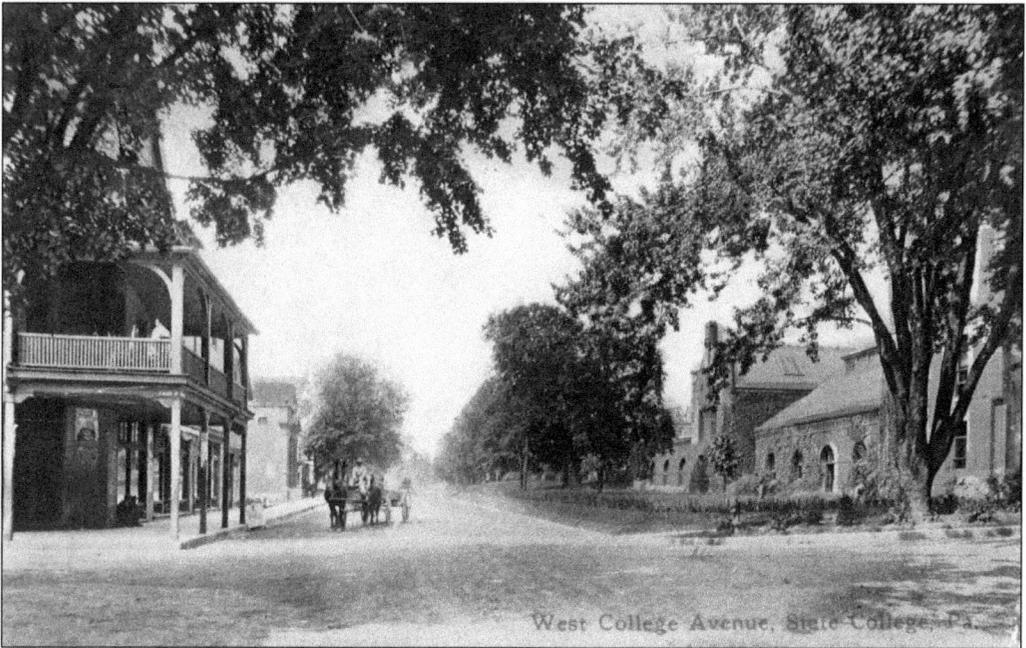

West College Avenue at the intersection of Allen Street has changed much since the early 1900s. To the left are the Corner Room and the Hotel State College. To the right is the Old Engineering Building that burned down in 1918. Just out of view on the right would have been the main entrance to Penn State. (CPCCCHS.)

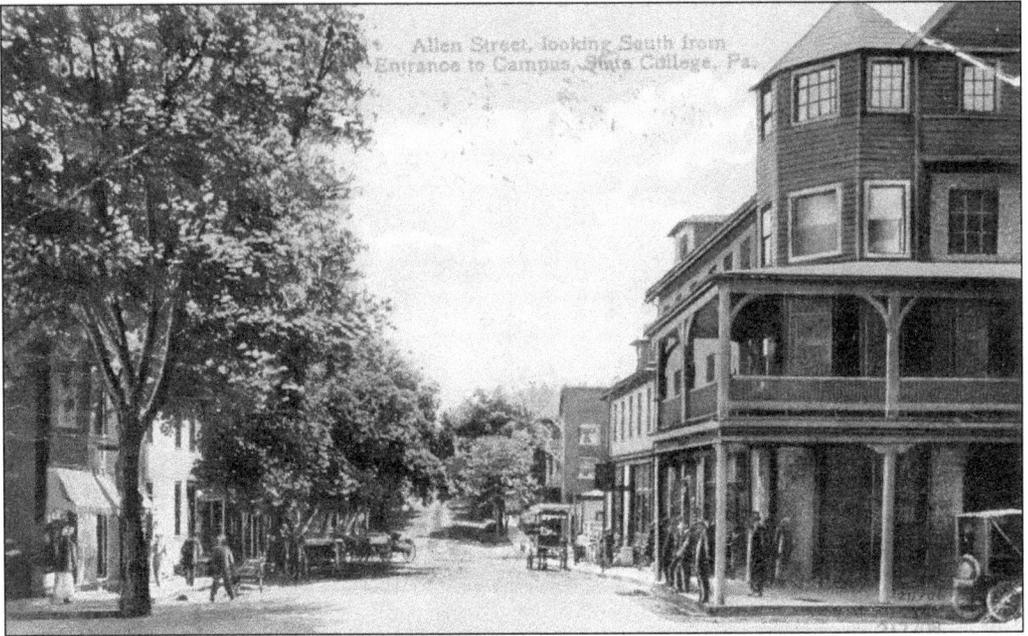

Allen Street, looking South from Entrance to Campus, State College, Pa.

This postcard depicts Allen Street in 1916. The only recognizable building that still remains is the Corner Room and the Hotel State College on the right. The opposite corner would be the future site of Moyer's Jewelry. Horses and buggies were still commonly used for transportation.

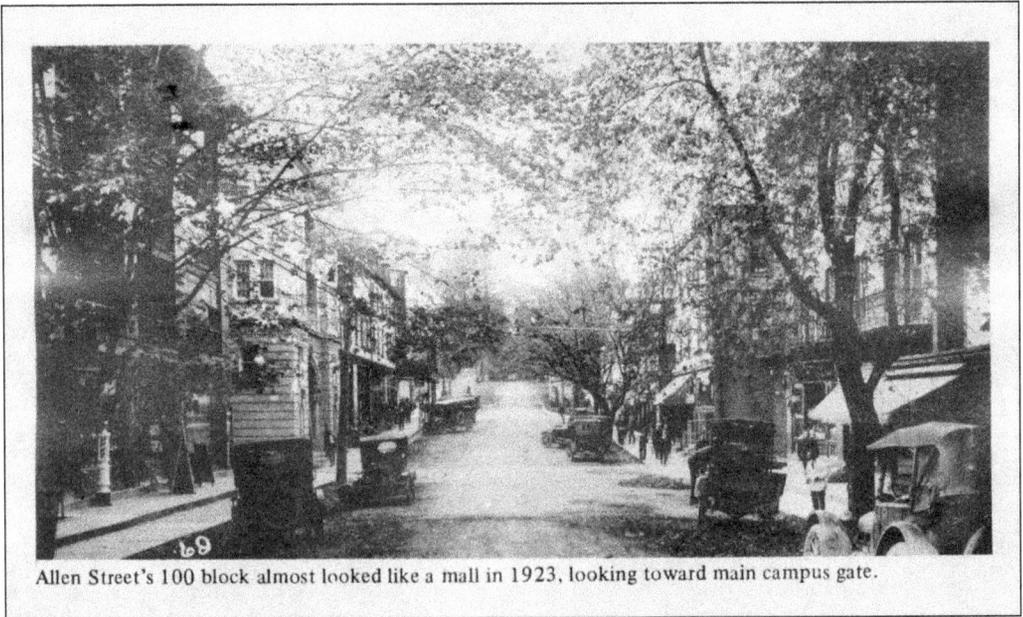

Allen Street's 100 block almost looked like a mall in 1923, looking toward main campus gate.

In a later snapshot from 1923, the horse and buggies have been replaced with automobiles. This view looks north toward the main gate of Penn State, which can be made out at the center of the image. At the time, the road continued into the heart of campus. This postcard was printed from a photograph of the Penn State Collections for the Central Counties Bank.

This triptych postcard from 1939 is an advertisement for the Corner Room and the Hotel State College at the corner of Allen Street and College Avenue. Guests can still enjoy a delicious meal at the restaurant, then spend the night at the hotel upstairs.

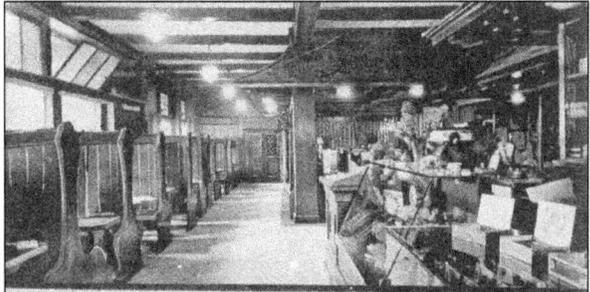

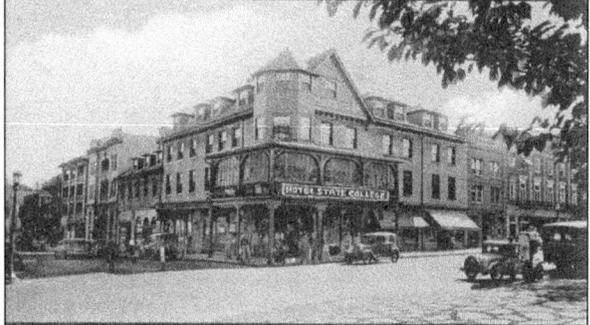

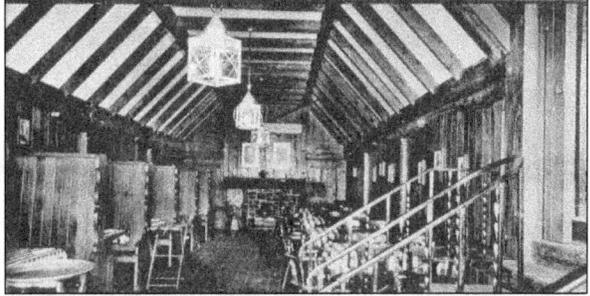

The corner of Beaver Avenue and Garner Street looked quite different in 1895. Old Main can be seen towering above the trees in the distance, and the Armory tower is just barely visible to the left of that. The Diplomat apartment complex and the Grace Lutheran Church diagonally across the street now occupy the site where this photograph was taken. This postcard was printed from a photograph of the Penn State Collections for the Central Counties Bank.

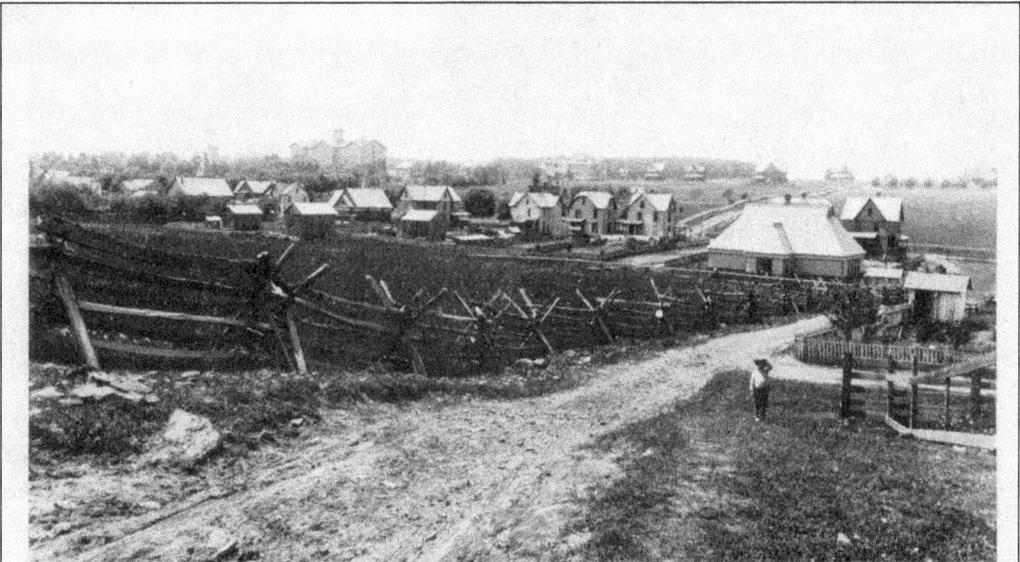

Beaver Avenue and Garner Street in 1895, now site of CCB drive-in. First school is larger building at right.

McLanahan's Penn State Room has been a fixture on East College Avenue since 1933. Located at the intersection of Garner Street, this student store and food market carries everyday essentials and knickknacks. The McLanahan's Downtown Market, which specializes in groceries, is located on Allen Street. (Photograph by C.G. Wagner Jr.)

This promotional postcard for the Family Clothesline in State College provides a nostalgic view of Beaver Stadium, as well as the 2015 football schedule. The Family Clothesline, located at 325 East College Avenue, specializes in moderately priced attire and accessories.

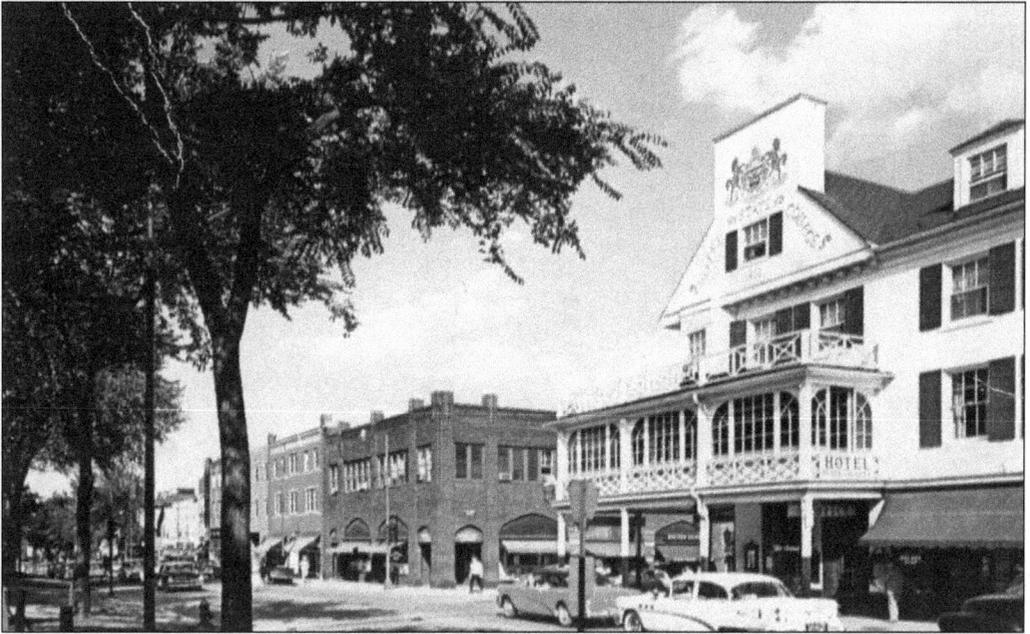

Looking east on West College Avenue, this postcard shows another view of the two establishments flanking Allen Street. The brick building in the center is the Athletic Store, and the white building on the right is the Corner Room, part of the State College Hotel. The Athletic Store is no longer in business, but that corner store is now occupied by Moyer's Jewelry. (CPCCCHS.)

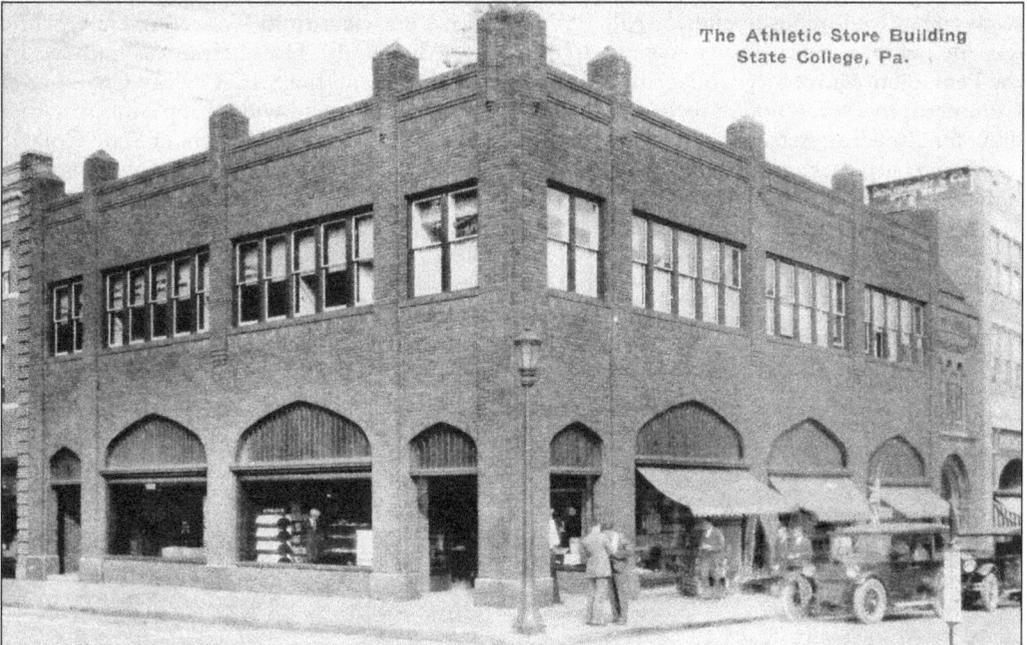

The Athletic Store was one of the first places in town where students, family members, and visitors could buy souvenirs from Penn State. The Athletic Store produced some of the postcards used in this book, including this one from 1926. This store could be considered a precursor to the Student Book Store, located at 330 East College Avenue. (CPCCCHS.)

The Arts Festival is a yearly tradition in State College, as well as on campus. Hundreds of artists set up display tents that snake through main campus and town. These images of the festival were taken from opposite ends of Allen Street. Above is a view from College Avenue, while the one below is from Beaver Avenue, looking toward campus. The festival was founded by the Penn State University College of Arts and Architecture and the State College Chamber of Commerce in 1967. Though seeing the wares of artists from far and wide is appealing, another draw for attending Arts Fest is the live music. Bandstands are created throughout State College and University Park, and attendees have their choice of music. (Above, photograph by Robert L. Goerder; below, photograph by Richard C. Miller.)

This promotional image shows the remains of what was once a bustling town known as Centre Furnace. The town existed from 1791 to 1858 and was right outside State College. James Irvin, who donated 200 acres for the Farmers' High School of Pennsylvania, co-owned Centre Furnace. This postcard was produced from a 1910 photograph by Leonard Mansell for the Central Counties Bank.

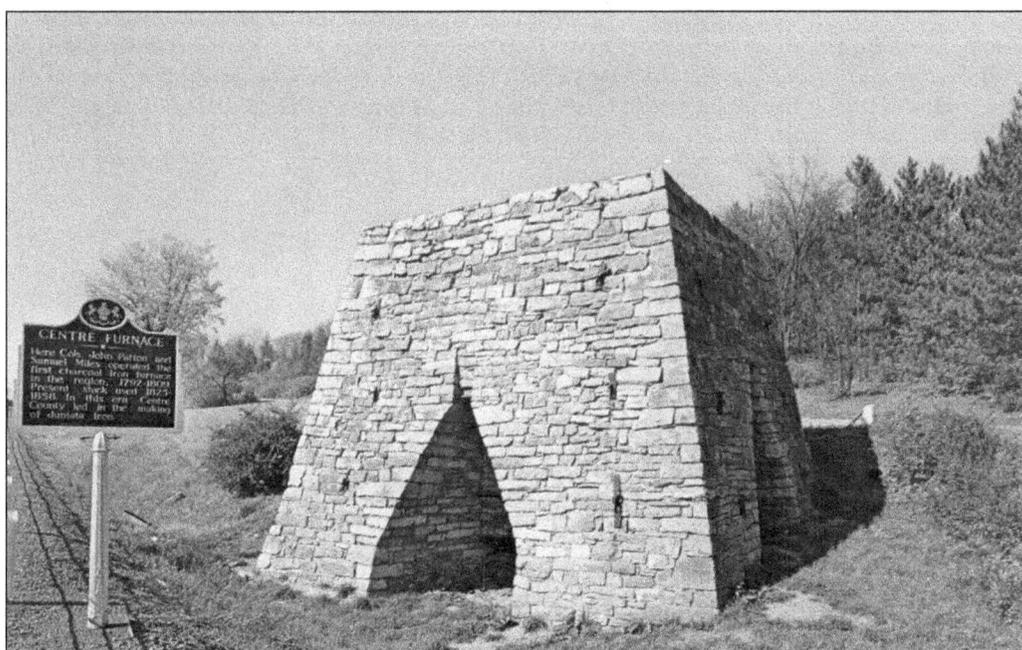

The stone furnace seen from Route 26 when traveling to Penn State from the north is all that remains of Centre Furnace. The historical marker pictured here was erected to identify the furnace. Centre Furnace was the first iron furnace in the area of Centre County. Close by is the Centre Furnace Mansion, which is the home of the Centre County Historical Society.

Penn's Cave is a one-of-a-kind attraction located in Centre Hall, only 18 miles east of Penn State. The cave is thousands of years old, and tours became a commercial venture in 1885. The hotel was also built in that year. The hotel provided accommodations until 1919, then continued to offer meals to visiting guests until 1929. It is now a private residence, and a more modern restaurant and gift shop were built in 1980. Penn's Cave is unique in that spectators "see it by boat," as the tagline boasts, rather than via a walking tour. Many out-of-state visitors stay at the Keller House Bed & Breakfast, located five miles west of the cave. The Keller House was built in 1887, just a few years after Penn's Cave was established.

Entrance to Penn's Cave Penn's Cave, Pa.

Just a few miles northeast of Penn State is Rockview State Penitentiary, located on Route 26 between State College and Pleasant Gap. Once a prison farm, the penitentiary comprises about 8,000 acres. The facility is now known as the State Correctional Institution at Rockview.

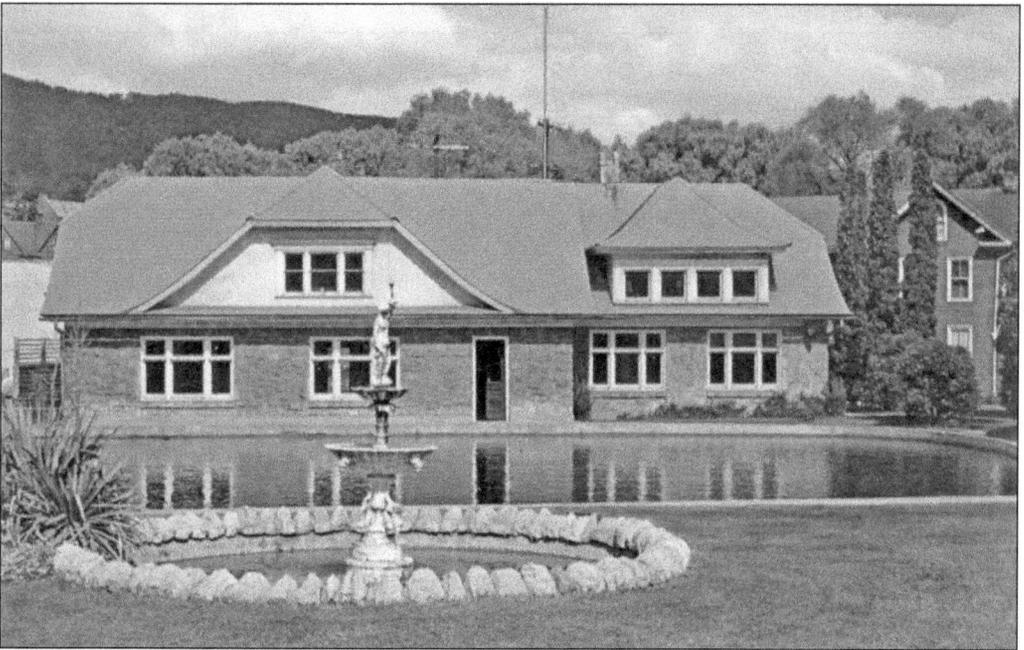

During trout season, it is not uncommon to see hundreds of fishermen near Big Spring in Bellefonte. Located north of Penn State, Bellefonte offers plenty of catch for the dedicated fisherman, as well as plenty of stores for the avid shopper. Nearby Spring Creek is heavily stocked, and supervised fishing is permitted during trout season. (Photograph by Richard C. Miller.)

The Penn Stater Conference Center Hotel is located on the edge of campus, about two miles east of Beaver Stadium in Penn State's Research Park. The hotel has 300 guest rooms, plus two restaurants, and boasts 58,000 square feet of meeting room or banquet hall space. (Photograph by C.G. Wagner Jr.)

This early view of the Autoport shows that it was originally built as a motel in 1936. According to the *Daily Collegian*, this motor inn at 1405 South Atherton Street was Pennsylvania's first motel, but it was in danger of closing until Anthony Melchiorri, the host of Travel Channel's *Hotel Impossible*, visited the 85-room property in 2014. (Photograph by Richard C. Miller.)

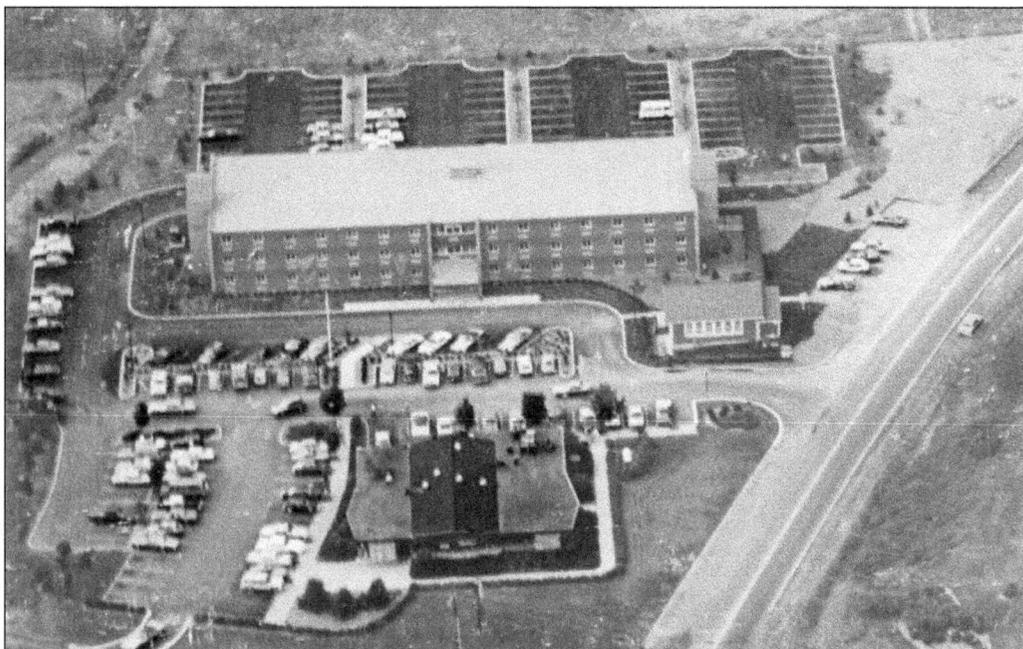

Originally known as the State College Inn, the Super 8 State College is located at the corner of South Atherton Street and Branch Road. The restaurant in front of the hotel has changed hands several times, first as an Elby's, then as a Perkins, and finally as an International House of Pancakes. (Photograph by Erin Wheeland.)

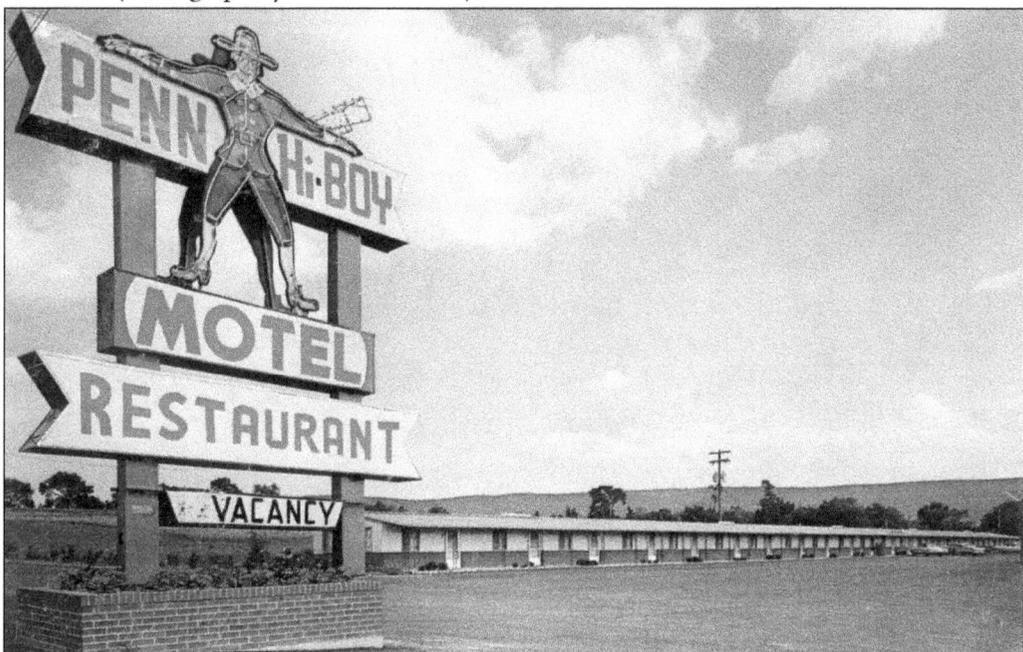

There are numerous hotels, motels, and bed-and-breakfasts in the State College area. All receive most of their income from travelers to Penn State. This Penn Hi-Boy Motel, which offered televisions in every room, plus tile floors throughout, was situated one mile east of Penn State on Route 322. This card was postmarked on May 18, 1964.

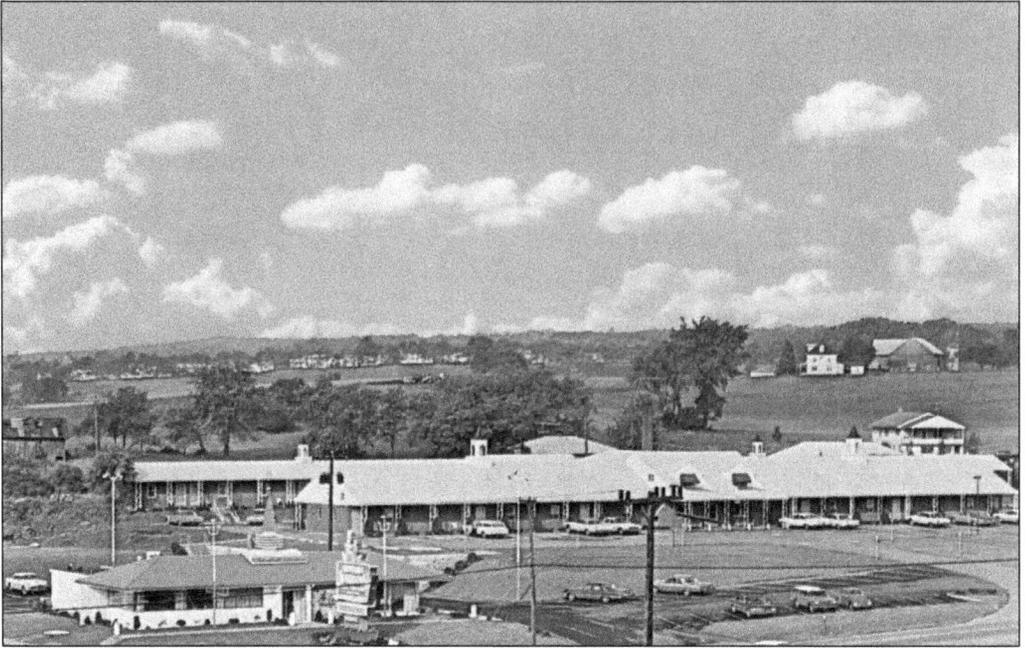

The Nittany Manor Motel was located one mile west of Penn State on North Atherton Street. It offered 39 air-conditioned units with ceramic tile baths, cable television, radios and telephones, and delicious fare at Howard Johnson's within walking distance. The motel has been replaced by a Quality Inn, and the Howard Johnson's is no longer there.

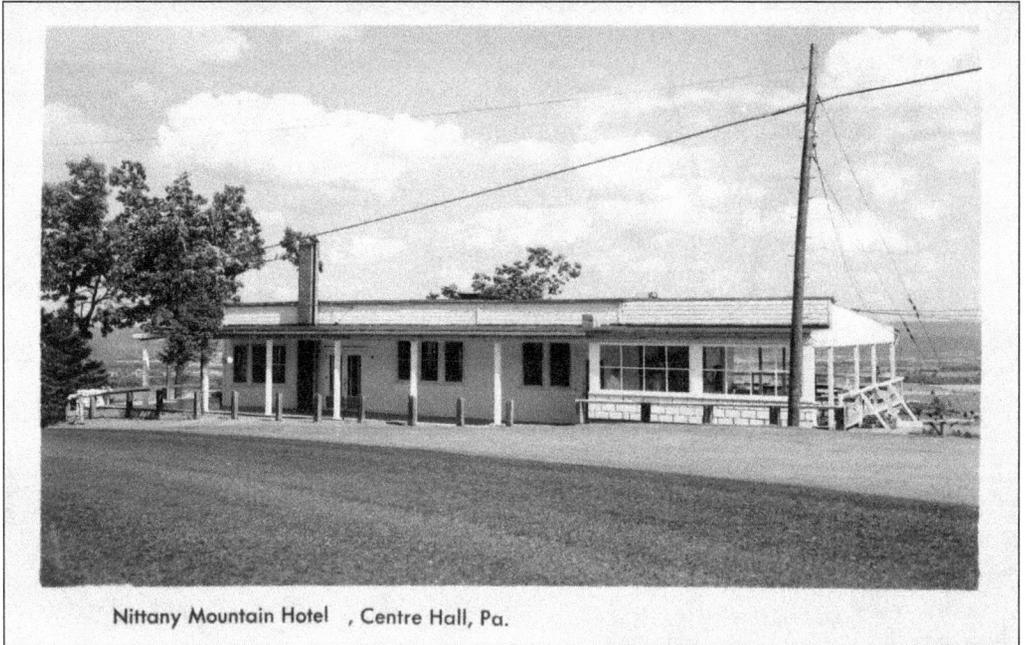

Nittany Mountain Hotel , Centre Hall, Pa.

The Nittany Mountain Hotel was situated on top of the mountain separating Pleasant Gap and Centre Hall, offering spectacular views of the valley. It suffered two fires and was rebuilt twice. The hotel was most recently called the Mount Nittany Inn and was just recently purchased by Harrison's Wine Grill & Catering. It was renamed Above the Valley in 2016.

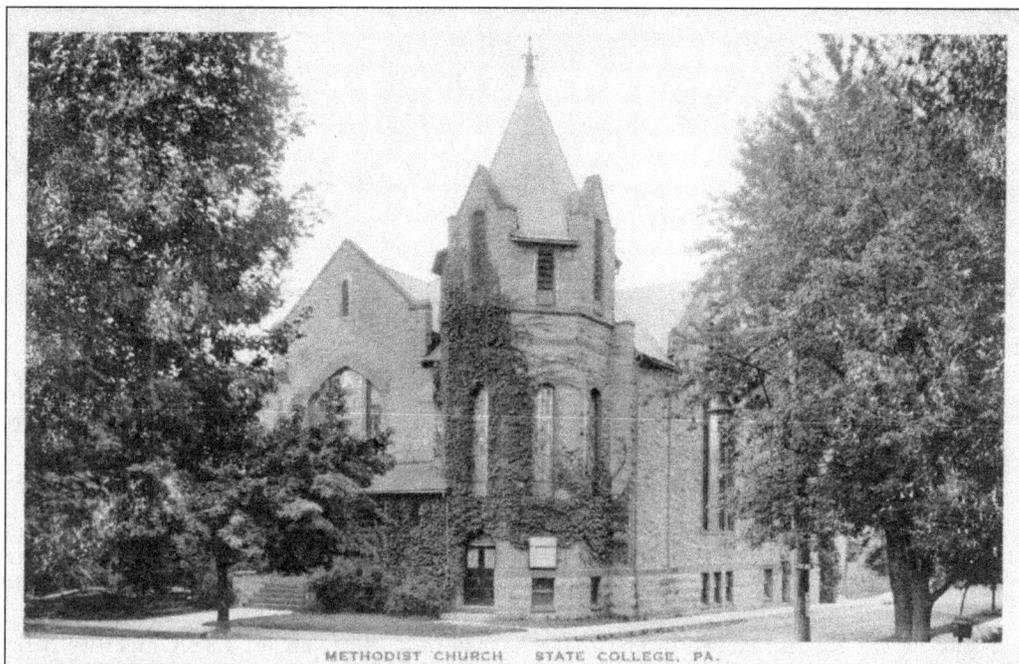

Built in 1888, St. John's United Methodist Church is one of the oldest churches in State College. It is located at 250 East College Avenue at the intersection of McAllister Street, directly across the street from the HUB lawn and the Health and Human Development Building. The congregation consists of local townspeople as well as students.

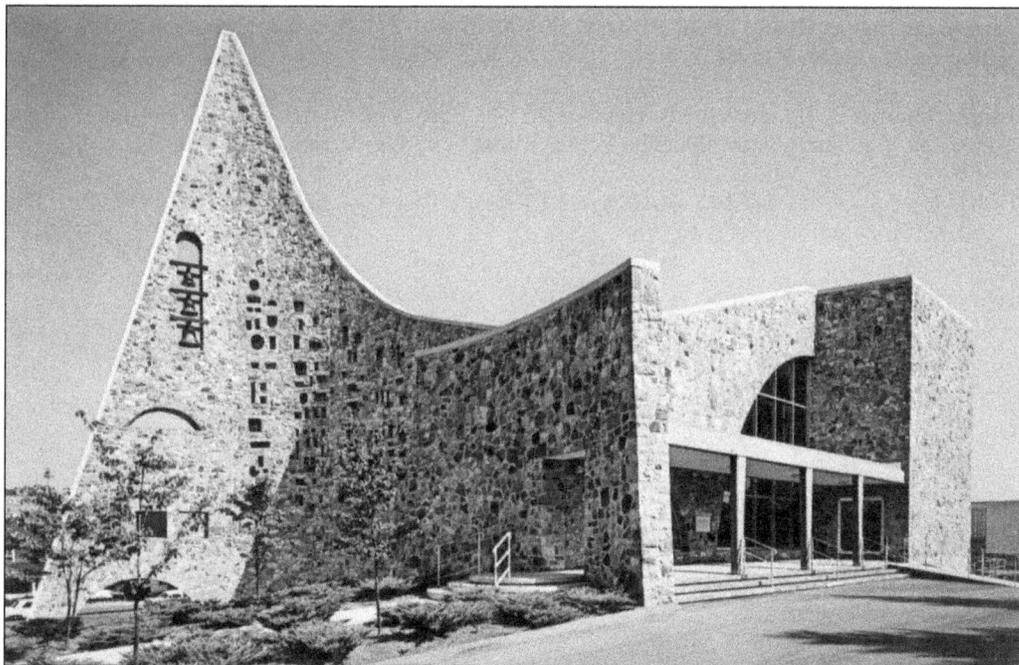

The Grace Lutheran Church is located at the corner of Garner Street and East Beaver Avenue, about two blocks up Garner Street from the main campus of Penn State and South Halls. This unusual church building is hard to miss while driving through town.

BIBLIOGRAPHY

Bezilla, Michael. *Penn State: An Illustrated History.* University Park, PA: The Pennsylvania State University Press, 1985.

Esposito, Jackie R., and Steven L. Herb. *The Nittany Lion: An Illustrated Tale.* University Park, PA: The Pennsylvania State University Press, 1997.

Missanelli, Michael G. *The Perfect Season.* University Park, PA: The Pennsylvania State University Press, 2007.

Range, Thomas E. II, and Lewis Lazarow. *Into the Game: The Penn State Blue Band 1999–2009.* Bloomington, IN: Xlibris, 2010.

Range, Thomas E. II, and Sean Patrick Smith. *The Penn State Blue Band: A Century of Pride and Precision.* University Park, PA: The Pennsylvania State University Press, 1999.

This Is Penn State: An Insider's Guide to the University Park Campus. University Park, PA: The Pennsylvania State University Press, 2006.

ABOUT THE ORGANIZATION

The Centre County Historical Society (CCHS) is the oldest and largest of the county's historical organizations, having celebrated its rich heritage since 1904. CCHS is headquartered in the Centre Furnace Mansion, a beautifully restored ironmaster's mansion and historic house museum with a rich history in Centre County and a listing in the National Register of Historic Places.

In the 18th century, soon after the American victory over the British in the Revolutionary War, two colonels, John Patton and Samuel Miles, bought tracts of land in a wilderness known as the Nittany Valley. There, they built the second iron furnace west of the Susquehanna River. Later, a store and sawmill were added, and some of the land was sold to the farmers.

In the 19th century, Gen. James Irvin acquired the furnace. His brother-in-law Moses Thompson managed it and oversaw the growth of the workers' village. In the 1840s, Thompson began building the Centre Furnace Mansion, where he would live as the ironmaster with his wife, Mary, and their children.

When the Pennsylvania Agricultural Society resolved to build a Farmers' High School, General Irvin offered to donate a portion of his land near the Centre Furnace. Throughout the commonwealth, other groups vied to have the school located in their own counties. A review committee appointed to assess each proposed site toured Irvin's lands on June 26, 1855. It is said that their subsequent decision to locate the school in the Nittany Valley was influenced by the sumptuous dinner prepared by Mary Thompson, which they enjoyed that evening at the mansion.

In the 20th century, the Farmers' High School became the Pennsylvania State University. The mansion where Penn State began later became the headquarters of the Centre County Historical Society.

In the 21st century, volunteers spend 6,000 hours a year in the loving upkeep of the Centre Furnace Mansion, furnace stack, gardens, and the Boogersburg School. Funding is made possible through membership, business support, grants, fundraising, and donations. Through exhibits, presentations, and publications, the history and heritage of Centre County is explored, preserved, and interpreted.

Join the society as it builds on the past. Local membership and business sponsorships make CCHS possible. For more information, visit the society at www.centrehistory.org or at the Centre Furnace Mansion (1001 East College Avenue, State College, PA 16801), or call 814-234-4779.

Visit us at
arcadiapublishing.com